D0164355

Unless Recalled Earlier

DATE DUE

DEMCO, INC. 38-2931

BRICKWORKS

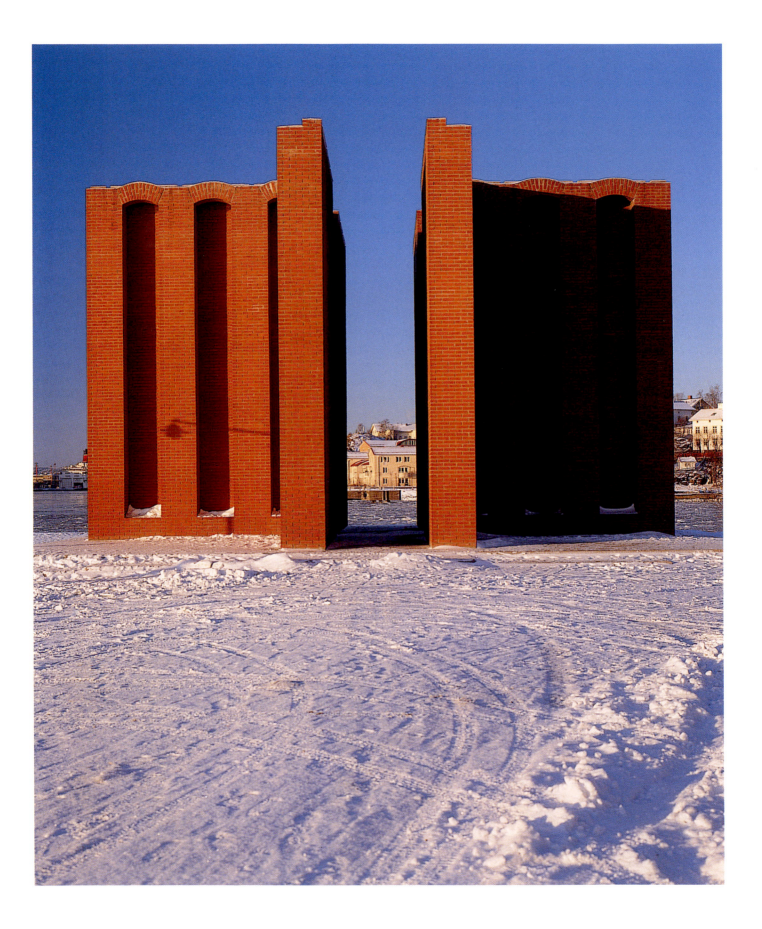

BRICKWORKS

Gwen Heeney

RECEIVED
NOV - 5 2004
MINNESOTA STATE UNIVERSITY LIBRARY
MANKATO, MN 56002-8419

A & C Black • London

University of Pennsylvania Press • Philadelphia

*Thanks to Michael Hammett senior architect BDA, for
all his help and enthusiasm, to Marco and Val for their
understanding, and to Mum, Dad and Mel for all their help.
Thanks also to Geoff Sansbury for all his help with Chapter Eight.*

TH
5501
.H395
2003

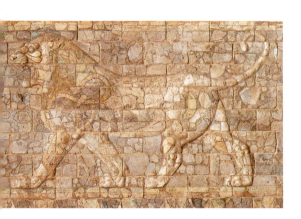

*Moulded brick lion, from the Palace of
Darius, Persia. Reconstructed in the Louvre
Museum, Paris. Photograph © photo RMN –
Hervé Lewandowski.*

First published in Great Britain 2003
A & C Black (Publishers) Limited
Alderman House
37 Soho Square
London W1D 3QZ
www.acblack.com

ISBN 0-7136-4880-5

Published simultaneously in the USA by
University of Pennsylvania Press
4200 Pine Street
Philadelphia, Pennsylvania 19104-4011

ISBN 0-8122-3782-X

Copyright © Gwen Heeney 2003

CIP Catalogue records for this book are available from the British Library and the U.S.
Library of Congress.

Gwen Heeney has asserted her right under the Copyright, Design and Patents Act, 1988,
to be identified as the author of this work.

All rights reserved. No part of this publication may be reproduced in any form or by any
means – graphic, electronic or mechanical, including photocopying, recording, taping or
information storage and retrieval systems – without the prior permission in writing from
the publishers.

Cover illustration (front): *Rhiannon (detail of face)*, by Gwen Heeney, Atlantic Wharf.
Cover illustration (back): Bjorn Norgaard, detail of *Thor's Tarn (Thor's Tower)*.
Frontispiece: *Gôteberg*, sculpture, by Per Kirkeby, photograph © Jens Markus Lindhe.

Book design by Jo Tapper
Cover design by Dorothy Moir

Printed and bound in Singapore by Tien Wah Press (Pte).

A & C Black uses paper produced with elemental chlorine-free pulp, harvested from
managed sustainable forests.

Thanks go to all the artists for kindly supplying images of their work
(unless otherwise stated images of artists' work is courtesy of the artist).

2955826
57920868

Contents

Introduction

In writing this book I hope to reflect both my own passion for the creative use of brick, and the increasingly important role it is playing as an artistic medium for international artists, architects and industrialists. Brick is not a new medium of artistic expression – its roots were laid down over 10,000 years ago, and it has featured significantly in every civilisation throughout world history. This book will provide both an overview of the history of brick, and will seek to cover the technical and practical issues involved in working with brick, while also looking at the work of contemporary makers.

It is not always easy to pigeonhole artists and architects working across boundaries, and this has made creating autonomous sections and chapters within this book a complicated task. The intervention of artists, for whom the brick has become an exciting new material with infinite creative possibilities, is having far reaching implications for contemporary ceramic practitioners. Internationally renowned artists collaborating with the brick industry on major projects serves to emphasise the flexibility and versatility of the material. The increasingly innovative and experimental uses of brick in architectural and site-specific artworks highlights concerns about the limitations of contemporary studio practice.

Not merely creative experimentation, but technological advances also have implications for the architectural design potential of brick. A number of architects, such as Tim Ronalds (architect of The Landmark, an entertainment centre at Ilfracombe in Devon), have started to use brick and ceramic products in an attempt to make connections with historical fabrics and to create increasing stimulation for the viewer through the materials used.

The implications for a positive exchange between the disciplines, collaboration with industry, and the growth of international symposia as forums for artistic innovation and contemporary discussion are immense. Additionally, the part played by the new universities, in assimilating and initiating these opportunities is having far-reaching repercussions on art and design education. Placements in industry are becoming a normal part of student life, providing opportunities for the realisation of large-scale architectural projects. Participation in innovative international projects and symposia with professional artists is helping to equip students for exciting careers within the arts and pushing creative boundaries ever further.

Historical, contextual and social

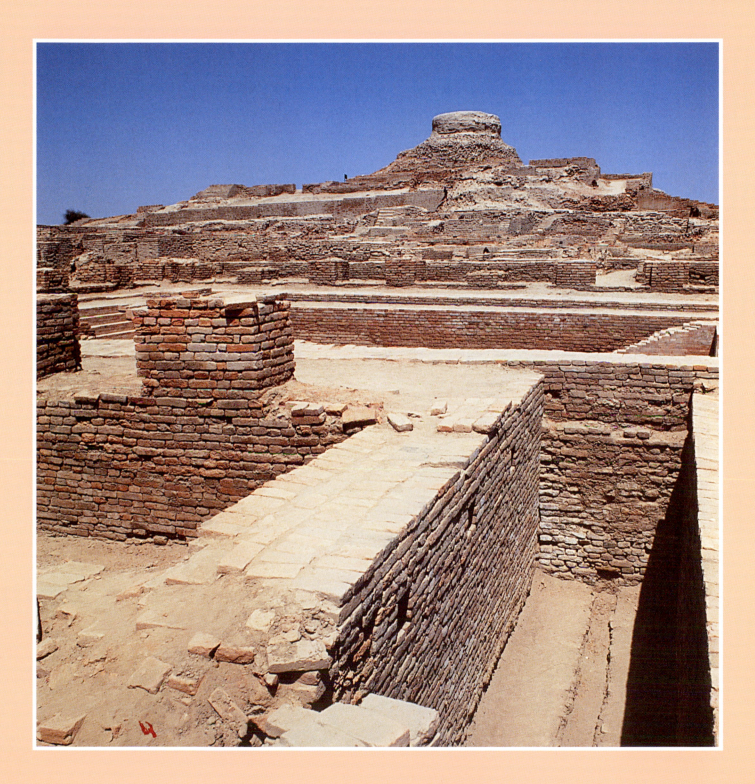

The ruins of the Indus civilisation at Mohenjo-daro, Pakistan, Asia.
Photograph courtesy of the Robert Harding Picture Library.

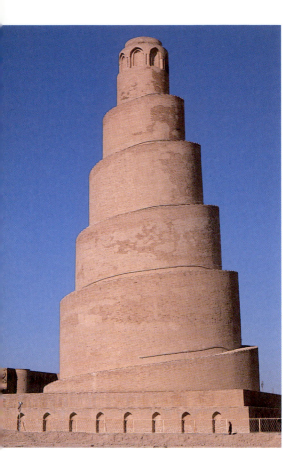

Above: Samarra Minaret, Iraq, 3000 BC.
Photograph courtesy of the Robert Harding Picture Library.

Building bricks

10,000 years ago man discovered that by shaping clay with his hands and drying it in the sun he could produce a unit – the brick – which could be used for building a shelter. There are numerous examples of its historic use. Ancient Egyptian tomb paintings show brick-makers at work using sun-dried mud bricks in many ways, sometimes for lining the walls of rock tombs. These ancient bricks were called 'adobe', a particularly functional material that soaks in the sun all day and gives off heat at night. Bricks dating from the same period were discovered in an archaeological excavation beneath the biblical city of Jericho, in ancient Palestine. Some of these bricks still had the marks of the brick-maker's thumb where he had made depressions in order to allow the mud mortar to adhere to the brick. According to biblical accounts, the tower of Babel was built of sun-dried mud brick. In South America, 2,000 years ago, Cahuachi – the lost city of the Nasca priests – was sculpted from the earth into huge pyramids with sun-dried brick walls.

The world's most comprehensive collection of brick and brick-makers art from ancient civilisations throughout the world can be seen at the General Shale Museum in Johnson City, Tennessee.

By the 5th millennium BC huge constructions were being undertaken especially in southern Iraq, with buildings rising higher and higher. Many were for ceremonial use. Brick-making became an important source of urban employment for the next 3,000 years, partly as a means of

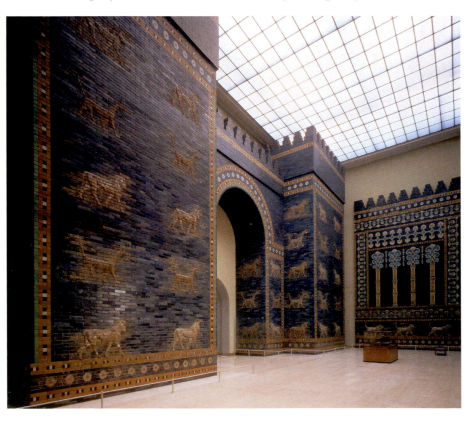

Right: The original gate of Ishtar, reconstructed in the Berlin Museum.
Photograph courtesy of the Berlin Museum.

keeping the masses occupied, (from Gwendoline Leick's lecture at the Creating the Yellow Brick Road symposium, 1999.)

Later bricks were fired to produce a very durable unit. In 1922 archaeologists discovered the extensive remains of Mohenjo-daro, a 4,500-year-old city of the Harappan Civilisation. The city is situated on the vast alluvial plains on the banks of the river Indus, in the Pakistan section of the Indus Valley. The construction was created entirely from millions of burned bricks fired in primitive kilns, some of which are still standing today.

Decorative bricks

Brick, as a creative medium, has been around for over 2,500 years; the Babylonians were the first recorded artisans to work decoratively in brick. In Babylon archaeologists discovered the 11 m- (36 ft-) high 'Gate of Ishtar' dating from between 604BC and 561BC, part of a 13-acre (5.25-hectarcs) palace complex.

In 515BC the emperor Darius created a new royal complex at Susa importing both building materials and workmen from all corners of his domain. Amongst the finest artisans were the Babylonians, assigned to create the glazed brick friezes that decorated the palace's façade. The bricks were made from a coarsely ground silica with a high calcium content which were moulded, dried and then fired. A vitreous coating of lead glaze was then applied and the brick re-fired to a higher temperature. Each brick was

Below: Glazed brick wall Archers, Palace of Darius, Persia, reconstructed by French archaeologists in the Louvre, Paris, from fragments found at the site.
Photograph © photo RMN – Hervé Lewandowski.

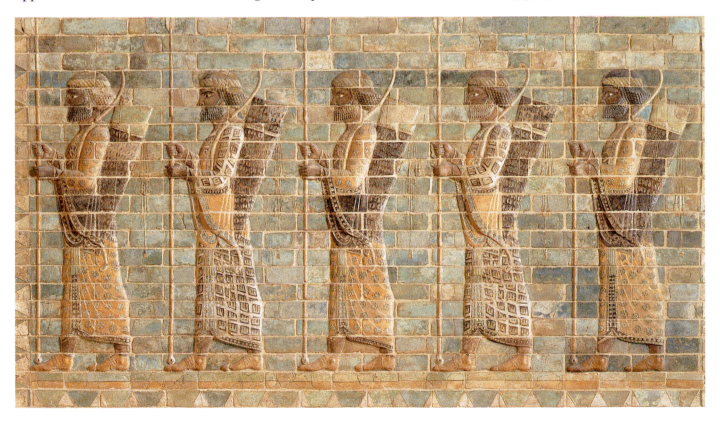

Right: Detail of Radkan tomb tower, Radkan East 1281–82, Iran.
Photograph courtesy of Brüsehoff Design.

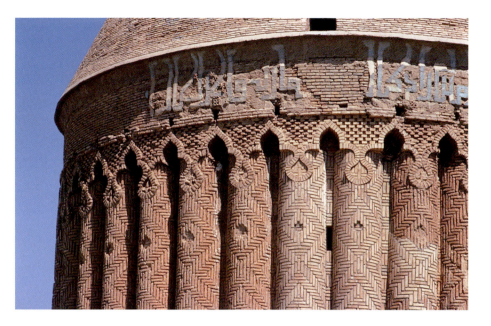

Below: Radkan tomb tower, Radkan East 1281–82, Iran.
Photograph courtesy of Brüsehoff Design.

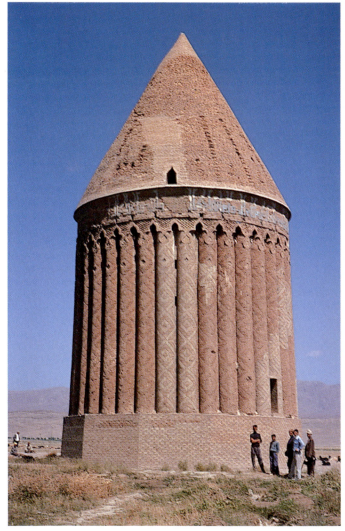

formed in the shape of a prism – the internal face being thinner than the external – allowing for thicker mortar at the back with discreet hidden joints at the front.

Some of the finest sculpted brick bas-relief is to be found at Prasat Kravan, Angkor, in East Asia. The reliefs form the walls of the palace complex, which dates around AD925. The scale and complexity of these works show the exquisite skill of the Khmer people.

From the 10th century onwards, Arab chroniclers refer to blue-glazed brick domes of mosques and palaces. Architecture and calligraphy were regarded as the greatest arts of Islam, and many brick buildings provided the surface on which increasingly complicated symbolic inscriptions could be carved and moulded. In the Mogul city of Sultaniyah in Iran the Tamurids developed an intricate decorative style known as the *Banna'I* technique, in which cobalt blue- and turquoise-glazed bricks were laid on their ends to form zigzag patterns or monumental inscriptions in the brick façades. For further information on Islamic tiles see Venetia Porter's book (see Bibliography).

Brickmaking in Europe and America

The Romans introduced brickmaking to mainland Europe and Britain; they used both sun-dried and fired bricks. Fired Roman bricks were vitrified and laid with lime mortar containing volcanic ash, thus producing a hard set. This enabled thinner walls to be

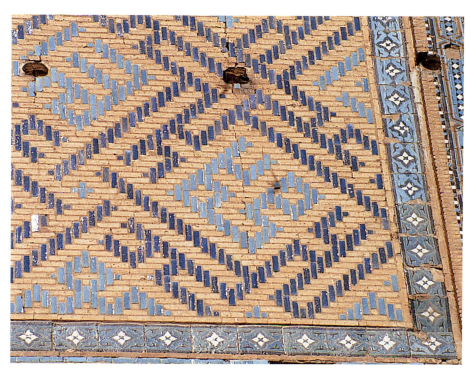

Left: Islamic tiles showing the Banna'I technique in the Aq Sarai palace at Shahr-I Sabz, 1379–96. Glazed bricks form the words Allah.
Photograph courtesy of Venetia Porter.

Below: Floor tiles at Tiberius's villa, Southern Italy, AD70–78. Photograph courtesy of Colinette Sansbury.

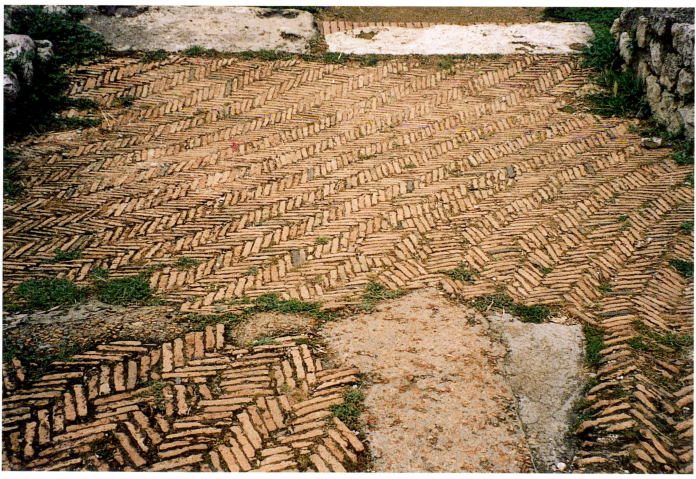

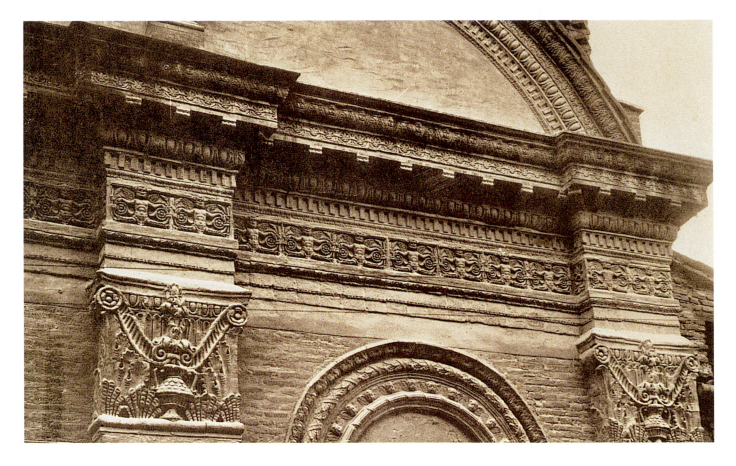

Terracotta cornice and capitals of the Church of the Corpus Domini in Bologna, showing how terracotta was used in the Italian Renaissance. Further information can be found in Terracotta of the Italian Renaissance *(see bibliography).*
Photograph by Mr Arthur Frederick Adams, courtesy of the National Library of Wales, Aberystwyth.

constructed and inspired innovative techniques in the structural and architectural use of brick such as those that can be seen in the Roman coliseum. In Britain the art of brick-making declined with the fall of the Roman Empire. The Anglo-Saxons, from AD440–1066, constructed simple wooden houses from the abundance of local wood. Many churches and public buildings were, however, constructed from Roman bricks from derelict buildings. In mainland Europe during this time, brickwork was employed in the Byzantine Empire and in the construction of Moorish buildings in Italy and Spain.

During the 11th century brick-making was revived in Flanders and the Netherlands; by the 13th century the art of brick-making began to flourish in the Netherlands and what would become Germany, where stone was in short supply. The Hanseatic League, a trading association that was formed in Flanders, began trading extensively with Britain during the 14th and 15th centuries. As a result vast amounts of bricks (especially from Holland) were shipped to Britain, influencing the architecture and the craft of brick-making. (For in depth information on the history of the brick try *Brickwork* by Gerard Lynch, see Bibliography.)

In Italy the use of brick reached a peak in the mid-15th century when decorative brickwork became a medium for symbolism and ornamentation on churches and cathedrals. In Britain the creative use of brick in

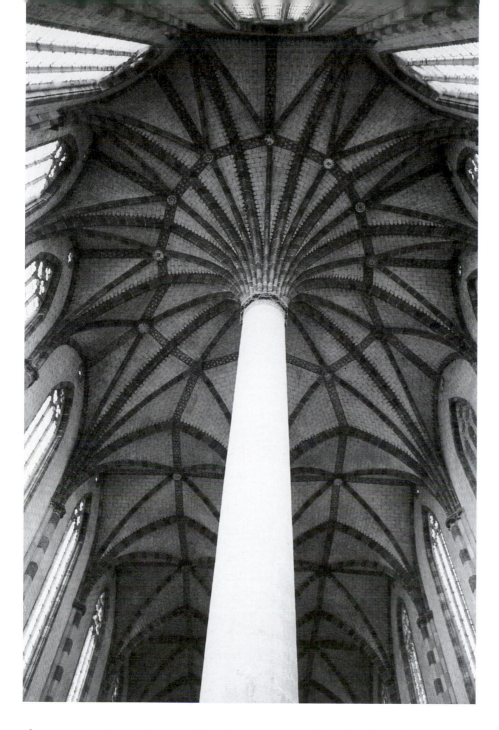

The 'Palmier' de Toulouse is one of the best known vaulted ceilings of medieval architecture.

the construction of many churches was a catalyst for the aristocracy to employ decorative brickwork for their own dwellings. By the 18th century technology was making rapid advances. Architects began to take advantage of the new cream coloured clays, and of the special shaped and moulded bricks developed initially in the Netherlands.

Both England and Flanders were responsible for exporting the use of brick to North America. Dutch settlers living in the American colonies employed brick widely in an effort to replicate the buildings they left behind. Homes of the grander English Colonists were often of brick. Many towns in America were competing with each other to attract residents and investors and brick was seen as a material of prestige and permanence. It also symbolised prosperity and the beginnings of a new era.

The Arts and Crafts Movement and brickmaking

In both Europe and the USA in the 19th century, the Arts and Crafts Movement, which developed as a reaction to the industrial revolution endorsed one-off production over mass-produced goods. At this time small 'specials' departments evolved within the brick industry, with separate equipment and kilns from the normal production lines. Kilns could be fired at slower rates, with smaller production ranges and one-off 'specials'. They began to flourish and develop, attracting some of the most talented sculptors and artists from around Europe. Artists and artisans travelled extensively from Europe to the USA to take advantage of the many openings for gifted modellers in the 'specials' departments of factories there. Architects began to develop the potential for the 'special' brick (usually an extruded brick, hand-cut in a wooden mould or made from soft clay thrown or hand-pressed into a plaster or wooden mould) and elaborate architectural detail began to emerge.

Architects designed buildings to take advantage of the expertise of the modellers within the special departments. In Britain, the architect and artist, Alfred Waterhouse designed the exquisite terracotta decoration for the Natural History Museum, London, whilst in Spain at the beginning of the 20th century architect Antonio Gaudi created some of the most inventive and complicated brick structures in Europe. He collaborated with experienced artisans and craftspeople such as the architect Joseph Maria Julio who created the fantastic mosaics at Parc Guell, Barcelona.

Brickmaking's recent history

The two World Wars severely affected the brick industry in Europe. New prefabricated housing replaced brick as the preferred building medium. By the 1960s the Modernist Movement had virtually destroyed the 'specials' departments within the brick factories, reflecting the fashion for concrete and minimalist buildings. By the late 1980s and early 1990s brick regained its popularity as a building material for office blocks, and domestic brick housing was preferred to high-rise concrete flats. There was a renaissance of decorative brickwork and friezes on the sides of buildings and a commitment to restoring deteriorating Victorian terracotta, for instance at the Natural History Museum in London. Two factories in Britain – Ibstock Hathernware (Leicester, UK) and Shaws of Darwin (Lancaster, UK) did have the foresight to retain their in-house craftsmen and have found an abundance of work (Hathenware is now restoring the façade of the Wrigley building in New York). Many factories have decided to re-employ craftsmen and artists who are employed freelance by the brick companies to carry out commissions that factory artisans would have undertaken in the past.

Brick clays

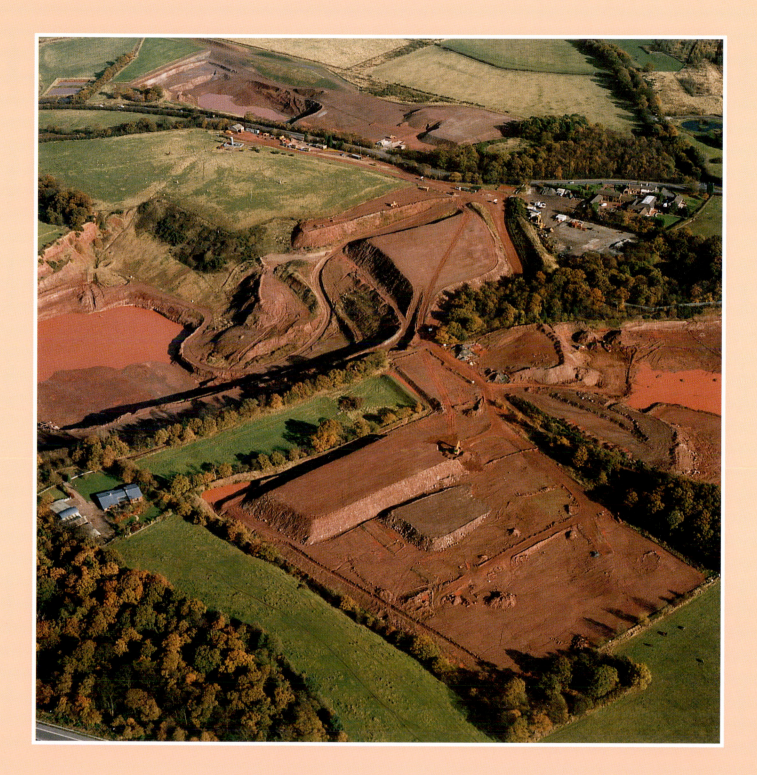

Aerial view of Ibstock Brick's 'Etruria Marl' quarry, at Lodge Lane, Cannock, Midlands.
Photograph courtesy of Ibstock Brick, Cannock.

The origins of clay

Brick clay can be found in clay seams all over the world and is part of the Earth's fabric. It is entirely inorganic and began forming when water first started eroding rock. The minerals that make up clay have particles loosely held together in sheets: as a result clay is slimy and slippery. Its flexibility and durability, and its connection with the Earth itself have given it many ancient and mythological associations. According to the Bible, man and woman were first created from clay.

For geological reasons, clay and coal seams often share close proximity. For example, in Ohio, USA, (a region permanently submerged during prehistoric times), organic materials such as animal and plant life compacted to become a vein of coal, and inorganic sediments over time became a deep vein of clay. This was used initially by Native Americans to make pipes and pots. Many towns in America were founded by virtue of their coal beds and entrepreneurs mining coal would excavate the clay found next to the coal seam. This would lead to the manufacture of bricks for building the town using coal for energy and powering machinery.

Constituents of clay

Brick clays are composed mainly of silica and alumina (which give them an elastic and tensile strength) and amounts of iron, lime, manganese and other materials.

There are several different types of clay used in brick-making. The Brick Development Association of Great Britain have information on at least 1,500 different types of brick clay. It is important for an artist exploring the possibilities of working with brick clay to know something about the properties of the material and its suitability for the finished piece. Some of the most commonly used clay types include Weald Clay, Keuper Marl, Lower Oxford, Etruria Marl, Brick Earth, Fireclay and Carbonaceous Shales. Keuper Marl for instance is from the eastern outcrop of strata known as the Triassic dips. The two main ingredients, which give clay its wide range of colours, are iron and free lime. The darker colours, and reds and blues are attributed to iron, while free lime produces buff coloured bricks by bleaching out most colours. Firing factors also influence the colour; bricks can be reduction fired or oxidised.

Certain types of bricks, with certain colour properties made in a particular locality, have become familiar to generations of builders. In the UK, for instance, blue bricks are made from a clay found in the coal measures of Staffordshire and the West Midlands – it contains about 10% iron oxide. Red iron turns blue with a reduction atmosphere in the kiln; the kiln is starved of oxygen by the addition of excess gas, creating an unstable atmosphere in the form of carbon monoxide. This in turn searches out oxygen to restabilise the atmosphere, finding this oxygen in

the red ferric compounds. The release of oxygen within the red ferric compounds turns them into blue ferrous compounds.

Factories will sometimes add oxides and colouring stains to their brick clay. Dennis Ruabon adds manganese to their Etruria Marl which under reduction comes out dark brown/black. Blockleys Brick add manganese to achieve a coal black under oxidation. Dennis Ruabon also add vanadium to bleach out the iron and achieve a yellow brick. Ibstock Brick, Cannock is the main British producer of blue Staffordshire bricks which contain a certain amount of natural manganese and fire under reduction.

Frost-proof qualities of brick clay

Brick clay is particularly suitable for environmental artworks because it is frost-proof. This relies on its low vitrification temperature – the clay melts at a temperature usually around 1140°–1160°C (2084°–2120°F). This means that the fired clay is impervious to water after firing. Individual factories will give advice on the vitrification temperatures of their clays. Before firing brick clay its porosity will need to be tested. Green bricks with a water content of 12% will need to be brought down to 1% through the drying process.

Textures of clay

Differences in textures result from the types of clays used and the different production methods. Bricks have traditionally been formed from soft clays hand-thrown into wooden moulds coated with sand; this gives a rough texture to the finished brick. Harder clays such as the Marls and Shales lend themselves to extrusion, and a dense hard clay such as the Etruria Marl used to produce terracotta at Dennis Ruabon, not far from the Welsh town of Wrexham, is excellent for carving. Many factories grind their clays to form fine particles giving a smoother finish. Others may add grog – ground up fired bricks – for greater strength. This gives a much coarser finish, especially when carving, and may appeal to artists for the mottled appearance it will give to the brick surface after carving. Most brick clays produce smooth finishes when extruded but some contemporary bricks may be given a handmade look by wire-cutting processes – wires are pulled along the surface after extrusion and sand may be added. Sand can be sprayed on at high speed, and rough sanded textures can also be achieved by throwing soft mud clay into wooden moulds coated with coloured sands.

The geology of brick clays

Clay was first laid down as a result of millions of years of erosion: geological evidence has dated it so. Below is a list of the different types of brick clay existing in the UK, where there is a clear divide in brick types

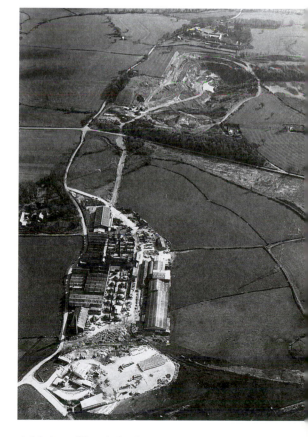

Ariel view of Dennis Ruabon quarry near Wrexham in 1977.
Photograph courtesy of Dennis Ruabon.

between the north and south. The softer southern buff varieties produce more absorbent bricks than the harder denser northern clays, which have a high iron content giving a harder, smoother red. The Brick Development Association of Great Britain have compiled a list of the geology of brick clay in the UK, but the system used below to explain geological time over millions of years are worldwide and these seams of clay exist throughout.

Paleozoic

Devonion (Laid down 395–345 million years ago.) Hard shale, fireclay: generally the softer buffs found in the south have a higher water absorption than the hard red and blue bricks which predominate in the north. This clay is a by-product of open cast coal mining in Yorkshire, South Derbyshire and Shropshire and gives bricks that have a low water absorption and high strength.

Special bricks: Etruria Marl clay, Red Bank, Measham.

Carboniferous (Laid down 345–280 million years ago.) Grey shale found in coal measures in Scotland, northern England, the Midlands, and Severn Estuary. It gives hard, deep red bricks when fired as it

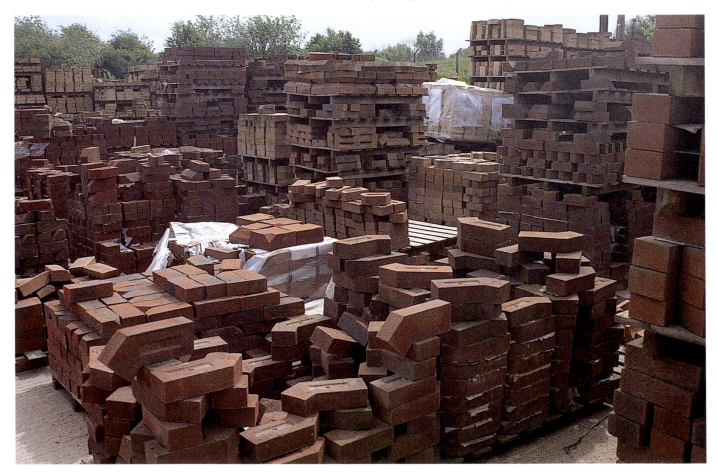

contains amounts of iron. There is also Etruria Marl for blue bricks and tiles. The clay has a very high iron content, which can lead to red or blue bricks according to the method of firing.

These bricks are well known for their hardness, high strength and low water-absorption properties, which in the past led them to being used as engineering bricks. They also provide good detailing in the production of specials. Their usefulness is enhanced by the fact that they have a wide vitrification – that is they fire without shrinking over a wide range of temperatures.

Many brick companies quarry their own clays and one such is Dennis Ruabon (Ruabon, Wrexham, Clwyd, Wales) which quarries clay from its famous carboniferous Etruria Marl seams of Colomendy Red and Heather Brown. The Etruria Marl seam provides some of the finest clays in Britain for brick and terracotta products and this clay, with its extremely fine sculpting and carving properties, has attracted a number of international artists over the years. Butterly Brick (Powys, Wales) now closed down, used carboniferous clay from a quarry which had been an ancient ocean bed. The clay contained trilobite fossils, which the workers took great delight in collecting.

Mesozoic

Triassic (Laid down 215–190 million years ago.) Keuper Marl is a hard reddish brown mudstone with thin bands of limestone and gypsum. It is a young clay, which produces bricks of low strength and high water absorption. The softness makes it ideal for handmaking bricks. It is widely used in Nottinghamshire and Leicestershire where light red and cream bricks are made, usually wire-cut.

Jurassic (Laid down 190–136 years ago.) Lias clays – middle Mesozoic clays – in the stone belt from Lincoln to Cheltenham. It was first used early in the 19th century. Oxford clay is a particular Jurassic clay to be found around Bedford and Peterborough. It has a high carbon content which burns and so saves fuel in firing. It is softish clay with a relatively low strength and high water absorption.

Cretaceous (Laid down 136–65 million years ago.) Wealden clay which often has fuel added to the clay to make Sussex bricks. This reduces the amount of fuel needed for the firing. It has also been used at Swanage in Dorset since the 18th century. Gault clay is another cretaceous clay, a blue/black in colour but burning white due to the high free-lime content which bleaches out most other colours at a high temperature. This clay is found in Kent, Dorset, Wiltshire and Cambridge. In preparing the clay it is often mixed with sand from adjacent beds.

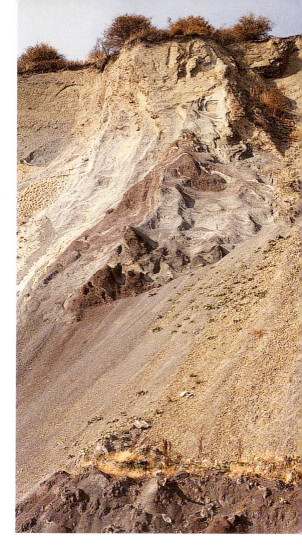

Butterly Brick quarry, Welshpool, Powys, Wales.

Cenozoic

Eocene (Laid down 54–38 million years ago.) Found in Reading, Bedfordshire, Berkshire and in Suffolk. Although the clays are mottled purple and grey they fire red.

Pleistocene (Laid down 1.5–0.5 million years ago.) Also known as Icenian clays, these are found mainly in East Suffolk and fire red.

Pleistocene (Laid down up to 0.5 million years ago.) These are glacial clays and sands known as 'boulder clay'. They are to be found in northern England, Wales and east Suffolk and have been used since late medieval times. They are also the 'clay with flints' used on the Hertfordshire–Buckinghamshire border.

Holocene (Laid down 10,000 years to the present.) Alluvial clays found in the Vale of York, Humberside, Lincolnshire, East Anglia and the Thames and Medway valleys and estuaries. They have been used since Roman and early medieval times. Another Holocene clay is Brick Earth, a riverborne deposit found mainly in Essex which produces bricks with a higher than average water content. Both yellow and red bricks are made with this clay.

Firing temperatures for the above clays differ according to the type of clay and the brick factory. The majority of clays that I have used fire between 1020°C (1868°F) and 1180°C (2156°F). The technical manager of the factory in which you intend to work will need to be approached for this information. Vitrification point is essential in the firing to render the brick frost-proof – that is completely impervious to water.

Processing and preparing clay

Primitive methods of clay processing and brick-making
Many countries such as Zimbabwe still use primitive brick-making processes and production methods – digging raw clay from the ground, shaping it in wooden moulds and leaving it to dry in the sun, before firing in clamp kilns (see Chapter Five).

Modern methods of quarrying clay
Clay is usually extracted from the ground using heavy machinery. At this stage the clay is wet and in large sticky lumps. At Dennis Ruabon, the quarrying is carried out using a CAT215B which digs into the clay seam whilst sitting on the top and then progressively works back across the seam. This is called 'winning' the clay.

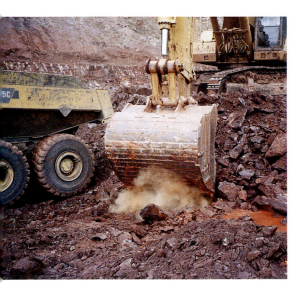

The quarrying is carried out with modern equipment which digs into the clay seam whilst sitting on top and then progressively works back across the seam. Quarry at Ibstock Brick, Cannock, Midlands. Photograph courtesy of Ibstock Cannock factory.

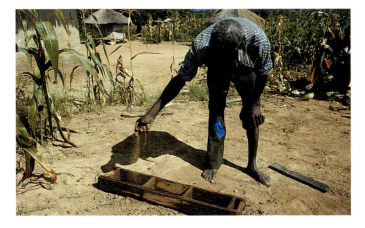

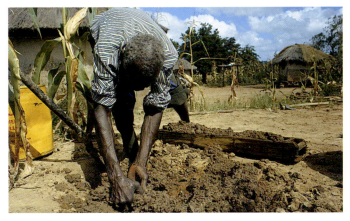

Brick-making in Zimbabwe. *Photographs by Howard Bowcott.*
1. Sanding the wooden mould.

2. Digging the raw clay.

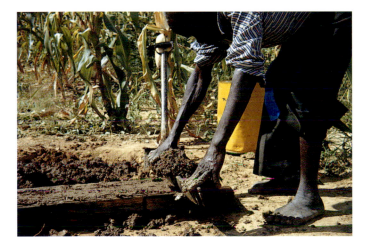

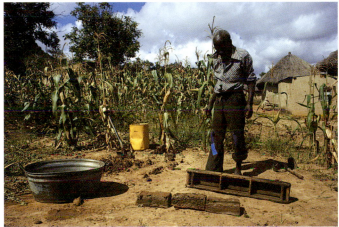

3. Filling the mould with clay, and skimming off the surface.

4. Tipping out the bricks.

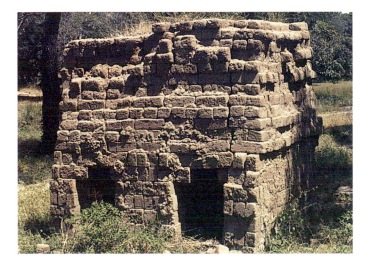

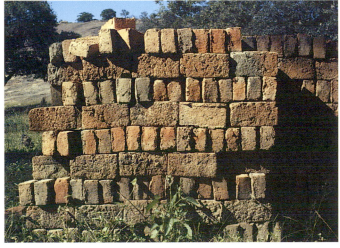

5. The bricks themselves make their own clamp kiln.

6. Bricks stacked after firing.

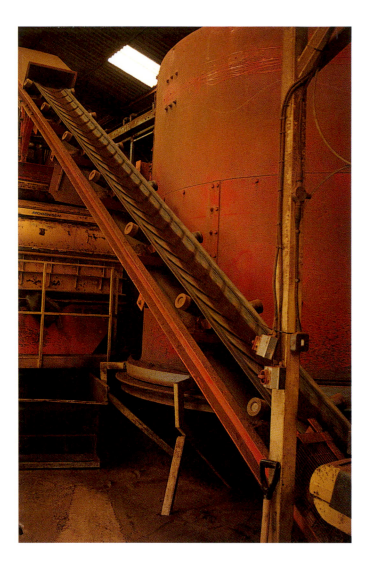

Clay being conveyed into wet pan at Redbank.

Clay preparation

To satisfy demand for an extensive range of brick colours, many brick factories blend their clays with imported clays or (as previously mentioned) stains and oxides. Factories will plan production months ahead linked with information received according to their order book. For this reason artists need to give plenty of notice of clay requirements when working with industry.

The first step in clay preparation is for the clay to be placed in a *kibbler,* where it is ground into smaller particles. The particles are taken by conveyor belt to the *nova rota* where they are further reduced by being ground and forced through perforations in a wet pan. Water is added to improve its plasticity and the clay is folded onto itself thus improving the mix. After leaving the wet pan the clay conveyor passes through a set of medium- and high-speed rollers that reduce the particles to no more than 1.5 mm (1/16 in.), making the clay finer and more workable and improving the strength of the brick. Refining the clay in this way also eliminates any danger of large lumps of lime inherent in the quarried clay blowing through the brick after the firing and rendering the brick weak and porous. Barium carbonate or more recently potassium nitrate is sometimes added to the brick clay at this stage to stop the lime coming through the brick after the firing, which manifests itself as a white scum.

Shaping the clay

Handmade brick 'specials'

These are made using clods, or soft lumps of clay, that are fed into a double shaft mixer consisting of two shafts fitted with knives, which rotates at speed. A certain amount of water is added at this stage. It is then dropped into an extruder forcing the clay through a die at the front. The extruder is made up of a barrel fitted with a close-fitting rotating axial screw. The clay is forced along the barrel of the extruder and pushed through the barrel of the die at approximately 30 cm (12 in.) above the conveyor-belt. From here clay is carried to the hand moulders. Each hand moulder will roll the clod in a prepared mixture of sand, stain and/or sawdust, and will then throw the clod into a wooden box mould. They are turned out of the mould and then placed on racks called *stillages,* air-dried for a few days and then placed in heated driers before being kiln fired.

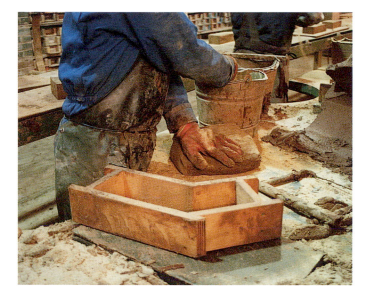

1. Clay is rolled in coloured sand, and box is sanded.

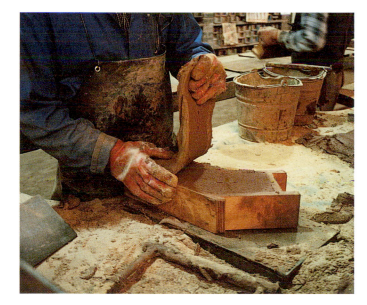

2. Clay is thrown into mould, and surplus quantities are sliced off.

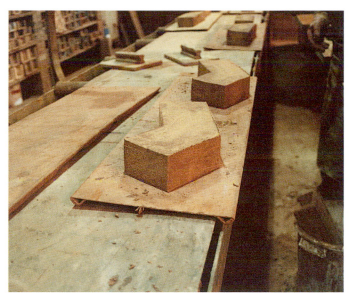

3. Surplus clay is removed from box.

4. 'Specials' are turned out onto the bench ready to be placed on stillage for drying.

Multiples of handmade bricks can be produced in this way. Ibstock Brick (of West Hoatherly, London), produce all their bricks this way and Blockleys Brick (Telford) have a handmade brick department.

Hand-pressed architectural blocks

Ibstock Hathernware (Leicester, UK) also use moulds for their special architectural blocks, but these are plaster moulds rather than wooden ones. Clay is only pressed into the mould at a certain thickness rendering the

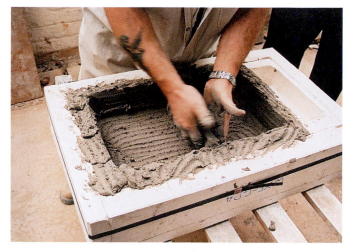

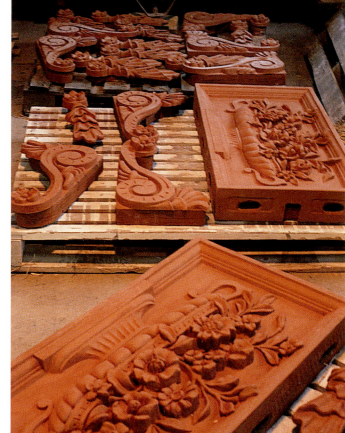

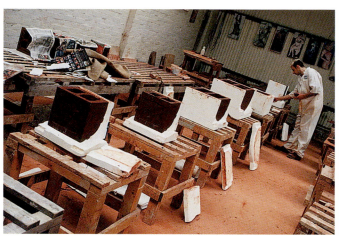

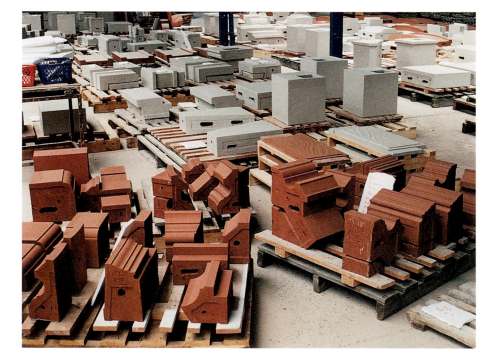

Processing architectural blocks at Ibstock Hathernware:

Top, left: Clay pressed into plaster mould.

Top, right: Finished blocks removed from moulds.

Above: Clods pressed into plaster moulds hardening up.

Right: Finished blocks waiting packing and transport.

blocks hollow. They are turned out when firm and finished off with a smoothing knife. Initially the original block will have been hand modelled by their in-house modeller, and a mould made from it. This method allows fine detail and complicated shapes to be reproduced.

Machine-extruded wire-cut bricks

Standard machine-extruded wire-cut bricks are manufactured by forcing firm clay through a rectangular die plate of specific dimensions. As the lengths of clay are forced through the extruder a set of taught wires spaced at certain lengths apart are forced down from above, automatically cutting the clay into blocks. The space between the wires can be altered to change the size of the brick. A standard wet brick measuring 228 x 228 mm (9 x 9 in.) will shrink to 21.5 x 21.5 cm (8.5 x 8.5 in.) when fired, ready to fit into a standard brick course. Each factory measures their unfired brick sizes so as to end up with the British standard size when fired – so different clays may have different wet sizes.

Special machine-extruded wire-cut bricks are forced through specifically designed metal dye-plates, which are fixed to the extruder. Metal dyes cost around £5,000, and are only used for large runs of 'specials'.

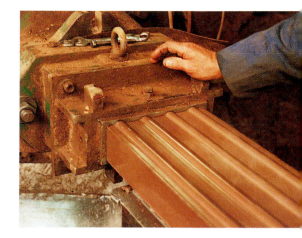

Clay being forced through metal die.

Selection of metal dyes, Blockley Brick factory.

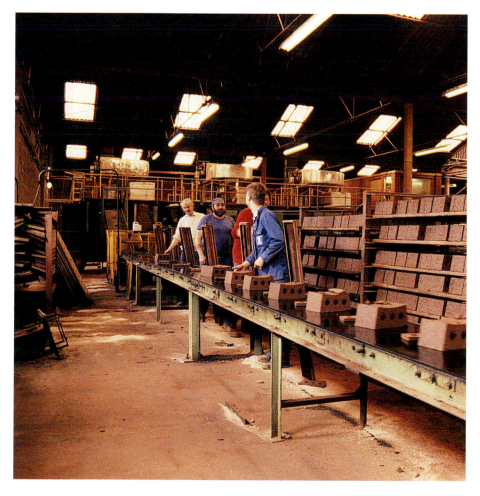

Production line of bricks coming from the extruder at Ibstock Brick, Cattybrook.

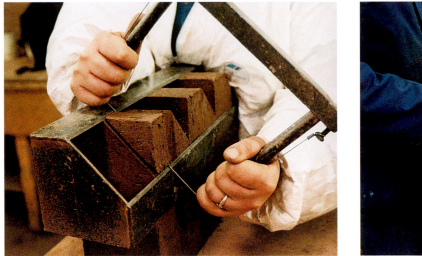

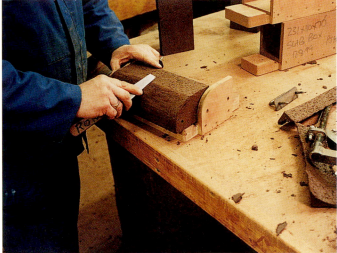

Above, left: Trimming extra clay off with a wire-cutter while the brick is in the metal box mould (here several are trimmed simultaneously).

Above, right: Finishing with a metal knife as the clay block is released from a wooden box mould.

Re-shaping machine-extruded bricks

To eliminate the need for expensive metal dies for small runs of special bricks, many factories use special wooden or metal cutting boxes to shape the brick by hand, after it has been extruded through a simple die. Clay is fed through an extruder and wire-cut at lengths required for the special bricks. The block is then placed into the wooden box and cut to the required shape. The brick may need to be cut in two or three boxes before the required shape is achieved.

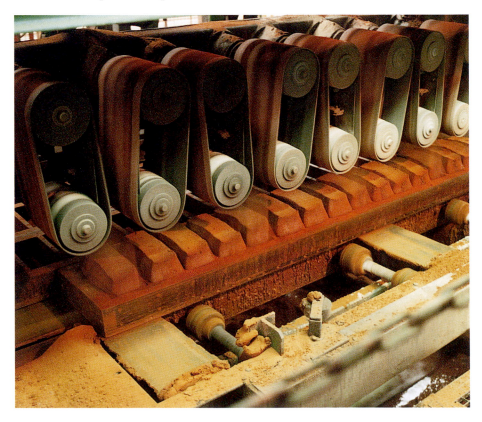

Rollers forcing clay down into moulds.

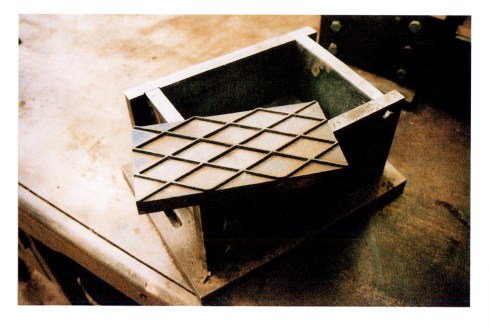

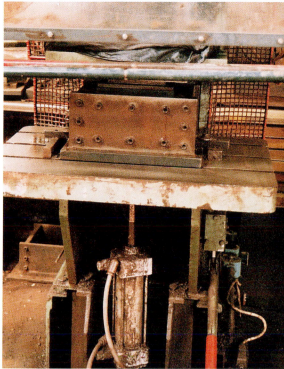

Above, left: The metal box and plate from the press.

Above, right: Blockley Brick's tile press.

Mechanised bricks

Red Bank Brick (Derbyshire) and Blockleys Brick (Telford) are just two of the UK factories who make mechanised bricks, with the appearance of and feel of handmade bricks. This is achieved by automatically throwing the cut bricks or clods into mechanical metal moulds that are normally lined with coloured sand.

Many factories such as Ibstock Brick (Cattybrook, Bristol, UK) use a metal press to shape 'specials'. Extruded tiles or bricks are placed under the press and a metal die is attached to the lever. This is brought down with great force, shaping the wet tile or brick beneath. Ibstock have a Flavoli tile press made in Italy used for this.

Drying and setting bricks

Standard bricks are taken straight to the dryer on a wet frame or *stillage* (perforated metal drying rack). Driers are often heated directly from the kilns or from gas burners and are automatically controlled on pre-set programmes designed to suit the product and ensure the optimum drying time. Special bricks often require a couple of weeks to air dry before being set on a slow drying programme, followed by a three day fast drying programme in the dryers. Special bricks may require hollowing out from the back to aid the drying process. The porosity of the brick will be measured at this stage and it is now that the water content of the brick must be brought down from 12% to 1%. The bricks are then packed into the kiln, loaded into the kiln cars (automatically in fully automated factories), but normally loaded by hand in 'specials 'departments, and after firing, a setting team will unload the bricks from the kiln and stack them on pallets. Some factories may require the artist to pack and unpack the kiln; it is important to establish whether this is the case at the start of the project.

Firing

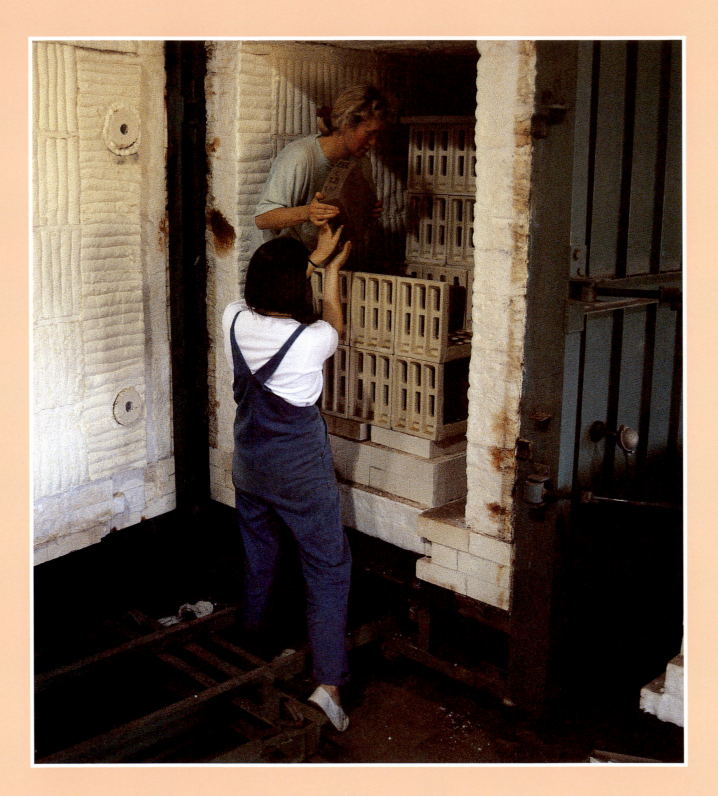

Packing the gas kiln at the Dennis Ruabon factory. Photograph by Marco Kuhl.

The method of firing chosen by an artist is vital to the success of his or her artistic vision. The variety of kilns and firing methods provide the artist with many possibilities, and form the basis of this chapter. It must be said however that many factories will have difficulty in altering their production firing cycles to accommodate artists, as this will slow down production, and not all will be able to offer firing facilities. It may take many hours of research to find a factory that has a modern continuous firing kiln of sufficient capacity and with the right firing cycle to enable an artist to fire the thousands of architectural blocks that make up a large-scale sculpture. (This can be an important factor in taking on a commission when time means money.)

Some factories such as Dennis Ruabon in Wales operate a small gas-fired kiln in which 'specials' can be fired slowly without interfering with the main production. Architectural blocks can be successfully fired in the gas kiln in 48 hours provided that the early part of the cycle runs very slowly. The kiln at Dennis Ruabon has to be packed by the artist, which again can mean many hours of extra work.

Artists wishing to fire bricks in their own gas or electric kilns need to follow an extremely slow firing cycle, which I advise should be carried out over up to four days.

Clamp kilns

Although modern continuous firing kilns are by far the most reliable and efficient kilns in industry, many artists are seduced by the stunning results that can be obtained by using primitive firings. The difference in the range of tone and colour from one firing to another can be dramatic; temperatures can vary from 900°C (1652°F) to 1100°C (2012°F). Clamp kilns are the most primitive kilns known to man, and often it is the unpredictable nature of such kilns that proves to be the greatest allure to the experimenting artist. Jacques Kaufmann, for example, began to use

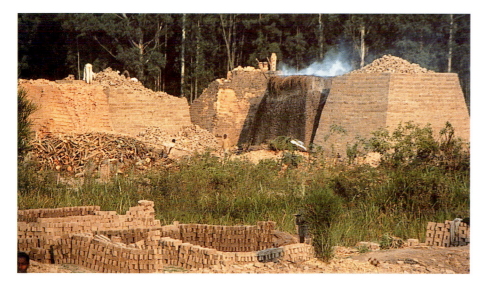

Clamp kilns firing 100,000 bricks in Rwanda.
Photograph courtsey of Jacques Kaufmann.

29

Right: Starting to dismantle the clamp kiln.
Photograph courtesy of Jacques Kaufmann.

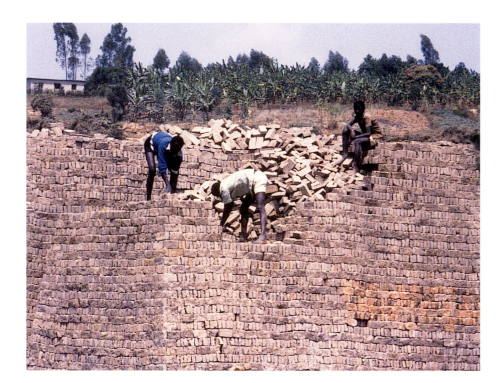

Below: Another example of a clamp kiln, partly dismantled.
Photograph courtesy of Jacques Kaufmann.

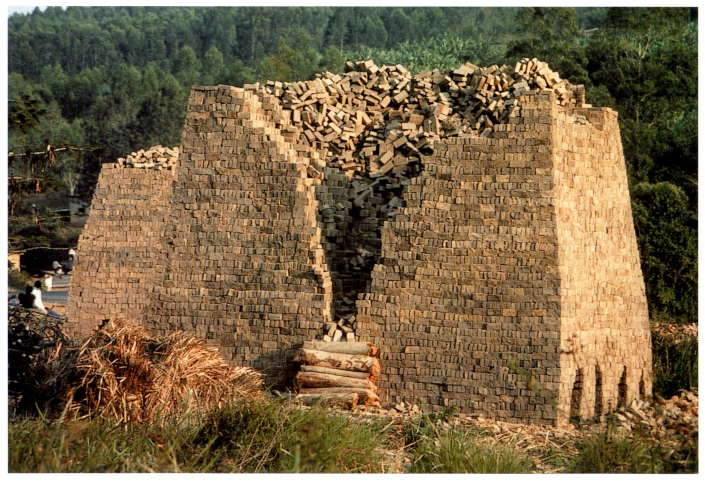

bricks in his work after visiting Rwanda in Africa where he saw huge clamp kilns still in operation. There are very few clamp kilns still in operation but Ibstock Brick, West Hoatherly, still fire handmade bricks in a clamp kiln. The bricks are sold at premium prices.

There are two types of clamp kilns: open and closed. An open clamp kiln has wide fire channels in the base to accommodate wood, peat and later coal; the whole kiln is covered with turf or waste bricks plastered with mud. Although extinct in Europe, they are still frequently used in developing countries, where they are fired with wood.

Closed clamps seem to have been used in the UK at the time of the great fire of London in 1666, and the method of manufacture of London Stocks as we know it, is first recorded in 1693. Town refuse and decayed organic matter was collected – ashes, half-burnt coal, bones and broken glass and pottery, was sifted out and the finer siftings added to the clay prior to making the bricks. The coarser layers were spread in several thick layers at the bottom of the clamp. These fuel layers were ignited by faggots and coal in a transverse flue called a 'live-hole'. Once the bottom courses were red-hot, the fuel in the bricks themselves started to burn and the heat permeated the whole clamp of up to a million bricks, taking two to six weeks to complete the firing. Temperatures would have reached 1100°C (2012°F) at certain points in the kiln. The quality of brick was very variable depending on which part of the kiln they were stacked in. (See *Brickwork* by Gerard Lynch for more information.)

Scotch kilns

Often bricks with small imperfections or 'seconds' from the clamps would be used to build a scotch kiln. Scotch kilns are a type of updraught kiln which were initially fired with wood and later with coal, the fuel being fed in through stoke holes at 20 minutes intervals over a three-day period. Scotch kilns could produce up to 50,000 bricks per firing but proved to be inefficient because of poor control over the firing cycle.

Down-draught kilns

These coal-fuelled kilns were stoked using mechanical screw-type stokers and were controlled by an electric fan heater. They eventually became more economical than the scotch kilns.

Beehive Kilns

The old beehive kiln at Dennis Ruabon was one of my personal favourites, producing as it did a bridled reduced brick with a multitude of hues. About 15 years ago Dennis Ruabon, like many factories, fired all their products in beehive intermittent kilns fired with coal and then later oil. The kilns were down-draught circular kilns with domed ceilings. Firebox openings were placed around the perimeter. The kilns were fired purely by eye to a maximum temperature of 1140°C (2084°F). A reduction

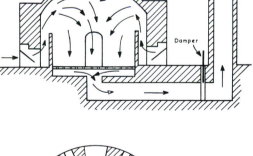

Down-draught intermittent beehive kiln. Circular beehive kilns were the most widely used intermittent kiln. Plan courtesy of Martin Hammond.

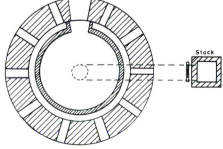

The beehive kiln has capacity for 13,000–40,000 bricks.

Right: Coal-fired beehive kiln at Dennis Ruabon, 1993.

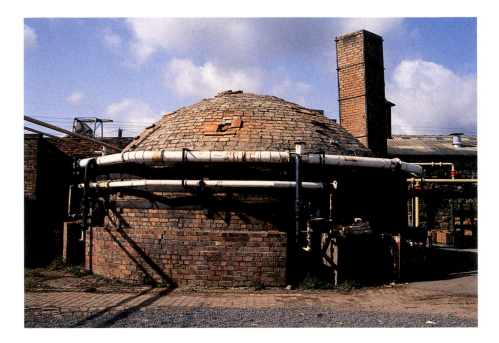

Below: Interior of a beehive kiln, at the Archie Bray Foundation (USA).
Photograph courtesy of Robert Harrison.

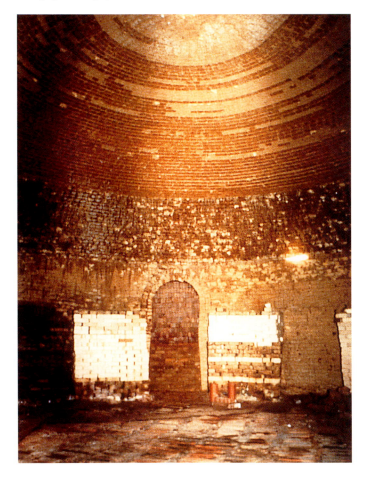

firing would consist of 12 half-hour reductions when the oxygen intake would be reduced. Every kiln had its own individuality and the firing would often be affected by the weather. These kilns at Dennis Ruabon have unfortunately all been destroyed. Michelmersh Brick (Romsey) however still fire all their handmade bricks in beehive kilns.

Chamber Kilns

The chamber kiln is another variety of kiln. I used the one at Butterly Brick producing vitrified brick of a deep rich red. This kiln was originally fired with coal but was later adapted to burn oil. It had a series of four chambers, each one filled with brick and each entrance then sealed with large sheets of paper. To ignite the kiln, oil and water were fed in causing an explosion of fire within. As each chamber reached a certain temperature, it would burst the paper into the next chamber, dramatically forcing through the heat. This continued until the last chamber was heated. The kiln would then reach its final temperature of 1140°C. Unfortunately this kiln is no longer in existence.

Gas-fired trolley kilns

Ibstock Brick, Cattybrook, has gas-fired intermittent trolley kilns in their 'specials' department. Here (where *Mythical Beast* was made and fired for the Ebbw Vale Garden Festival) special bricks are fired in both oxidising

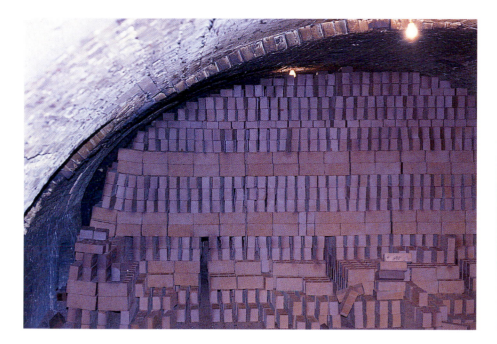

Left: The bricks after firing in the chamber kiln, have become a vitrified deep red.

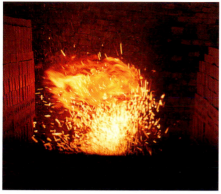

and reduction atmospheres. The trolley kilns have two bases and one movable firing hood, allowing bricks to be packed over a number of days on the one base while the kiln hood is firing on the other base. After firing is completed on one base the trolley hood is moved over to the second base where bricks have been stacked and are awaiting firing. This kiln is a manageable 6 m (20 ft) long and the temperature can be easily altered to suit the artist. Another example of an intermittent kiln (which can be found in many special departments) is the crocodile kiln at Ibstock Brick, Cannock, where specials are fired on a base which moves into the kiln and out again when the firing is finished.

Above: Oil-fired chamber kiln at Butterly Brick, Powys. It was used to fire Boar Bench, from the Seats in the Woods competition, Gaer Fawr Wood, Guilsfield, Powys, 1991. A fire ball of oil and water is used to start the kiln firing.

Below, left: Trolley kiln at Ibstock Brick, Cattybrook.

Below: Bricks stacked ready for the trolley kiln.

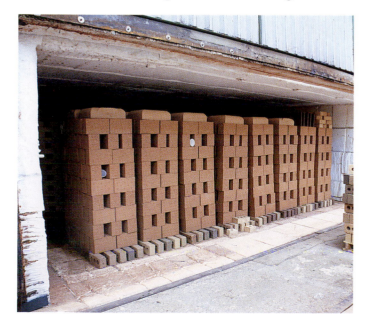

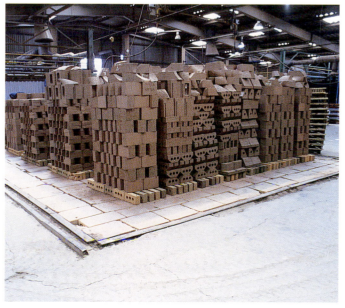

Right: Intermittent crocodile kiln at Ibstock Brick, Cannock.

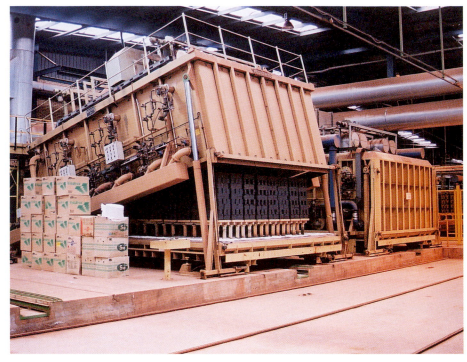

Below right: Brick sculpture packed onto a trolley, ready to go into the continuous firing kiln at Blockleys Brick. Special sculpture bricks are placed in the centre of the production bricks creating a saggar effect in which the 'specials' are secured and avoid burners which could explode thicker bricks.

Below left: A packed trolley inside the continuous firing kiln.

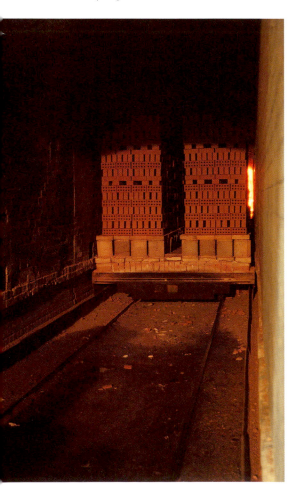

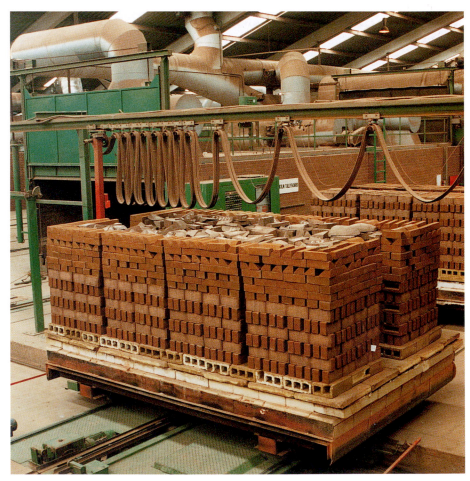

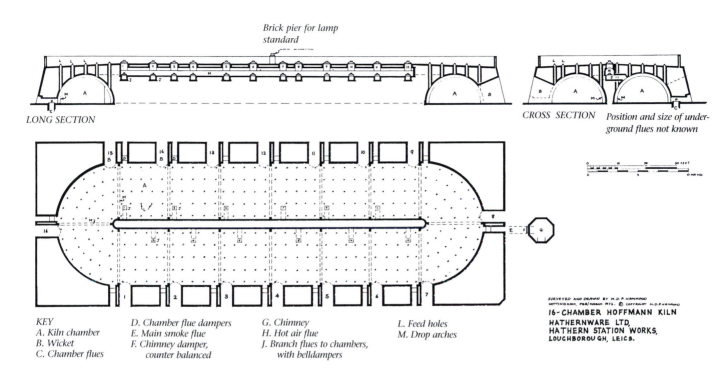

Brick pier for lamp
standard

LONG SECTION

CROSS SECTION Position and size of under-
ground flues not known

SURVEYED AND DRAWN BY M.D.P. HAMMOND
NOTTINGHAM, FEB/MARCH 1973. © COPYRIGHT M.D.P.HAMMOND
16-CHAMBER HOFFMANN KILN
HATHERNWARE LTD,
HATHERN STATION WORKS,
LOUGHBOROUGH, LEICS.

KEY
A. Kiln chamber
B. Wicket
C. Chamber flues

D. Chamber flue dampers
E. Main smoke flue
F. Chimney damper,
 counter balanced

G. Chimney
H. Hot air flue
J. Branch flues to chambers,
 with belldampers

L. Feed holes
M. Drop arches

Modern continuous firing tunnel kilns

In 1858 Fredrich Hoffman designed the best known continuous firing
kiln, at first circular but then in 1870 he designed a rectangular version.
This became the forerunner for the modern continuous firing kiln. A
demand for the weekly production of millions of bricks in regimented
sizes and colours has resulted in many factories converting to modern
continuous firing tunnel kilns. Bricks come straight from the production
line, through a drying cycle into a continuous gas-fired kiln about 100 m
(328 ft) long. The bricks enter the kiln cold and move progressively fur-
ther into the centre of the kiln where the firing temperature is achieved.
They then move through the final part of the kiln, cooling as they go.
The conveyor belt carries them further to the packing area. The efficiency
of these kilns makes it more difficult for artists considering working

Plans of the Hoffman continuous kiln.
Plans courtesy of Martin Hammond.

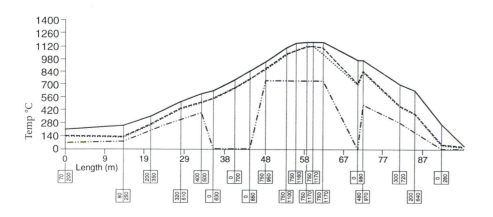

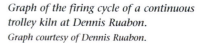

Graph of the firing cycle of a continuous
trolley kiln at Dennis Ruabon.
Graph courtesy of Dennis Ruabon.

35

within industry, as factories often will not interrupt production cycles in order to fire complicated artworks. Furthermore, architectural bricks normally need a long, slow cycle with slow cooling. In order to reduce the shock, special bricks may have to be protected inside the bulk of the ordinary bricks.

Shuttle kilns

Other modern firing kilns include shuttle kilns which consists of 16 chambers arranged eight on one side and eight facing, placed back to back and connected either end. On top of the kiln are ten trolleys, which are fitted with 12 burners and controlled by a processor. Each chamber after being filled with dry bricks is partitioned off by a line of paper. After each trolley has completed its scheduled 45-hour firing, the heat moves on to the next chamber. Once the bricks have been fired and the fire zone has moved off the fired chamber and forward to the next chamber the bricks can be drawn from the kiln when sufficiently cooled.

Experimental methods of firing

The artist Ray Meeker builds and fires houses in situ in Southern India using sun-dried bricks. The initial attraction came from India's need for low-cost housing, especially given local traditions of mud building. The building site has to be close to a source of good local clay. They are fired from the inside and are filled with unfired floor tiles, pipes, garden seats and stools, which can be used in the house or sold. Casuarina wood grown locally as a fuel crop is used to fire the house. A down-draught chimney is placed in the centre of the dome, fired bricks are placed around the outside, and a slurry of cow dung and husks placed on the dome to make sure the bricks reach temperature – up to 980°C (1796°F). When the firing is over, the house is ready to move into. The technique works by building around a light movable frame on which the masons can build a series of arches that make vaults. This would have been a method of building mud houses in prehistoric Britain, (see also comprehensive article by Jane Perryman in *Ceramic Review*, see Bibliography).

In the UK Helen Clifford builds and fires her own kilns, which act as receptacles for offerings fired within. These are made from fired or carved unfired brick, *Chimney* was an example of the latter shown at the Yellow Brick Road symposium held in 1999, at the Ironbridge Gorge Museum in the UK. (For further reading on brick kilns see Martin Hammond's article 'Brick Kilns: an Illustrated Survey' in the *Industrial Archaeology Review*, see Bibliography.)

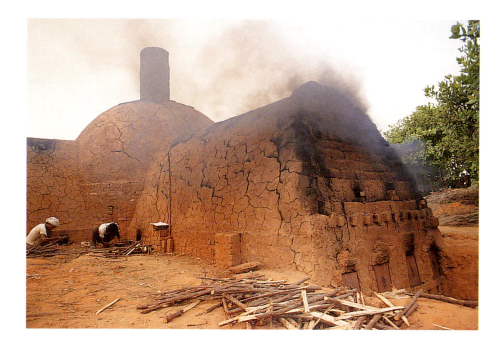

Left: Firing the house kiln at Agri Jata, Auroville, Pondicherry, India, 1988.
Photograph by Ray Meeker.

Below: 'Kiln' National Eisteddfod, Wales, 1997.
Photograph by Helen Clifford.

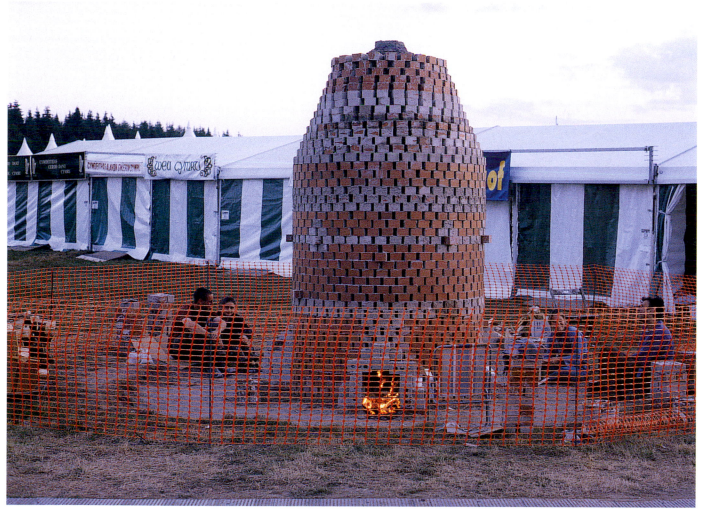

Working with unfired 'green' brick

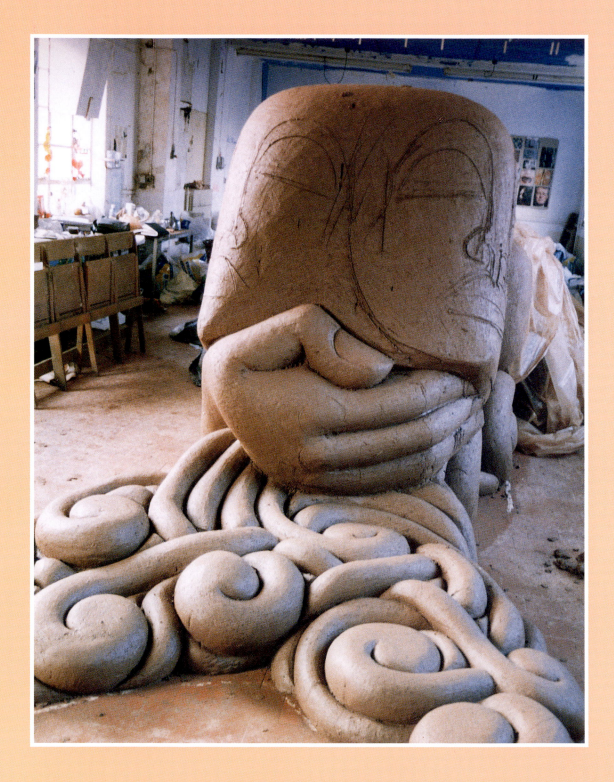

Carving of Bid Ben Bid Bont.

'Green' brick is the name given to raw, unfired brick. This following chapter looks at various methods of working with green brick, exploring the creative possibilities of both traditional carving and cutting methods, and of more industrialised, mechanised processes. I have included some of my own major sculptures to demonstrate and describe working methods, and concentrated also on the works of Swedish artist Ulla Viotti, one of the best known practitioners of green brick.

Extruded clay being cut into architectural blocks on the production line.

Carving three-dimensional green brick

Carving is a very traditional low-tech method of shaping green bricks. The process is one of patiently revealing the form within. Research needs to be carried out on which clays are suitably dense for carving – my own favourites are Dennis Ruabon Red, Ruabon Buff, or the Etruria Marl from Ibstock Brick, Cannock, but many factories produce a good carving brick.

I often use architectural blocks, straight from the extruder on the production line. These are solid bricks usually measuring 45 x 45 x 10.2 cm (17.7 x 17.7 x 4 in.) although they can be larger. I have found it possible to stand at the extruder and cut required lengths of block up to 1 m (3.3 ft) in length. This can be useful when carving, for example, seating capping etc. (The German artist Sabine Heller likes to retain the production holes in extruded bricks, feeling they add an unexpected dimension to her artwork.)

Bid Ben Bid Bont, *sculpture finished and installed.*

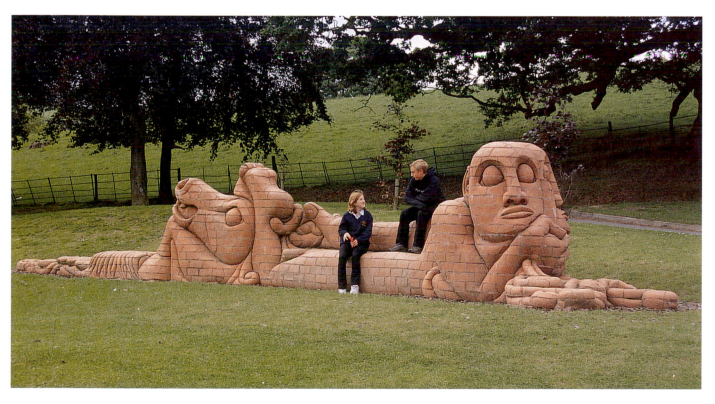

Wire-cutters, machine-cutters and sharp knives can be used to cut bricks to the required shape and skim off the surplus when sculpting. The factory may need plenty of warning should the wire-cutter need to be altered to fit the needs of the artist. The size of brick or angle of cut required will dictate this. For short runs of special shaped bricks wooden formers can be used, which eliminates the need for expensive dies.

Preparation

To start, I usually draw an outline shape with white emulsion on the factory or studio floor, using the site plan as a guide. The site plan will have been drawn out to size on my initial visits to the site on which the sculpture is to be built. Bricks are laid straight onto the concrete or tiled factory floor. It is important to use bricklaying bonds to build up a stable structure. The bond you choose will have an effect on the final aesthetic of the sculpture.

My method of construction is to decide upon a shape, and then bricklay the green blocks to a size a little larger than I need. Circular structures may require bricks to be cut at angles prior to building the structure. Structures may also need to be cantilevered – bricks are built outwards overlapping by a small amount on each layer. Nothing keeps the blocks in place except suction, (caused by the machine oil with which the blocks have been coated as they are squeezed through the extruder on the production line). At this stage I have found paint scrapers to be useful for manoeuvring bricks and for cutting straight sides.

Carving the brick

To hew out the initial shape I use a sharpened gardening spade. I then use a large sharp tool to draw on the structure giving some indication of

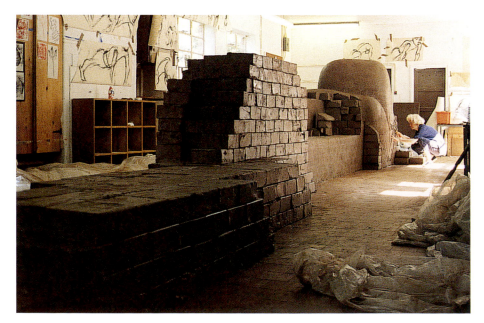

Bricks built up into a large 3D structure ready for carving.

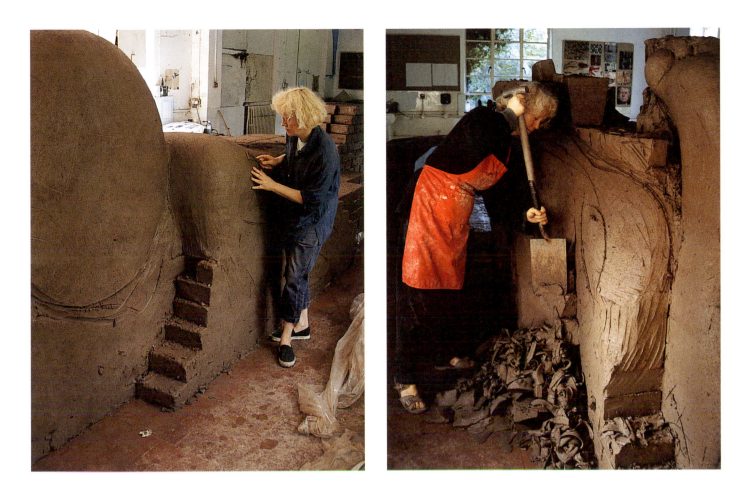

the form and content of the piece. If need be, a rubber mallet can be used to shape and force the bricks back into place while still soft. All the carving is done while the bricks are still unfired.

I start to carve with a large loop tool, which cuts through the brick at an alarming rate. I then find it easier to switch to smaller, sharper loop tools, ranging from a diameter of 0.5 up to 5 cm (0.25 to 2 in.). The more they are used the thinner and sharper they become. These sharper tools are excellent for carving out areas of finer detail and for refining the roughly cut initial form. It is helpful to constantly draw the design onto the piece to retain a sense of structure. (At this stage the lines between the bricks will have disappeared.) Depending upon the level of finish required, the final carving stage can be painstakingly long.

It is important that the brick be kept damp at all stages, and for this purpose it is useful to have a garden spray to hand, to keep the piece soaked down. Any areas not being worked should be covered with large sheets of polythene, and the sculpture should be thoroughly covered at night as any drying out can destabilise the structure. Too much water will also result in an unstable structure. Once the carving is complete, the work has the appearance of an exquisitely carved velvety piece of clay sculpture. It must then be left for a few days with a thin plastic covering. As it dries, lines will begin to appear between the bricks.

Above, left: Initial carving mapping out the structure. Photograph by Marco Kuhl.

Above, right: Using a garden spade to roughly shape the bricks and remove excess clay. Photograph by Marco Kuhl.

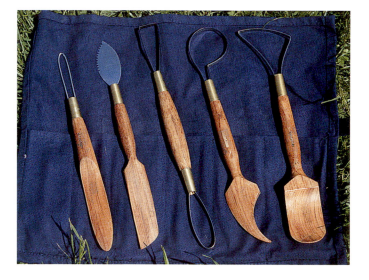

Above: Metal loop tools used for shaping.

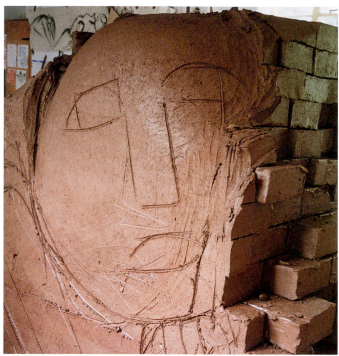

Right and below: Sequence showing the initial shaping and carving of Bid Ben Bid Bont.

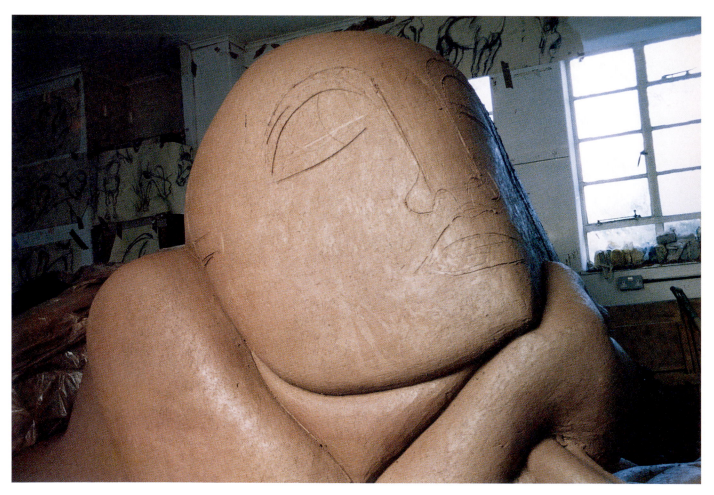

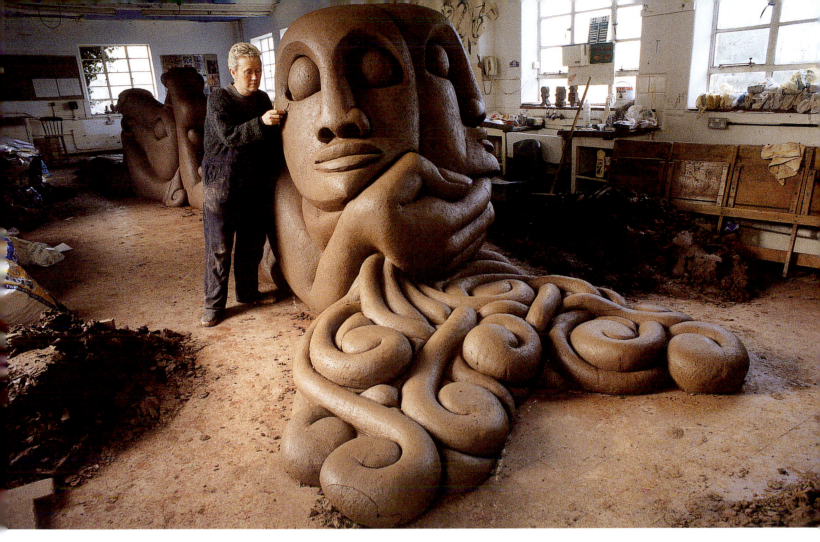

Above: The carved bricks taking shape as a sculpture. Photograph by Cordelia Weedon.

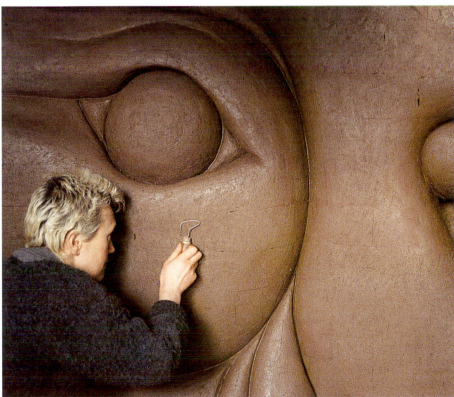

Left: Using a loop tool to carve the detail. Photograph by Cordelia Weedon.

Right: Semi-circular structure of green bricks to create Rhiannon *at Atlantic Wharf. Each brick is cut as a wedge shape in order to create the semi-circle.*

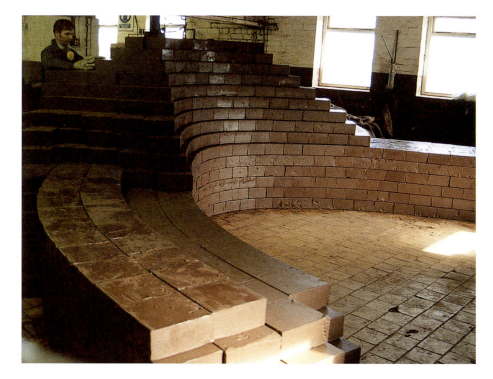

Below: The sculpture taking shape.

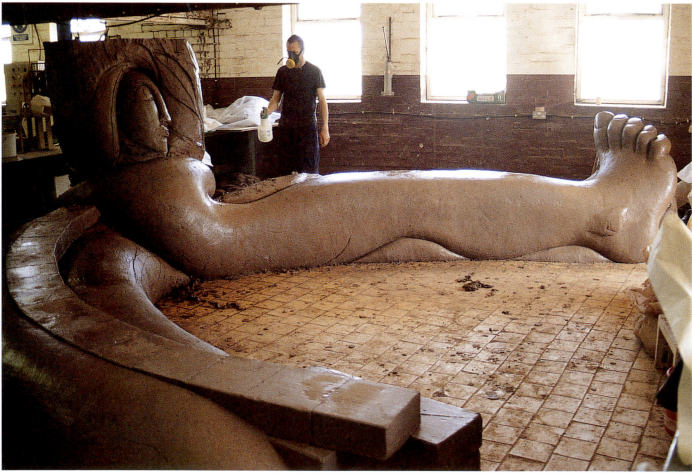

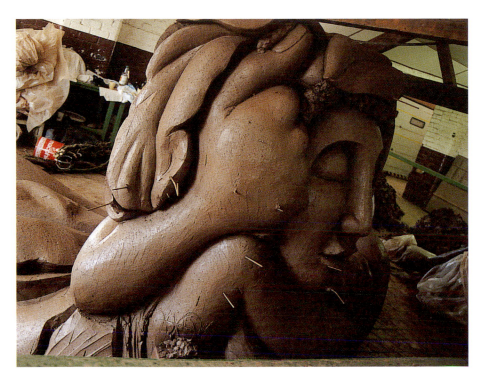

Left: Cantilevered bricks spiked with welding rods to stop them from falling out while carving finished.

Below: Rhiannon, *detail of the face, now in situ at Atlantic Wharf.*

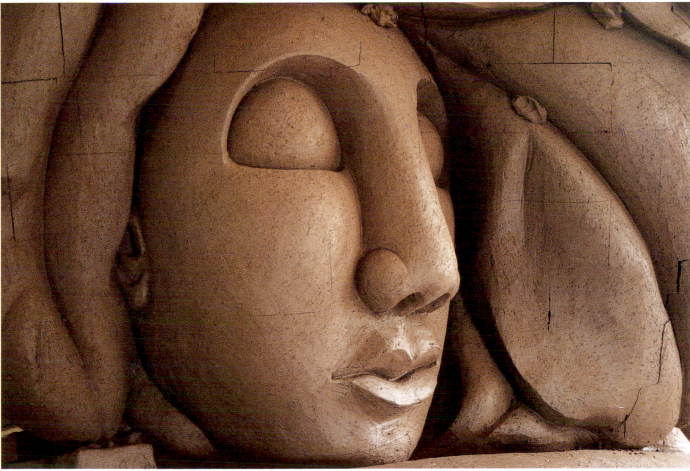

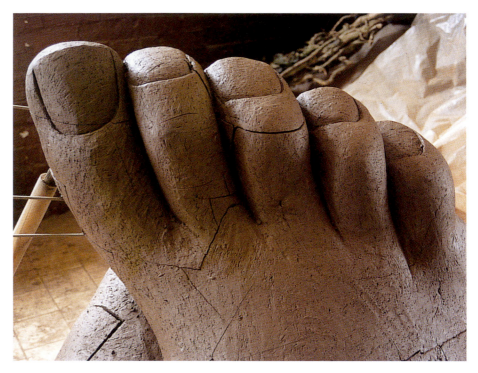

Right: Rhiannon, *detail of the foot.*

Below: Completed sculpture of Rhiannon in situ at Atlantic Wharf.

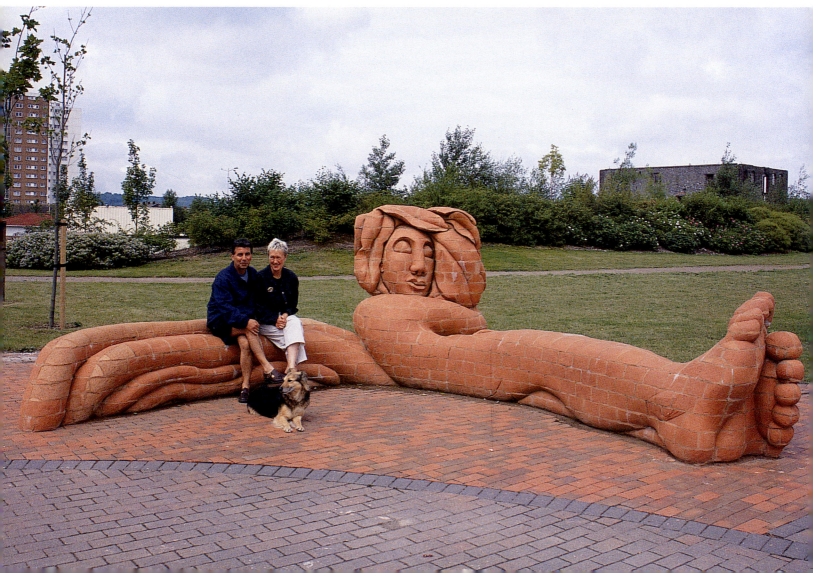

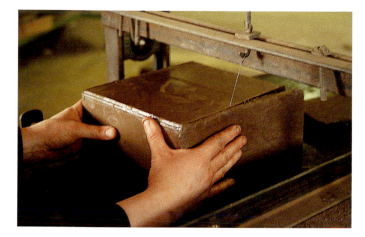

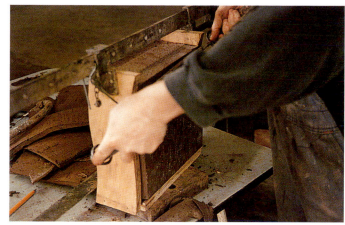

Dismantling the sculpture

As the work dries, so it will become easy to dislodge each brick. For me this dismantling of the work is an important stage; the perfect image is destroyed, never to be seen again in so pristine a state, for the nature of bricklaying dictates that the finished object will have broken lines. I do not mind if the lines are irregular in my sculptures when reconstructed on site, however some artists, for example David Mackie, will remove tiny slices of brick from bricks at various points when dismantling the green brick to allow for all the joints to be exactly the same size on reconstruction.

On a large-scale curved figurative artwork altering the joints after dismantling still cannot assure that the joints stay regimented on reconstruction as the artwork can move dramatically during the carving process. For me the amount of extra time needed to alter each joint does not justify the finished result.

As the sculpture is dismantled, every brick and every layer must be numbered and lettered – nothing must be lost. As the work is broken down into thousands of pieces it becomes a three-dimensional, and chaotic, jigsaw.

The numbering of each brick is crucial, so that the sculpture can be perfectly reassembled at a later stage; for this reason I use a 50-50 slip of ball clay and china clay to paint large bold letters and numbers on the top of each piece. A darker slip containing manganese will be used on lighter clay bodies. The top layer of bricks will, of course, need to be numbered on the underside or side, so that the markings do not show when the sculpture is put back together (the marking medium must be one that does not burn off in the firing). I never scratch in the numbers as such a method is too difficult to read especially from a distance on site.

I usually start at the top of the sculpture and this layer will be my 'A' layer. Each piece in this layer is then numbered starting with '1'. Having completed this top layer I then move onto the layer beneath, until all are marked. By the end of the marking process each brick or part of brick will

Above, left: Specialised wire-cutting machine shapes bricks. Photograph by Marco Kuhl.

Above, right: Cutting curved bricks in special wooden cutting boxes. Photograph by Marco Kuhl.

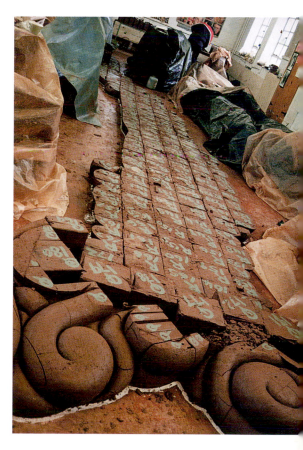

Dismantling bricks from the sculpture; every layer is given a letter, and each individual piece is also numbered before being removed.

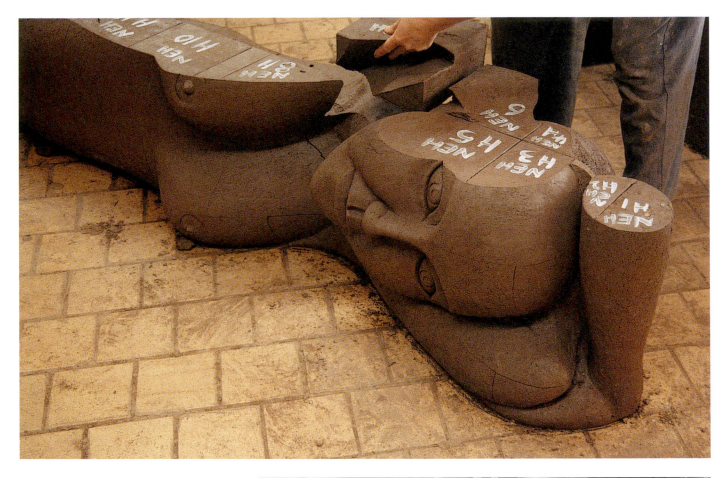

Above: Another example of numbering and dismantling and numbering (Nine Benches, Cardiff Bay). Photograph by Marco Kuhl.

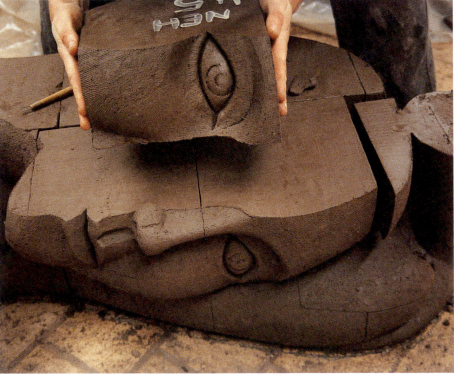

Left: Removing each layer after numbering. Photograph by Marco Kuhl.

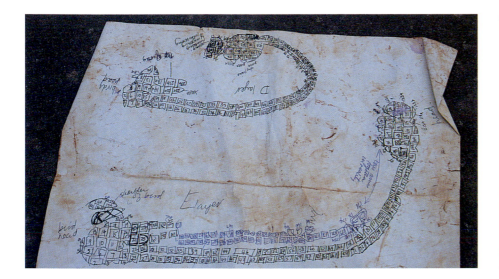

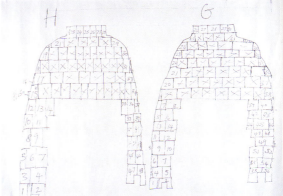

Above: Taking plans of each layer on paper (plan shown of front section of Mythical Beast).

Left: Plan on paper of Branwen Arena sculpture.

be marked with both a letter and a number identifying which layer it belongs to and the place it occupies within that layer. Each layer is dismantled as soon as I finish marking it.

Detailed plans showing letters and numbers need to be taken of each layer as it is marked and dismantled. These plans are made on paper using a permanent marker and I always photocopy them. Once this stage is completed the bricks may need to be hollowed out from behind on the unmarked side, so that air can circulate around them for drying and to enable them to fire without exploding. The top layer will be hollowed out on the side or bottom, whichever is unmarked. The resulting hollows also help to key the blocks in when bricklaying. Some brick clays do not need to be hollowed out and the factory will advise you on this. If they do however, this is a factor in production time and physical labour that needs to be taken into account. Sometimes, if the bricks need to be hollowed out, I have discarded any uncarved middle bricks and had them produced by the factory again with holes, to save time.

Before removing the final layer from the factory floor a white emulsion paint line should be painted around it, to provide a template for a plastic plan which will be used as a guide on site, indicating the size of the foundations and the position of the work (see picture on following page). To produce the plan, I place a plastic sheet over the painted line and trace it with a black line in permanent marker on the plastic. This plan may have to be stored for a few months whilst waiting for bricks to be fired; for this reason I find plastic the most practical material. I never place plastic under the bricks initially as this can become slippery and messy when carving the bottom edge. If the work is being carried out outside the factory, as can be the case for an artist in residence, the bricks need to be carefully stacked onto pallets after dismantling and covered with clingfilm, ready for collection. This can present problems if a forklift cannot access the building and they have to be stored in the rain before removal.

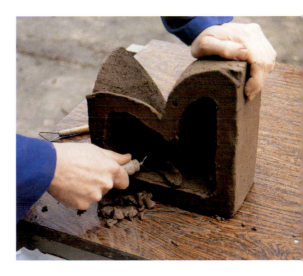

Hollowing out the bricks while dismantling.

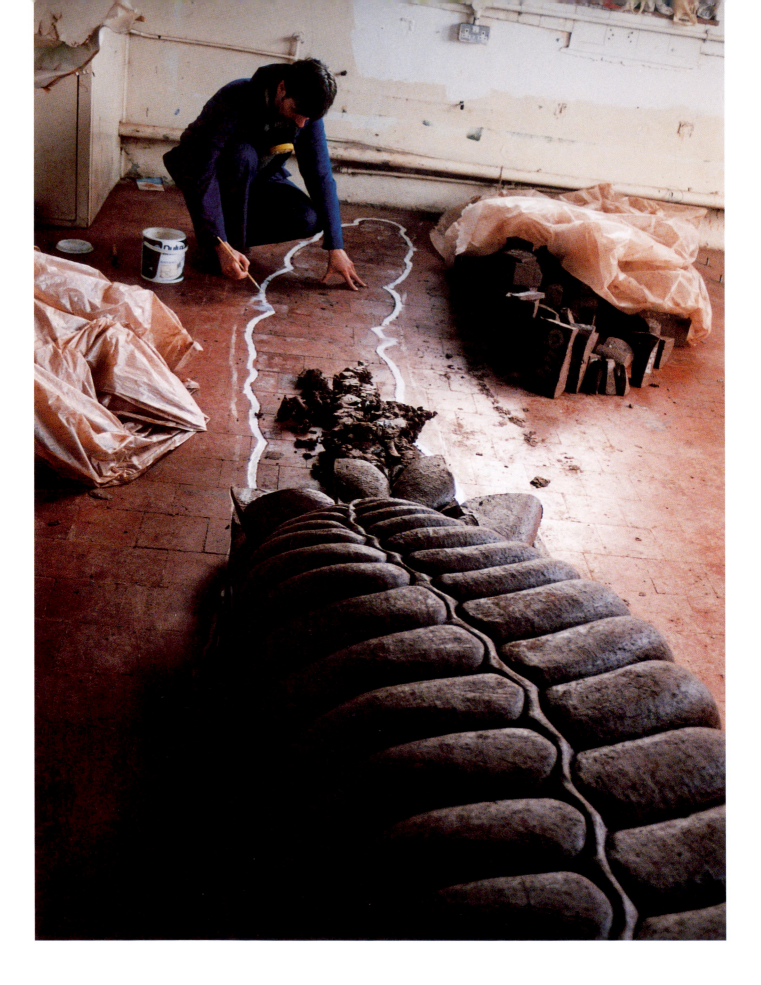

Opposite: Assistant Mike Priestly painting white line around the bottom of the finished Bid Ben Bid Bont sculpture.

Left: Plastic is laid over the white line, and the white line traced onto the plastic using permanent pen. The plastic with the outline of Bid Ben Bid Bont is then taken to the construction site.

Drying, firing and transporting the bricks

Once the bricks are dismantled (and transported back to the factory if need be) they are placed on a stillage so that air can circulate. They are left in a natural drying atmosphere for up to two weeks so that slow, even drying can take place. The stillages are then wheeled into the drying cabinets, which pump out hot air. Water is forced out of the bricks over a number of days, after which porosity is tested. When the porosity reaches 1% the bricks are ready for the kilns. The firing can take from 48 hours to four or five days depending on the kilns used. Once the bricks are fired, they need to be placed on pallets again. The larger, less detailed bricks are placed at the bottom and the smaller more detailed pieces on the very top. The palleted bricks are then shrink-wrapped and transported to the site where the sculpture is to be constructed.

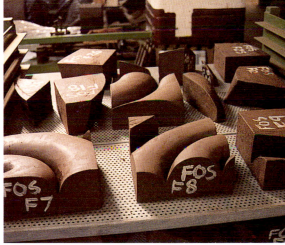

Bricks numbered on stillage ready for drying and firing.

Utilising brick for colour and pattern

The way in which the bricks are laid can have a dramatic effect on an artwork. For *Rhiannon* (Atlantic Wharf, Cardiff Bay) large bricks were laid at angles in a herringbone pattern for the seat capping. For this patterning I alternated a red Ruabon brick with a cream/buff brick to create movement and a varied colour (see the picture of *Rhiannon* on p.46).

Using arch formers

Architecturally, arch formers have been used for centuries to construct brick arches in churches and other public buildings. Many modern artists influenced by this traditional method have integrated arches into site-specific artworks and street furniture.

Traditionally these formers have been made of wood. I usually use marine ply, as the arch may soak up water from the green brick, and they may need to withstand adverse weather when being used to rebuild the arch on site. The formers will be used twice, once to build the green brick sculpture, and then again on site to build the fired sculpture. They will need to be stored in the intervening period.

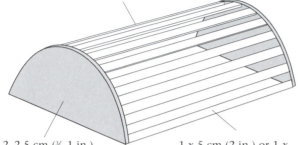

Centre rib may be needed for strength.

2–2.5 cm (¾–1 in.) thick end board

1 x 5 cm (2 in.) or 1 x 7.5 cm (3 in.) slats, spaced 1 in. apart.

Left: Making a simple wooden arch former on which to build the green clay arch. The arch former can be screwed together from each end to enable easy dismantling.

Below: Finished Boar Bench *in situ.*

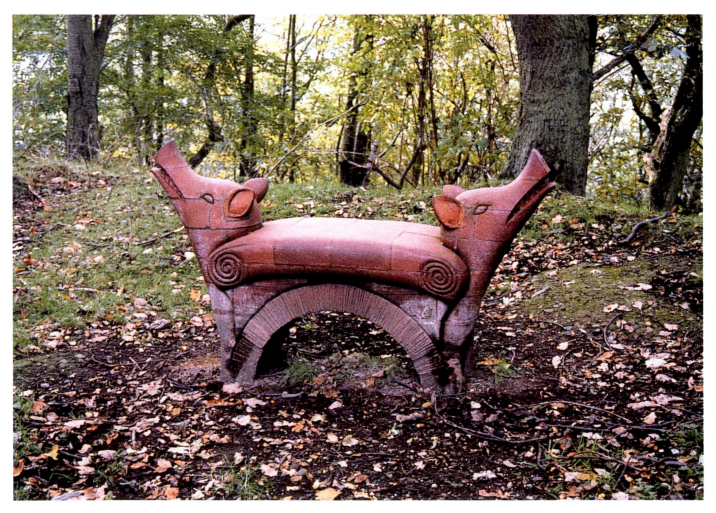

Boar Bench in Gaer Fawr Wood

This project came about through the 'Seats in the Woods' competition run by the Arts Council of Wales and the Woodland Trust. The brief required a collaborative project with local industry/community. I successfully approached the local brick factory at Buttington, Powys. I chose Gaer Fawr Wood as the site for the work because of its archaeological significance as a Bronze Age hillfort. A tiny bronze boar had been found at the foot of the hill and is now housed in the National Museum of Wales. The boar in Celtic mythology therefore became the inspiration for the work.

This project offers a good example of how to build and use a simple arch former.

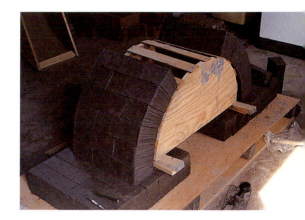

Arch blocks were produced on the production line and placed over the arch former box to the width required, they needed to be tied in by using the brick bond. If the factory does not produce arch blocks, they will need to be cut by hand in a wooden former.

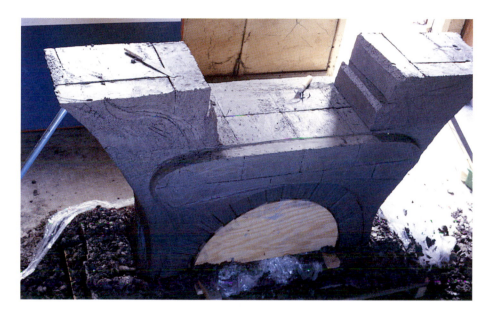

Extruded architectural blocks measuring 42 x 42 x 25 cm (16 ½ x 16 ½ x 9 ¾ in.) were shaped to fit up against the arch made by the arch bricks. The head area and seating area were built up from the larger blocks using nothing but suction. Props were needed to hold cantilevered sections.

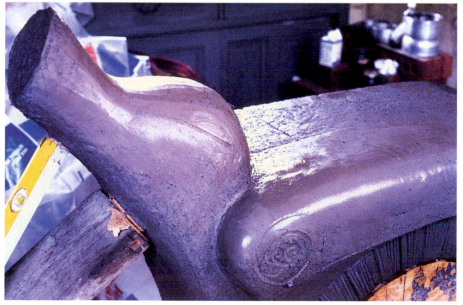

Using large looped carving tools the boar is carved, while any overhang is propped up.

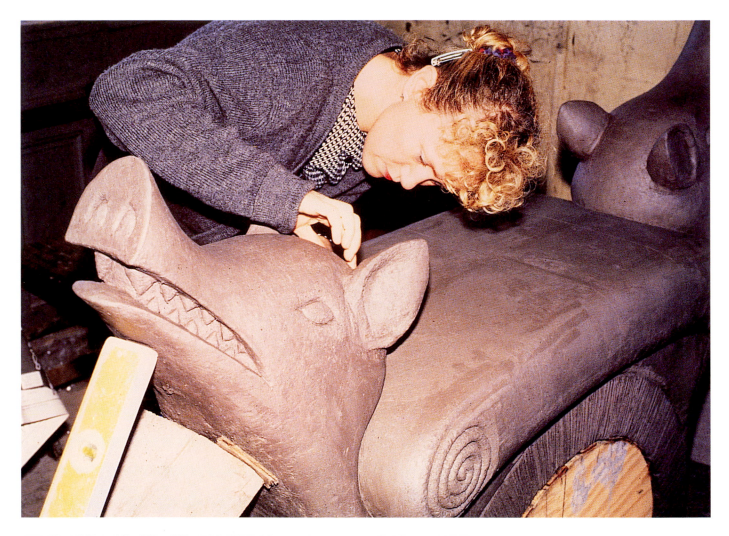

Above: Finished carving of green brick.
Photograph by Marco Kuhl.

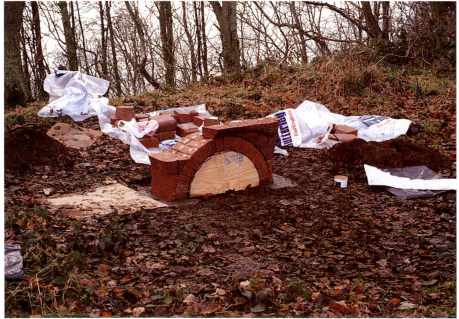

Left: The Boar Bench being constructed on site after firing, using the original arch former which has been kept for this.

Bricks were bonded together with epoxy resin, the temperature was below zero and this prevented it setting. This was remedied by lighting a series of fires around the work.

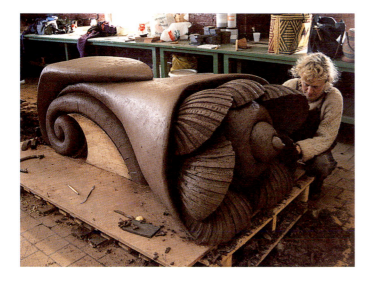

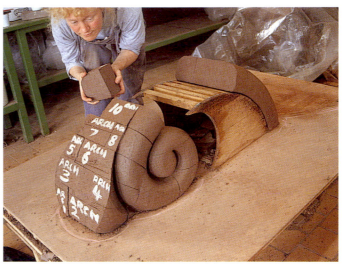

Above, left: Carving Cornucopia *in the factory. Photograph by Marco Kuhl.*

Above, right: Dismantling Cornucopia, *and saving the half-arch former for reconstruction. Photograph by Marco Kuhl.*

Left: Cornucopia *in position on site.*

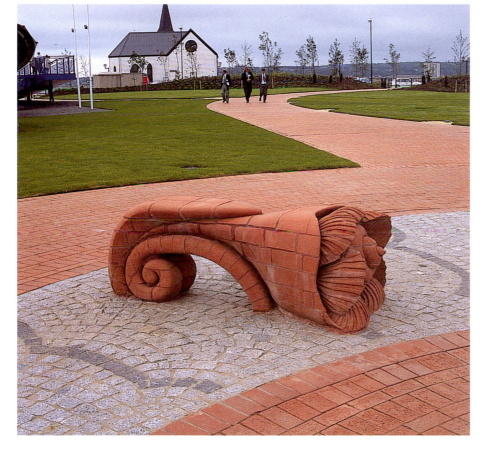

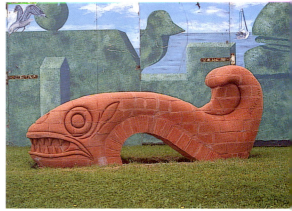

Above: Laughing Fish, *1994, Cardiff Bay.*

'Nine Benches' Cardiff Bay

Another example of constructing sculptures over arch formers. The formers used in *Cornucopia* and *Laughing Fish* are irregular and bricks may have to be individually cut to fit over such formers. These benches are based on Dylan Thomas's poem the 'Ballard of the Long Legged Bait', and refer also to Celtic imagery relevant to the site.

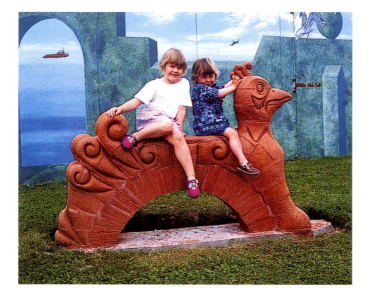

Above: Bird After Dark *sculpture, 1994, Cardiff Bay.*

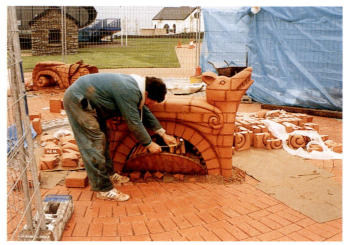

Above: Removing the arch box from the dog during the on-site construction.

Below: Finished Nehalennia *and dog sculptures in position. Photograph by John Donat.*

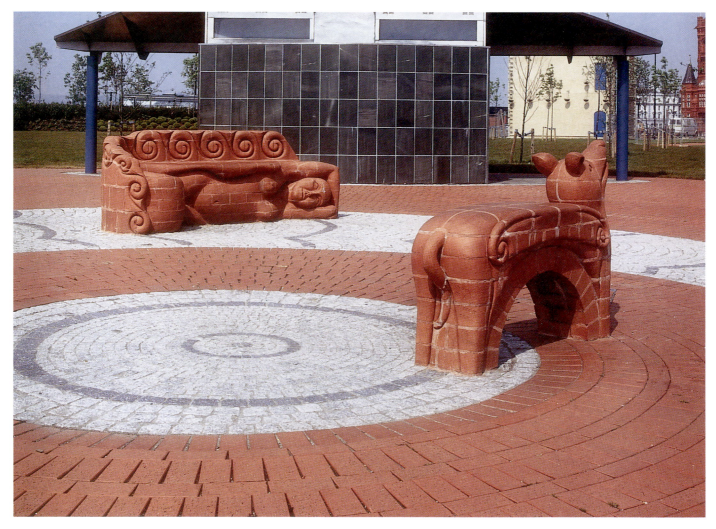

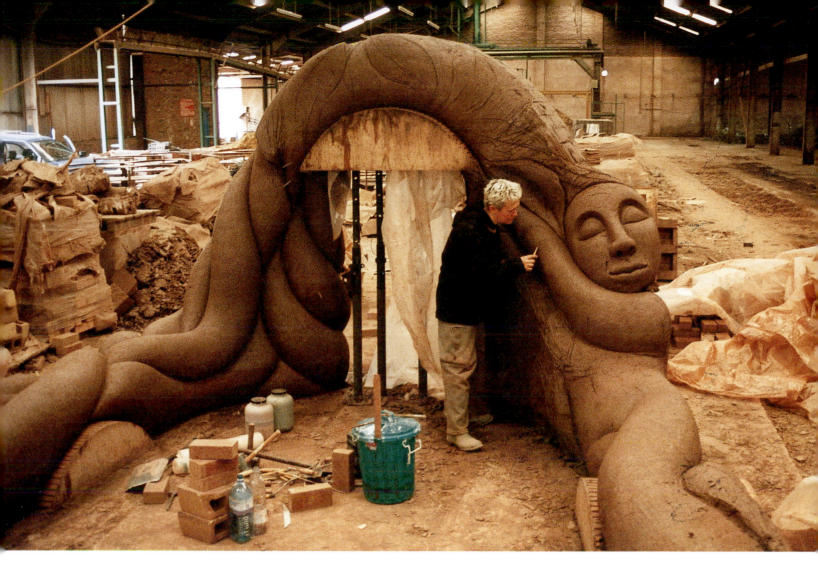

Goddess Archway, Glan Clwyd Hospital, Wales

This project was obtained through an international open competition run by Denby County Council and the Hospital Trust. Work was presented in the form of maquettes and design boards and displayed also for public voting. The site consisted of an open courtyard within the hospital flanked on all sides with buildings and required an artwork possessing height and presence. Many factors had to be taken into consideration such as colour of the brick, height of the artwork and the construction technique. I chose to work at Blockleys Brick, Telford.

The arch for this structure was constructed while green over a wooden arch box supported with acro props (metal bars with adjustable screws that tighten under a structure). The entire arch was heavily carved while leatherhard. Hard hats needed to be worn during the making process. As the archway is 3 m (9.8 ft) high, it was necessary to erect scaffolding at certain stages throughout so that I could access the top of the arch to carve. It is difficult if you are carving the arch whole while green. It may be necessary to carve it in sections in order to access the underside. American artist Robert Harrison, for example, constructed a green brick arch in sections at the UK's 1999 Creating the Yellow Brick Road symposium and conference at the Ironbridge Gorge Museum.

Above: Construction of Goddess Archway in Blockleys factory. Photograph by Marco Kuhl.

Below: Dismantling and numbering of archway in factory.

Right: Reconstructing Goddess Archway *on site at Glan Clwyd Hospital, North Wales.*

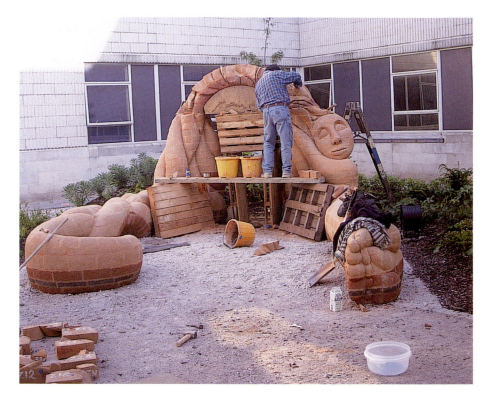

Below: Robert Harrison creating arch and chimney stacks in sections. Photograph by Nick Hedges.

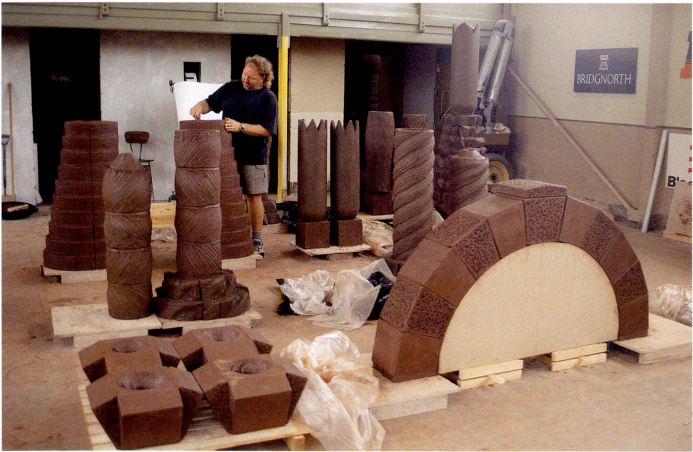

Working with complicated wooden formers

As with the wooden formers used for *Mythical Beast,* complicated struc-
tures can be built up with the use of specifically designed wooden for-
mers. The following former was used to produce *Insight* at the Yellow
Brick Road symposium. My chosen site was the 'pit', an industrial scar
cut into the ground by the excavated base of a former brick kiln, at the
Ironbridge Gorge Museum, Blist Hill. Recalling traditional processes
and materials, green bricks were stacked up in a complicated wooden
former consisting of a series of diminishing sections. A strong wire-cutter

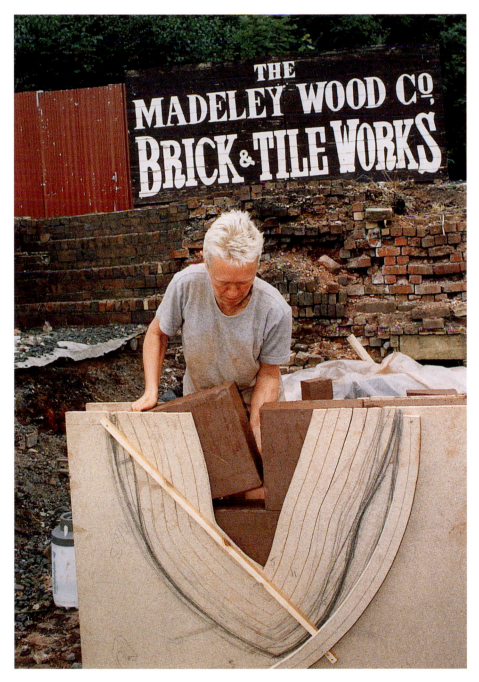

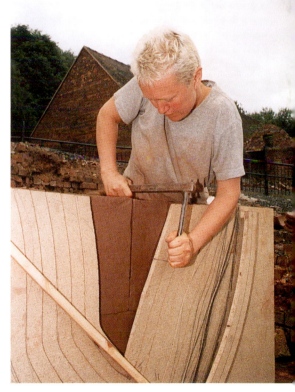

*Left: Placing architectural bricks into the for-
mer, every other layer starting with a half
brick so that the bonding resembles English
garden wall bonding. Photograph by Nick Hedges.*

*Above: Cutting through the bricks with a
wire-cutter. Photograph by Nick Hedges.*

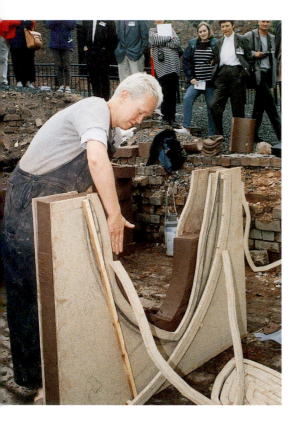

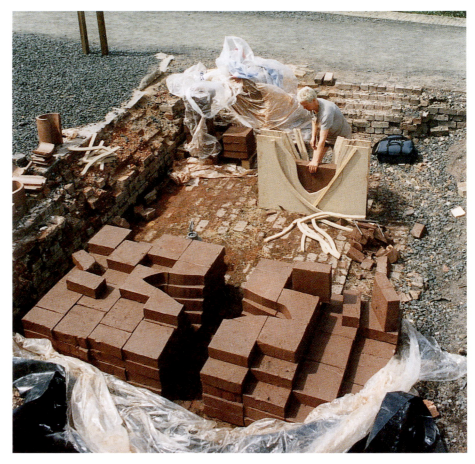

Above: Removing bricks from the former.
Photograph by Nick Hedges.

Right: As each section is cut and removed it is laid out in position, so that a structure of the sculpture begins to develop. Photograph by Nick Hedges.

Opposite: The finished sculpture Insight *after firing and installation, at the Rufford Country Park, Nottingham.*

bow was used to cut through the brick. The bricks were then taken out and assembled after each cut to create an ellipsoid structure alluding to the deep chasm of the eye. I created an architectural construction, that appeared to alter its form as light reflected upon it during different times of the day – a human symbol for the visual and emotional journey into the archaeology of a past industry.

Additional considerations

Working in the factory environment I had access to a large studio space enabling me to work simultaneously on a number of large-scale sculptures. It also meant that these could be constructed as one piece within the factory rather than having to be built in smaller sections in a smaller studio space. Additional benefits of working within a factory are the ease with which clay can be transported between areas using a forklift truck. Working in your own or temporary studios (for example, as artist in residence) presents a number of problems relating to the management and transport of thousands of delicate bricks from the studio to the factory. These are issues that need to be seriously considered when embarking on a large-scale work.

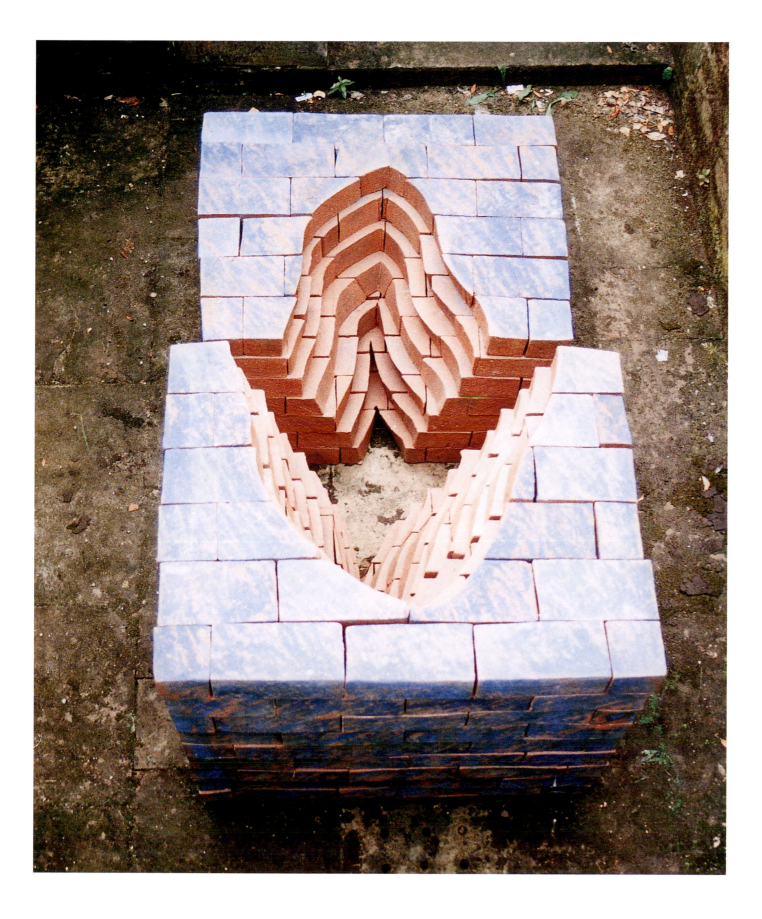

Themes, inspiration and content

The themes behind my brick sculpture are important, and indeed dictate the making process. My large-scale, site-specific artworks aim to reconcile figurative compositions with function. The work is of a human scale, constructed out of a familiar material – vernacular brick, which has a resonance of the home and the domestic environment. I operate on a variety of levels, on the one hand fulfilling my need for personal expression, on the other allowing me to appeal to a wider public through my use of symbolic imagery. One of my main sources of imagery is taken from popular mythology, with its powerful narrative potential being invariably constructed around eternal and complex questions of social identity and meaning. These stories are ideally suited for tackling contemporary issues related to, for example, gender roles and the nature of the modern family with its associated problems of structure and function. Much of my work articulates such tensions and attempts to resolve a conflict of emotions. As my young son matures, I am increasingly conscious that the work in some way tacitly reflects this development and my relationship to him. In *Bid Ben Bid Bont* (see p.39) both sides of the two-headed Janus, (the Celtic God) vie for dominance whilst pulling at a rope, a symbolic umbilical cord. I aim to create a visual tension within the work. Myths are a constant source of such imagery and encourage an anthropomorphic realisation, which in turn provides an opportunity for a broad range of interpretations. The symbols are multivalent.

Construction on site

The Goddess Nehalennia, Brittania Park, Cardiff Bay, 1994.

This was part of the *Nehalennia Trio*, inspired by Dylan Thomas's Venus and interpreted as the Goddess with her dog and cornucopia, depictions of which are found in Celtic shrines around the North Sea.

After the bricks have been fired and delivered to the site, the sculpture must be reconstructed. Firstly, however, both site and foundations need to be prepared. (This will be covered in detail later in the chapter.) Using the plastic outline plan (see p.51), the size of the foundations need to be painted on the concrete foundation slab, again using white emulsion paint. This will enable the first layer of bricks to be placed accurately. The bricks will shrink by about 10 –12% so when you place the first layer back on the plan you need to leave a gap of about 1 cm/⅜ in. (6–10 ml in bricklaying terms) for the mortar. Curved structures are more difficult as the curve can tighten and the plastic plan will just be a basic guideline. In this case it is wise to put the first three layers together dry before using mortar to make sure you have the right positioning of the bricks and right angle on site. Arch formers may present a problem

Above: Tiny pieces to be fitted into the sculpture, the result of carving.

Opposite page
Top left: First layer of bricks for The Goddess Nehalennia.

Top right: Idwal Inkpen (master bricklayer and stonemason) building up the layers.

Below: Laying the few final bricks in The Goddess Nehalennia.

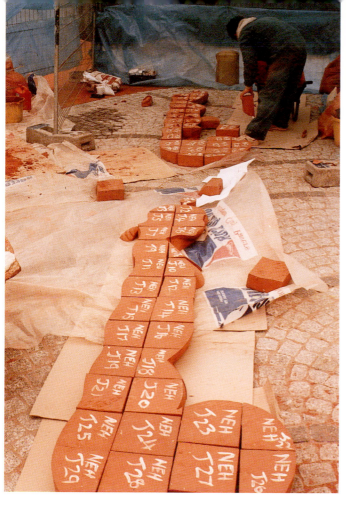

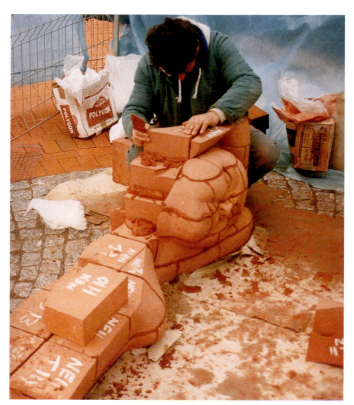

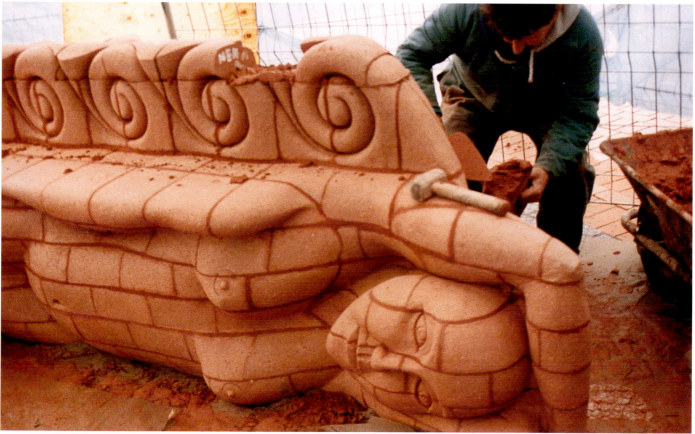

Right: Bricks are sorted into layers and stacked on site at Llanfyllin High School, for the sculpture Bid Ben Bid Bont. *Photograph by Ann Stephens.*

Below: Bid Ben Bid Bont *foundations laid and initial layers mortared together. Photograph by Ann Stephens.*

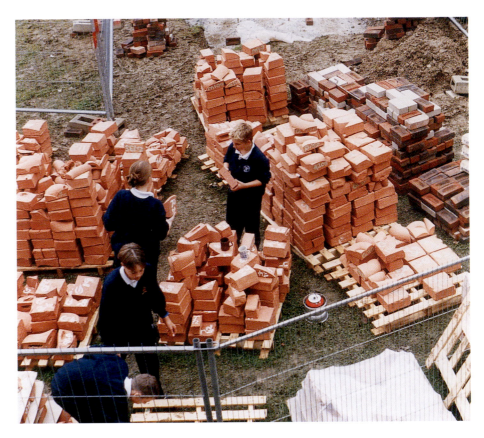

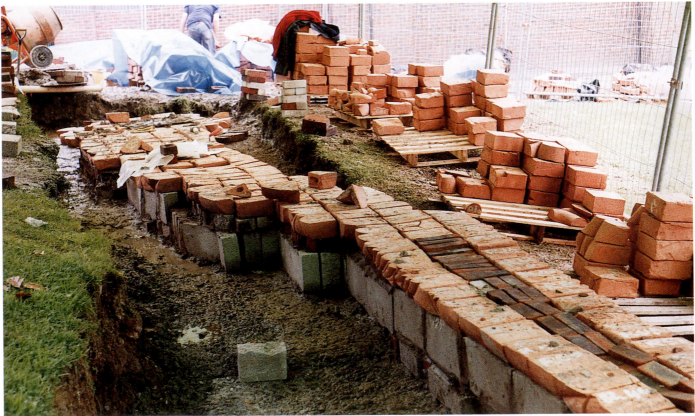

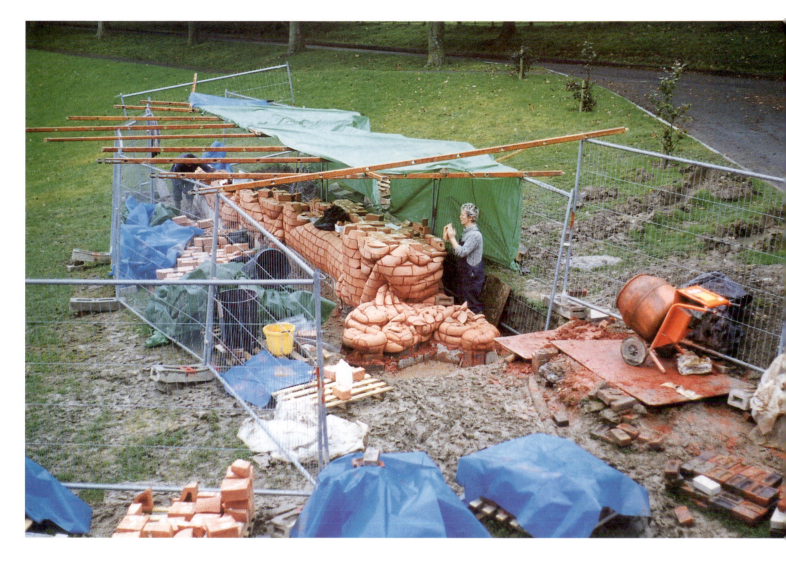

The sculpture developing under protective tarpaulins. Photograph by Ann Stephens.

as the first bricks are placed over the arch box – the mortar will usually make up the shrinkage difference. It is worth laying the arch dry first to see how much mortar is needed.

In order to put the bricks in the correct positions, the detailed working plans on which the position of each brick is noted will need to be referred to. It is recommended that the bricks are all sorted into layers before reconstruction commences. The first layer of bricks (here 'R') will be the last to be marked and dismantled in the factory. Conversely the final layer to be added (here 'A') will be the first to have been dismantled in the factory.

Once the bottom layer is entirely in place the bricks are ready to be mortared together using a 4:1 ratio of sand to cement. (A ratio of up to 6: 1 can be used; the supplier should recommend the right mix). I normally add another layer of bricks immediately on top to make sure there is a good fit. If adjustments need to be made, they can be done whilst the mortar is still workable. Up to three layers can be worked at the same time.

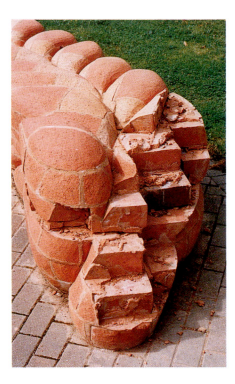

Bricklaying a three-dimensional sculpture presents a number of problems. If you commence with a tightly constructed and regimented first layer, the subsequent layers often do not fit with the problem worsening as the work progresses and the joints become tighter. A certain amount of fluidity is essential in the reassembling process. For example, a joint may occur within a very fine detail, such as an eyeball – here a thin line of mortar is appropriate. A thicker line of mortar will then be needed elsewhere, in a less detailed joint, to compensate. Within the finished product such seeming discrepancies will not be noticed.

In dismantling the sculpture an enormous number of tiny numbered, often finely detailed pieces will have been generated. These will occur when almost all of a brick has been carved away in the carving process. Once fired these all go into a bucket on the site, easily accessible, and can be adhered with epoxy resin when required. It is possible to stick these with slip at the dismantling stage but this can be a lengthy process.

Left: Sculpture damaged by reversing vehicle.

Below: Green bricks brought to site and placed in damaged sections.

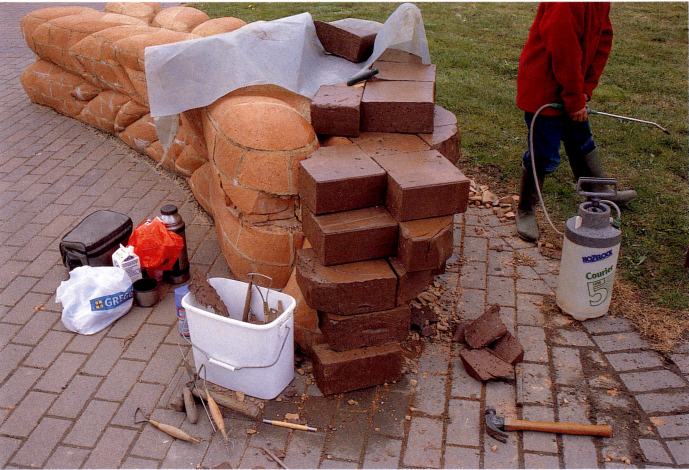

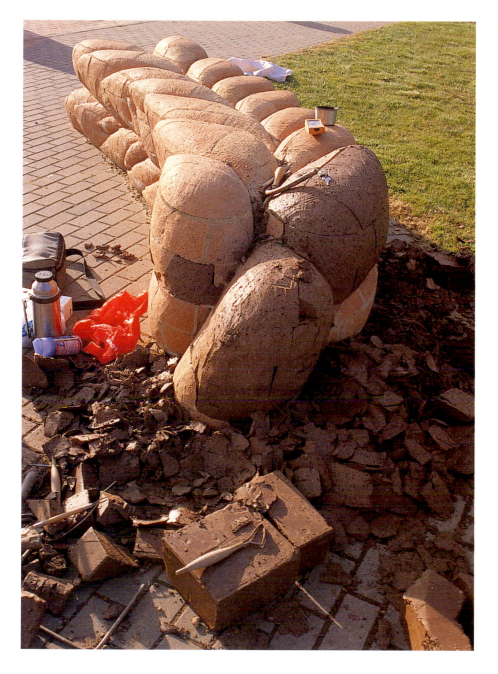

Carving the green bricks to fit the shape of the sculpture again. The new bricks are then numbered and taken away for firing.

Repairing damaged sculptures

If a sculpture is damaged for example by a reversing vehicle (see the pictures opposite), it is possible to repair it. Firstly you will need to clean up the broken areas as well as possible. Then take more green bricks to the site (obviously the same bricks as were used previously), placing them in the position of the damaged bricks. The new bricks will need to be carved to the correct shape, dismantled and taken away to the factory for firing. The new bricks will probably be smaller than the rest because of the shrinkage involved in the firing, but the mortar can be used to make up any size difference.

Following a public commission

Mythical Beast was a project initiated myself in 1989, during my time as a student at the Royal College of Art. Aware of the potential for large-scale artworks at the Welsh Ebbw Vale Garden Festival, due to be held in 1992, I began to work on a design for a 30 m (98 ft) long, 5 m (16 ft) high sculpture, made from carved brick. I was inspired by the site, located in a desolate, winding valley in much need of regeneration. The project was developed from initial sketches and maquettes and the idea presented to the Projects Manager at Ibstock Brick. It was important to have sponsorship agreed before approaching the Garden Festival organisers.

The festival site ensured that the piece would have a dramatic impact on the valley and the sculpture was also designed to function as a garden. The backbone of the beast was made to be planted with exotic plants, the colours of which would change with the seasons like the skin of a lizard. The sources of inspiration for my original concept included the prehistoric Serpent Mounds in the Ohio Valley and Gaudi's Parc Guell in Barcelona. The imagery relates to the serpent as the protector and rejuvenator in Celtic mythology, which was relevant to the site in Wales.

Mythical Beast, *Ebbw Vale Garden Festival Wales, 1992.*

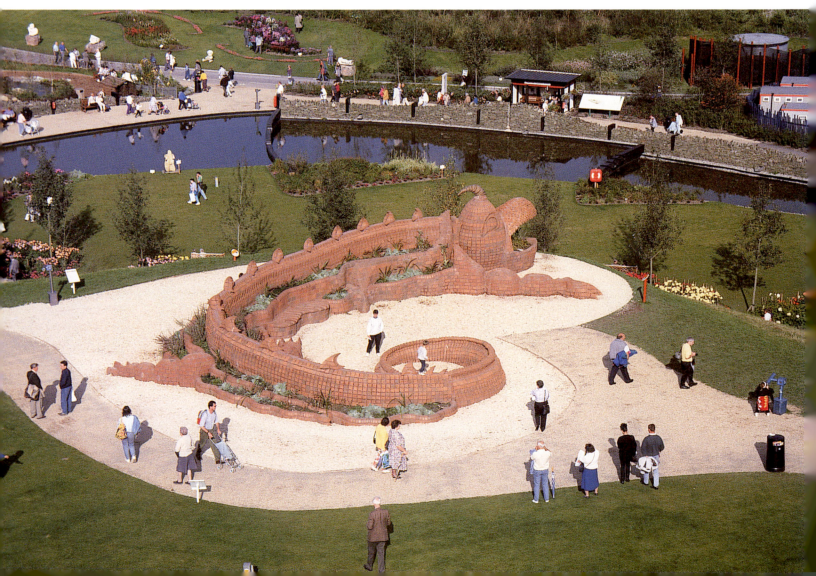

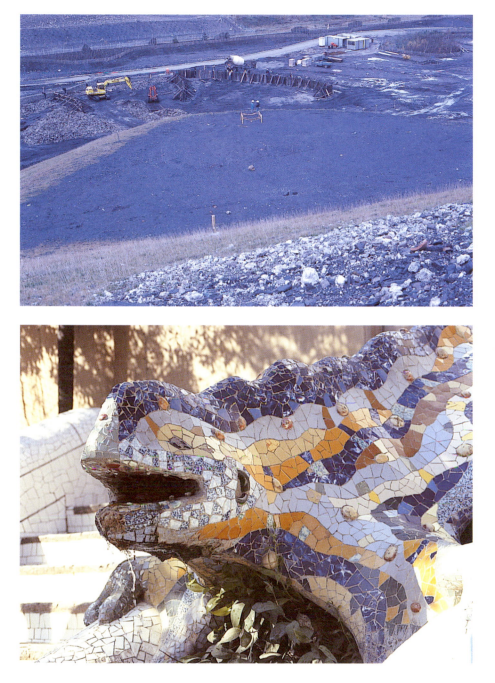

Valley in need of regeneration with site of
Mythical Beast *being prepared, Ebbw Vale*
Wales.

Inspiration taken from Gaudi, Parc Guell,
Barcelona, Spain.

The spiral shape of the *Mythical Beast* was based on the golden section, a complex articulation of space used by medieval architects when designing sacred places such as cathedrals and churches.

Detailed design drawings were produced on a 1:20 scale and a maquette to give an indication of the space for planting etc. when the project was presented. I find a scale rule is an essential part of my tool kit.

Right: Maquette of Mythical Beast.

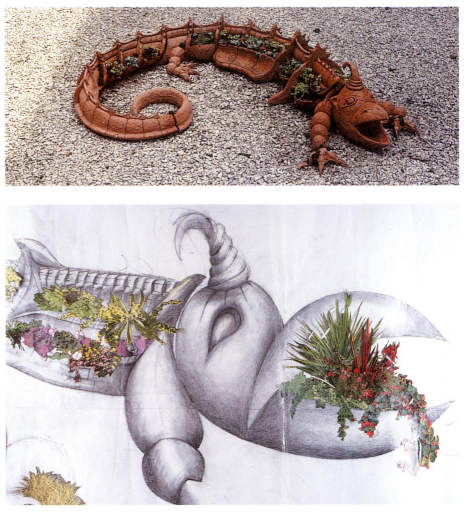

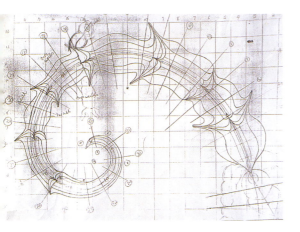

Above: Development of golden section in plan for Mythical Beast.

Right: Detailed planting designed through consultation with a horticulturalist, showing exotic plants, the colours of which would change with the seasons like the skin of a lizard.

Construction

Ibstock Brick allowed me free rein of their 'specials' department for a period of nine months. During this time I was able to use factory production methods and machinery to create various sections of the *Mythical Beast* sculpture. It was an ideal opportunity to exploit the potential of mechanized factory processes. In the factory ideas would become reality; 5,000 bricks designed one evening would be delivered to my workspace early the following morning. There were several disparate elements that needed careful consideration, and designing, to create a successful and structurally sound whole.

Brick bond

When planning construction it is essential to decide on what *brick bond* is to be used. This is a term used to denote the design pattern in which you lay your bricks. The brick bond has to both enhance the visual appearance of the sculpture, and provide a solid framework whilst work is in progress.

Examples of brick bonds

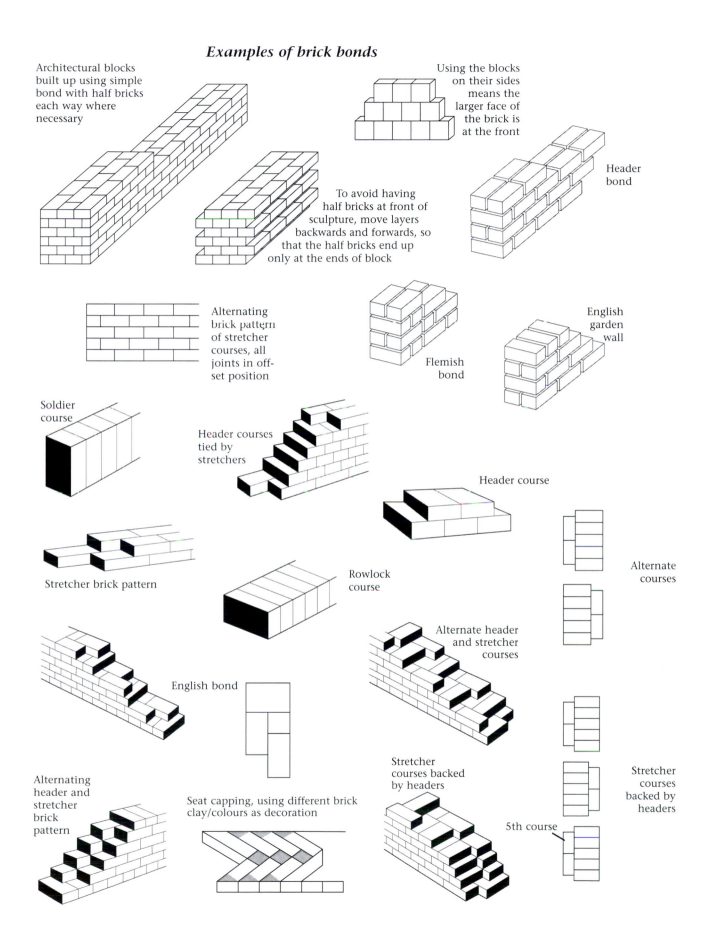

Architectural blocks built up using simple bond with half bricks each way where necessary

Using the blocks on their sides means the larger face of the brick is at the front

Header bond

To avoid having half bricks at front of sculpture, move layers backwards and forwards, so that the half bricks end up only at the ends of block

Alternating brick pattern of stretcher courses, all joints in off-set position

Flemish bond

English garden wall

Soldier course

Header courses tied by stretchers

Header course

Alternate courses

Stretcher brick pattern

Rowlock course

Alternate header and stretcher courses

English bond

Stretcher courses backed by headers

Stretcher courses backed by headers

Alternating header and stretcher brick pattern

Seat capping, using different brick clay/colours as decoration

5th course

Right: Large bricks for capping on seating.

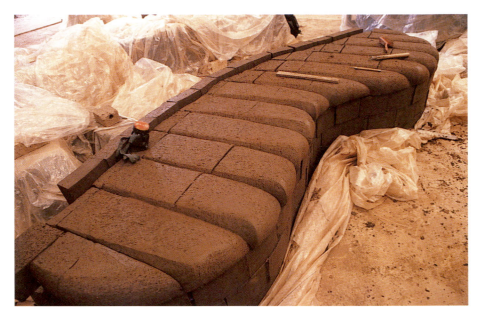

Below, left: Bricks being carved into basic structure. Photograph by Marco Kuhl.

Below, right: Wooden cutting box holds the stacked bricks, while the excess brick is sliced off using a wire-cutter, to form the special shaped bricks for the spine of Mythical Beast. *Bricks carved and fired at Ibstock Brick, Cattybrook. Photograph by Marco Kuhl.*

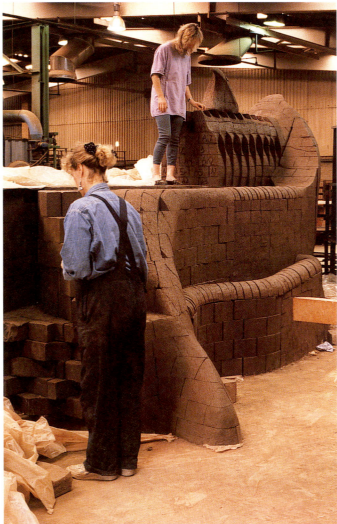

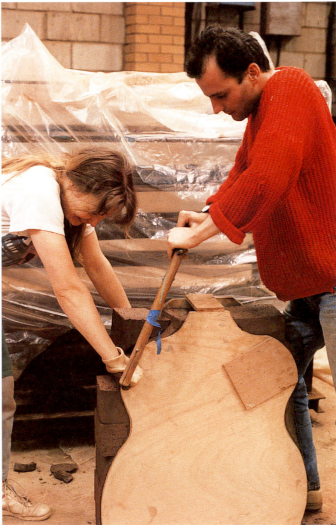

Extruded brick forms

I designed a series of convex and concave curved bricks and capping bricks, that were then produced by the brick extruder. In similar fashion I produced 70 cm (28 in.) lengths of brick as capping for the seating.

Wooden moulds/formers and profiles

The expertise of the carpenter/mould maker was essential. Wooden moulds and cutting boxes enabled me to produce multiples in a short space of time and to facilitate the construction of complicated structures.

Stacked spinal sections and fins

The carpenter constructed a simple *cutting box* to produce a series of stacked spinal sections, which were worked out through drawings. This was a simple two-sided box cut to a specified shape, with bricks stacked to the top of the box and a wire-cutter taken down both sides. The bricks were then removed and numbered. Multiples of these were stacked and staggered to form the backbone of the piece. The idea for a complicated many-faceted detail (such as the fins on the back of the beast), was developed through experimenting with structures, and then translated into more complicated wooden cutting boxes in which bricks could be

Spine and fin constructed on sculpture.

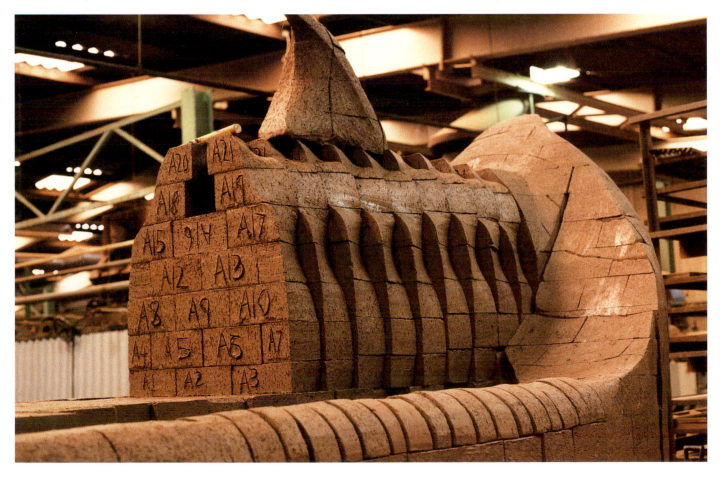

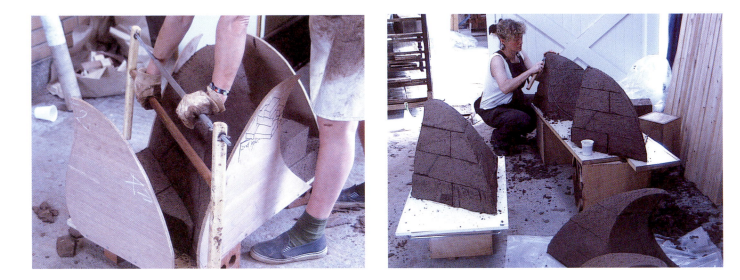

Above, left: Complicated cutting box stacked with bricks and cut with wire, to create fins on sculpture. Photograph by Marco Kuhl.

Above, right: Hand finishing fins. Photograph by Marco Kuhl.

Below: Structure being built up with various sizes of arch bricks to enable carving of the eyes and curving of the bricks to create a more organic structure. Photograph by Marco Kuhl.

stacked and then sliced at different angles with a wire-cutter. These sections could then be hand-finished.

Developing large self-supporting structures

The head of the beast was developed from a series of diminishing arch bricks, the structure and format being designed and worked out with the aid of a computer. It was designed so that I could (if necessary) build the beast myself, a construction sponsor not being found at this time. (Bovis Construction later took on the building of the beast.)

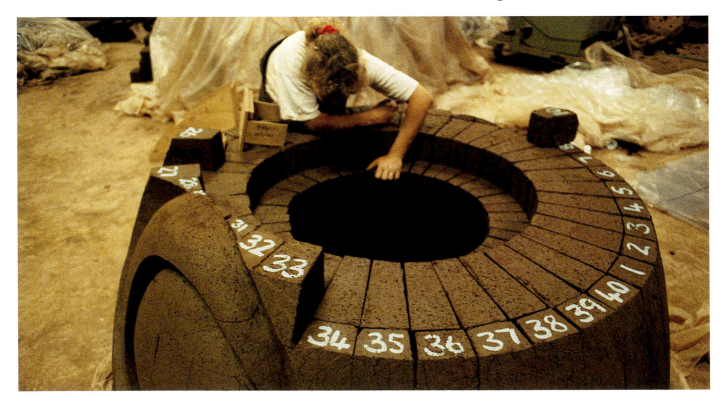

To construct the beak of the beast (see below) unfired roofing tiles were produced and then sliced and shaped over a metal structure. These were stacked and fired to retain their shape. They were fixed on site to the metal structure with roofing pins.

Installation on site

The aspect of the site needs to be considered. For whilst installation is taking place there will need to be some degree of protection in winter, or shelter from the rain. This may entail raising scaffolding, and using tarpaulins to protect the site. Fencing may be needed to protect the work during installation – the loss of just one piece could be extremely detrimental to the final result. It is important to raise fencing professionally to avoid accidents. Polythene sheets will be required for covering work.

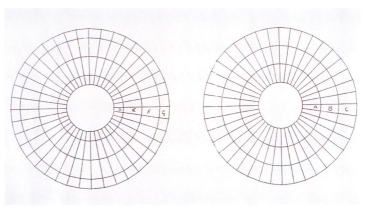

Above: Original plan of the structure of the head (preliminary sketch produced on the computer).

Below: Using a metal framework over which the tiles are shaped and placed in position for the beak of the Mythical Beast.

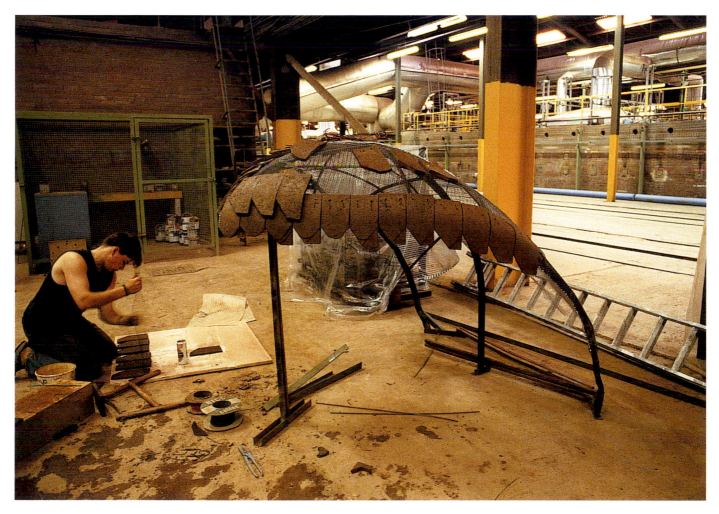

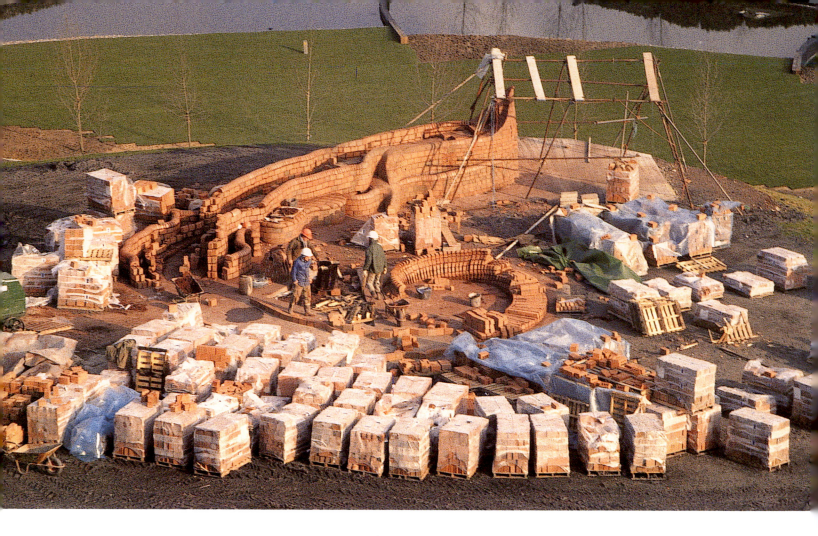

On-site construction. Sections of walls and planters being constructed.

Preparation of foundations

Depending on the size of the work, and the conditions on site, it is often advisable to employ a surveyor and construction engineer to ensure that adequate foundations are laid. Depending on the type of soil and depth necessary for the foundations, it may be necessary to use a digger to prepare the hole. Often, though, a spade is all that is needed. Construction engineers usually advise a concrete pad with a depth of 3.7–5.5 m (12 – 18 ft) with reinforced steel mesh sheeting built into the foundation structure. The weight of the sculpture will be an important factor in determining the depth of the foundations. It may be wise to order a consignment of ready-made concrete for a large foundation or consider hiring a cement mixer. Stainless steel mesh may be required inside the sculpture when constructing the first two or three layers, to prevent them from moving and cracking should the foundations move. This should be laid in strips and embedded in with the mortar. A plinth may need to be constructed to elevate the sculpture above the ground. It may also be advisable to tie the sculpture into the foundations with metal bars.

Collaborating with craftspeople

This is very important on large-scale commissions, and as many difficulties can arise it is important to research their reliability and workmanship. Many bricklayers for example, do not have the necessary expertise

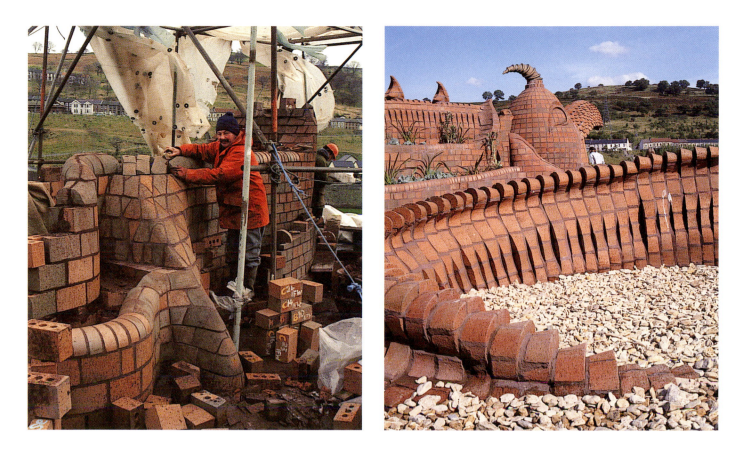

to construct complicated brickwork that may demand a lot of patience and an artist's eye. I have always used the same bricklayer (Idwal Inkpen).

Specialist bricklaying tools

A number of specialist tools are required such as spades, trowels, (four various types of trowel can be used – for laying the beds, jointing, pointing and finishing), hods, spirit levels, buckets, rubber hammers, metal bolster and cold chisels. Lump hammers and bricking hammers are needed to take off excess edges and a tooth hammer will break down small particles of brick. A good bricklayer will be able to shape, to an extent, a brick to replace any lost in firing or transportation.

Mortar joints and finishing

It is important to decide on the type of mortar joint to be used as this can alter the appearance of the finished work. I use flush or flat joints as these tend to add to the overall continuity of the form. Other joints are; recessed or racked, keyed joints and bird's beak joint. The size of the joint is also important, normally bricklayers will use 6 ml or 10 ml joints (approx. 1 cm/⅜ in.). In the UK, Tilcon will prepare special coloured sand for use with different bricks. Alternatively, special colour additives for sand can be obtained from builders' merchants, who should be able to advise on the correct mix. Some artists, such as Rodney Harris, prefer the effect achieved

Above, left: Idwal Inkpen at work (bricklayer), head-hunted for Garden Festival, constructing the Mythical Beast.

Above, right: Detail view. Tail end and head of Mythical Beast *in sight.*

by natural sand and grey cement. As work progresses cloths and sponges or gloved fingers will be needed to wipe off smudges and clean up the pointing. Structural Adhesives produce epoxy resins for sticking small pieces vertically on to the sides of an artwork. The instant resins are easier to work with than those with a long setting time which therefore need holding. A brick acid cleaner such as 'Cementone' may also be required.

Once the joints are completely dry – this will take a week or so – it may be advisable to clean the brickwork with a very weak solution of brick acid cleaner diluted in water. It can be applied with a brush and then washed off with clean water. The acid will cause the excess dry mortar to bubble making it easily removable. You need to be cautious at this stage not to get the acid directly onto the joints as it can eat through and ruin them.

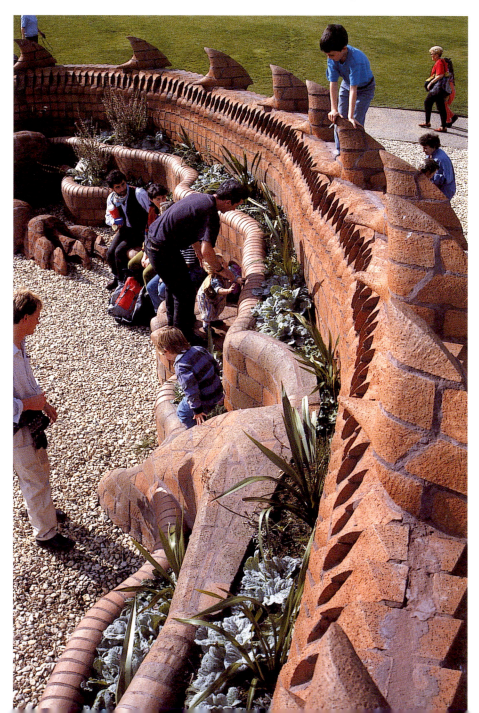

Finished Mythical Beast, *with plants.*
Photograph by Marco Kuhl.

Case study: Ulla Viotti (Sweden)

Ulla Viotti is one of the foremost artists in the world working with brick within a factory environment. She first became interested in brick after working at a symposium held in a brick factory in Gdansk, Poland in 1973. She has since then created a number of site-specific commissions from extruded green brick which is then cut into a variety of shapes using wooden profile boxes. She sees bricks as the perfect medium for creating architectural ceramics – using a medium so strongly identified with buildings, which can be employed to create integrated and integral artworks.

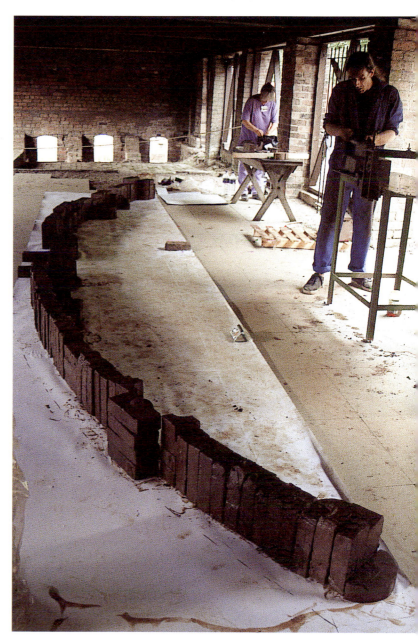

Bricks laid out on Fabricana paper rolled out on floor, length: 8 m (26.2 ft). The curve is calculated. Photograph by Nick Hedges.

The brick is made of clay and is our earliest building material. It is closely linked to our own history and the development of our civilisation. I see the brick itself as a symbol for civilisation.

The medieval decorative brickwork adorning so many churches and cathedrals throughout Europe, especially in the Hanseatic towns around the Baltic, have been a great source of inspiration to her. She works directly with architectural details which are translated and combined with the use of profiles in new and contemporary ways.

Viotti works in collaboration with many brick companies throughout Scandinavia, the most important being the family company, Hans A. Petersens in Nybolnor, Denmark which has been in production for seven generations. They produce coal-fired, hand-made bricks, the individual quality of which has inspired many of Viotti's works. The factory is part of a traditional brickmaking region along a 3.1 mile (5 km) stretch of water around Fleusburg Bay, where seven of the original one hundred 19th-century brick factories still function. Artists from about 20 different countries now work at the Petersens factory.

After winning a competition or being invited to create a commission, Ulla will sign a contract with the client which is usually produced with the aid of the Swedish Arts Council. In producing commissions she emphasises the importance of communicating professionally with architects and becoming conversant with their language, for example, by making presentations using scale models and understanding proportions, materials, and light. She feels artists also need

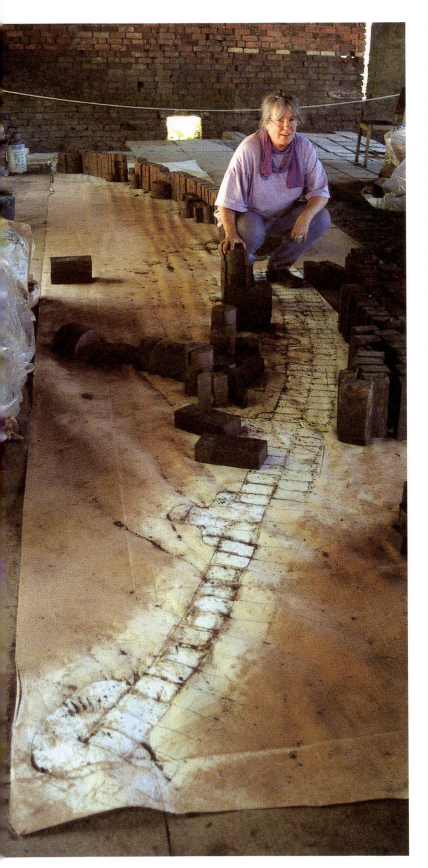

to be aware of the building process and the difficulties of integrating artwork in a positive way within the architecture.

Ulla Viotti moves into a factory with a clear idea of what she wishes to create. She says of her factory base, 'When I move into a factory I feel like a missionary for the future of brick culture.' She often finds herself at the nucleus of a 'brick family' and a valuable collaboration ensues – through understanding individual factory processes the artist begins to develop her personal visual language, whilst craftworkers in turn see hidden potential in a familiar material. Viotti often works with new ideas inspired from old wooden profile boxes and other details found in forgotten corners of the factory. Extruded bricks are placed into the old or newly developed box and the excess is sliced off with a wire, making the surface smooth and polished. She often experiments with altering production line techniques, firing cycles and industrial processes to accommodate essential creative development. An abundance of inexpensive material and the ease with which quantities of bricks can be acquired within the brick industry encourages her to produce large-scale artworks. She sees collaborating with industry and architects as stimulating and encouraging experimental ways of thinking.

Initially Ulla Viotti will begin her sculpture by drawing the shape of the base with charcoal onto an 8 m (26 ft) roll of good quality cartridge drawing paper (Fabriano paper is recommended, available from most good paper suppliers). The wet bricks are then laid on top of the paper to form the base of the work. Sections are then built up with the green bricks and the amount of each profiled brick needed to complete the wall is calculated. The bricks leave their print on the paper creating a working drawing or print, which acts as an important guide to the final construction of the piece. She works with experienced brick layers to construct her works on site.

Impression from bricks forms the print. Photograph by Nick Hedges.

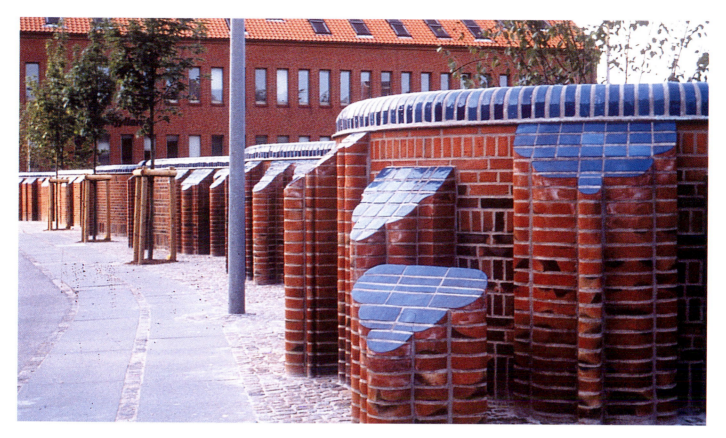

Site Specific Commissions

Telewall

This was executed in Aabennaa, Jutland in Denmark in 1993. It is a 60 m (197 ft) long winding wall comprising of 18,000 bricks, about 5,000 of which were hand-cut in a wooden profile boxes. Some of the bricks are glazed with a cobalt blue glaze, applied after the bricks are fired and then re-fired to 1050°C (1922°F) in an electric kiln (glaze cannot be fired in the coal-fired kiln at Petersens). The wave shaped wall is a sculptural and symbolic communications link between the telephone company's head office and the museum in Aabennaa. Glazed bricks form lines that are associated with modern telecommunications lines. For this commission, Viotti worked with bricks from Petersens and collaborated with the Swedish architect Sten Samuelssou. The wall took the bricklayer one year to complete.

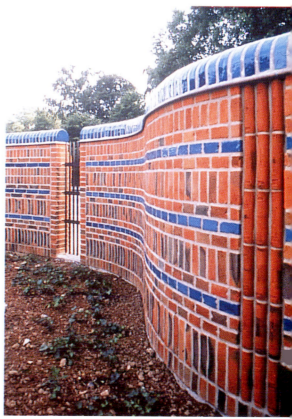

Top: Telewall, *Aabenna, Denmark.*

Right: Detail of Telewall.

Right: Profile bricks cut from wooden boxes, these ones were used for the Telewall.

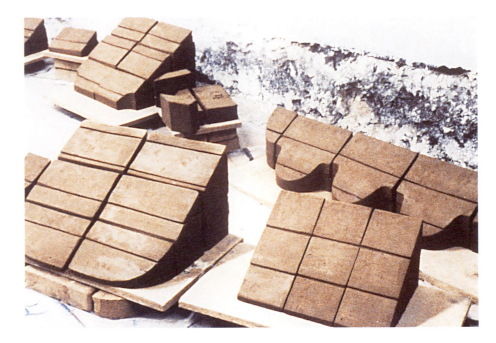

Below: Ulla Viotti cutting bricks in a wooden former. Photograph by Nick Hedges.

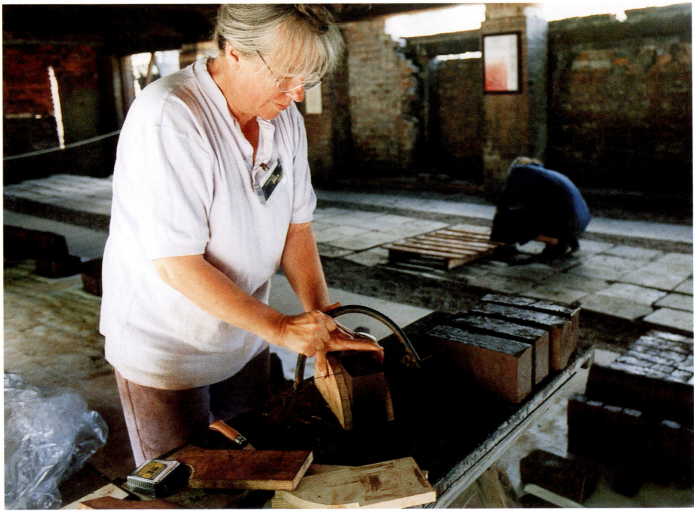

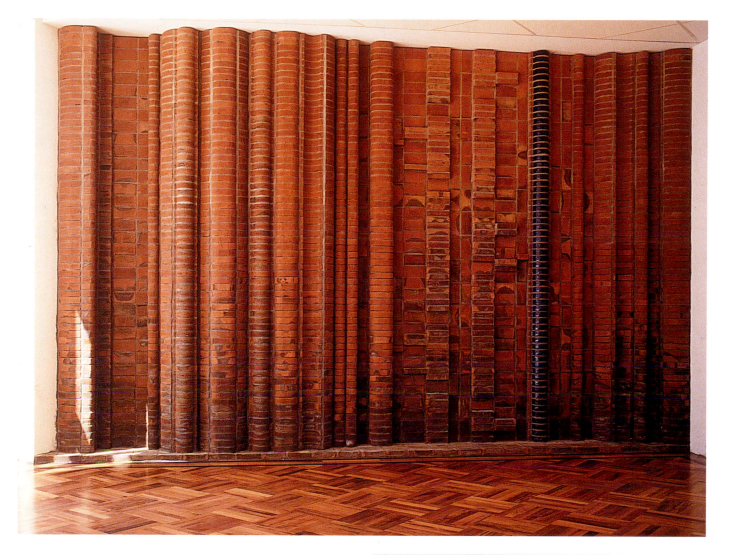

Malmo Energy Building

In 1991 the Swedish Energy Authority in Malmo commissioned Viotti to create a large wall in the office canteen. A number of smaller walls were created on different floors in front of the elevator. The vertical columns within the large wall refer to gas piping, which became part of Viotti's inspiration after a chance meeting with the engineer! This work was carried out at the Petersen factory using their coal-fired bricks.

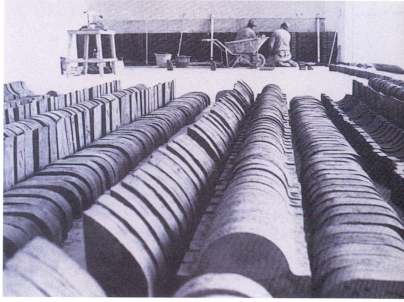

Above: The wall at the Malmo Energy Centre.

Right: Work being constructed for the Malmo Energy Centre.

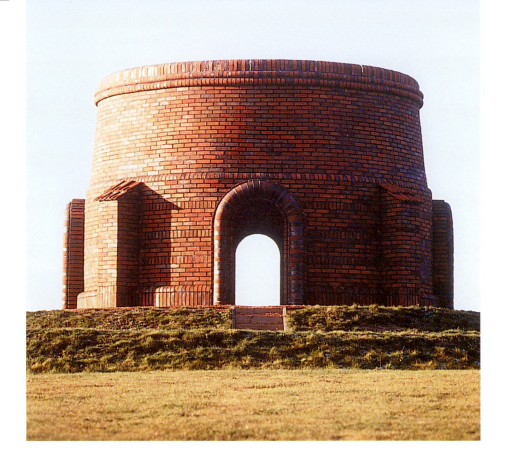

Cimbris. Brick and grass installation, 1997–98. Created in memory of the brick industry in Cimbrishham. Coal-fired at Petersen Tegel factory in Denmark. Created from their product Architect Klinker.

Cimbris

This work was created in 1997–98 at Cimbrishham, Denmark in memory of the brick industry there. It reflects Viotti's growing interest in the paradox between functional architecture and sculpture. *Cimbris* was created from brick and grass. It is a 'non' building with an entrance so small that only the smallest child can enter. The work is constructed from hand-cut profile bricks and extruded specials. The bricks are coal-fired at the Petersen factory and given the name 'Architect Klinker', because they are used by architects wanting a very special handmade appearance – the coal appears as blots and melted discolouration on the fired bricks.

Site-specific exhibition work and symposia

Exhibiting and building installations in the landscape is, for Ulla Viotti, essential to her intellectual development and enables her to experiment with ideas, free from the pressure of public commissions. Artworks generated at working symposia (such as *Gravefield*, made at Brickstein in Belgium, 1987, and *Viking Memorial*, made at the European Culture Capital Festival, Glasgow 1990) can also provide an opportunity to develop a new methodology or concept of great potential significance to the artist's future work. Often these ideas only come to fruition one or two years after the symposium has taken place, an essential growing period for reflection and development.

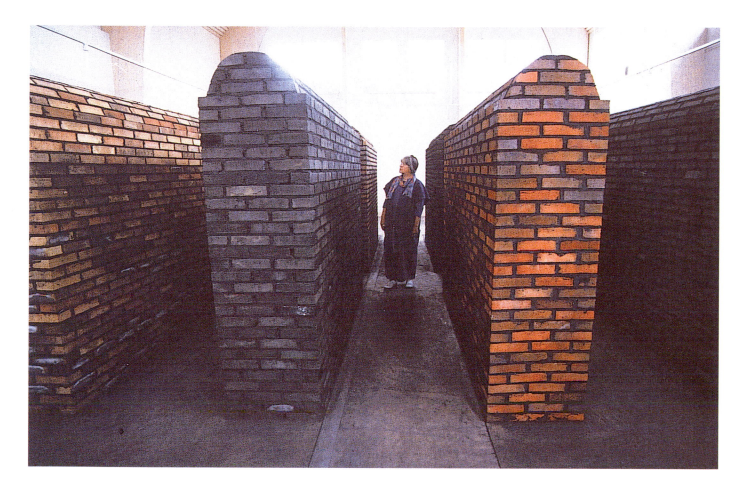

Ulla Viotti constructs books from bricks, as ancient Mesopotamians printed their writings into bricks. She sees them as memories of our time, brick novels in tune with the landscape.

A library is similar to a brick installation and a brick wall is like a symbolic library, the words and philosophies of life are deep inside, it is very spiritual. The paper book can burn down, but never the words.

She perceives both the book and the brick as potent symbols of our civilisation and our history and both are important elements within her personal visual language.

The cross-cultural brick, is interpreted as a world traveller through our cultural history, tracing our civilisation....
The brick is a common symbol, understood by many different cultures. You can communicate through bricks, they become literary words in a symbolic alphabet.

The Book as Architecture, *1997.*
Installation in Staffauslorps Art Gallery, 1997, in memory of the fire at Sarajevo and Linkoping Library.

Right: Gravefield *made during* Brickstein *a brick sculpture symposium in Korsritch (near Brugge) in 1987.*

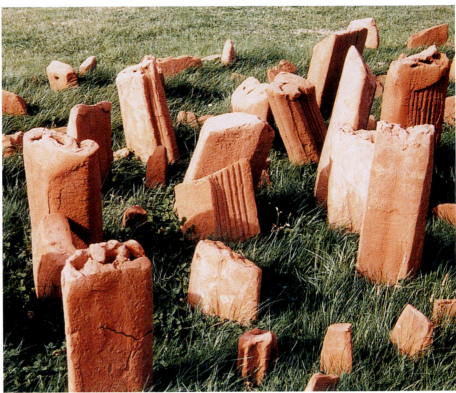

Below: Homage to King Bol. *A Bronze Age Hill where King Bol is buried. Seats 20 people. Viotti creates her own archeaology in the landscape. The work is constructed only with shale and sand.*

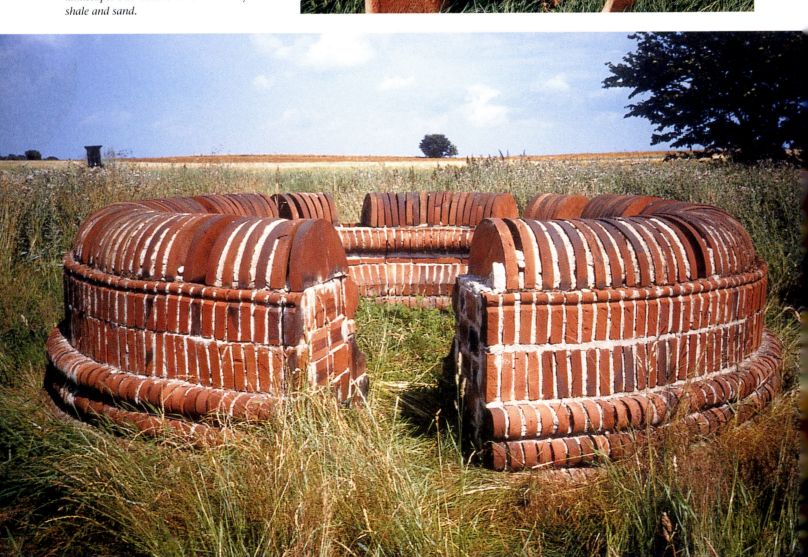

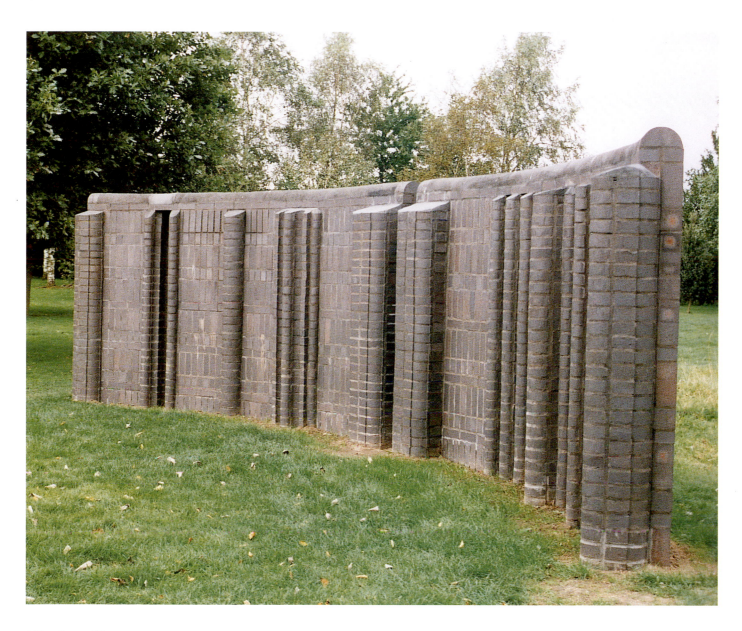

Black wall

This work was created for the Creating the Yellow Brick Road symposium, and was later permanently sited at the Rufford Country Park in Nottinghamshire, England. Viotti's choice of working site at the symposium reflected her interest in industrial archaeology, and provided her with the inspiration for a 2 m (6.6 ft) high wall constructed from a series of six different hand-cut profiled bricks from simple wooden formers. A narrow central opening in the wall was inspired by the end wall of the drying shed. The bricks used were Ibstock green bricks from the Ibstock, Atlas factory at Walsall. These fire to blue/black under reduction. The old drying shed became a small production unit and Viotti enlisted two of the students to work with her cutting and carrying the bricks.

Black Wall, *permanently sited at Rufford Centre for the Crafts, Nottinghamshire, England.*

Site-specific artworks using fired, reclaimed and salvaged bricks

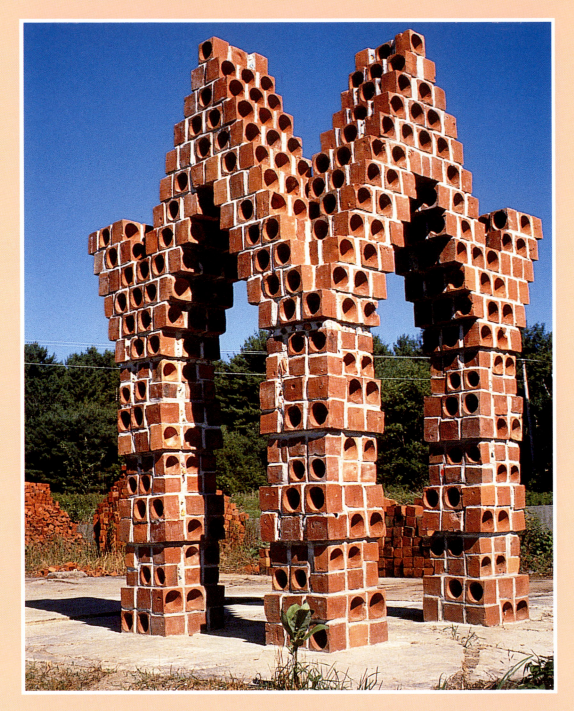

Shedway, by Robert Harrison, from assembled Watershed brickpots, Watershed Centre for the Ceramic Arts, North Edgecomb, Maine, 1989. Dimensions: 3.7 x 1.8 x 0.6 m (12 x 6 x 2 ft).

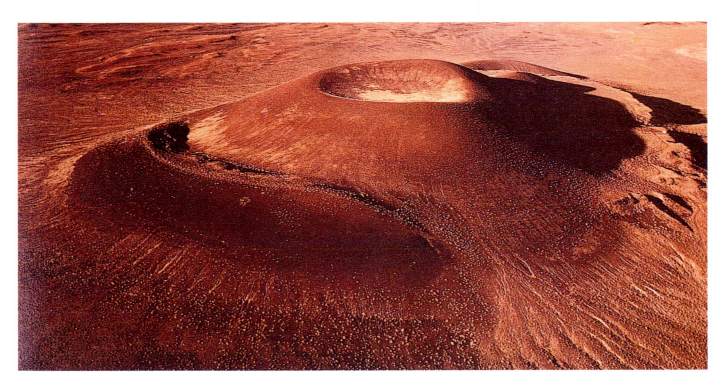

To create public artworks from ready-fired bricks requires very different techniques and machinery for the process of construction. This chapter looks at a number of practitioners who use newly fired bricks, especially selected for qualities of colour and vitrification, or bricks salvaged from derelict buildings, crumbling walls and riverbeds.

Robert Harrison (USA)

Robert Harrison is one of the foremost brick artists in the USA using brick extensively in his architectural, site-specific environmental works, which are sited across North America. He is the President of the board of directors of the Archie Bray Foundation and a former board member of The National Council on Education for the Ceramic Arts, (N.C.E.C.A.) and between 1985–87 was the assistant to the head of the Banff Centre (Alberta, Canada).

Harrison is drawn to spiritually resonant sites and his installation and site-specific works are influenced by the sacred spaces found in those great cathedrals, ruined Roman temples, Celtic megaliths and prehistoric

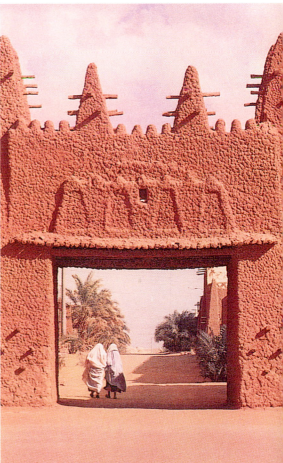

Above: Roden Crater Project (1972–present/ ongoing), Northern Arizona, by James Turrell (USA). A natural cinder volcano, James Turrell has been planning to turn the crater into a large-scale artwork that relates through the medium of light to the universe of the surrounding sky, land and culture.

Right: Monumental entrance to the town of Timimoun in the Algerian Sahara, dating from approx. 1930. Photograph by Bruno Francais, 1981.

burial mounds, encountered on his numerous visits to Europe. Gaudi has been a particular source of inspiration, as have ancient cultures and landscapes such as Mayan architecture in Central America, Ayers Rock in Australia and the Montana land-art of North American. He considers his installations to be sanctuaries, reliquaries of a private religion: 'when you enter them I want you to enter another dimension'. Natural influences such as the intensity of the sunlight often has a dramatic effect on his work.

The majority of Harrison's works are constructed on site using fired brick (some late Victorian ornamental brick), tile, adobe, stone, wood and as in *Potters Shrine* shards from pots discarded by his fellow ceramicists. He begins by making small-scale models in clay, to work out his ideas and prepares detailed drawings. Harrison finds the physical nature of the building process exhilarating and uses many of the tools of the masonry trade – trowels, pointing tools, hammers, chisels and spirit levels – to execute his work. He also uses standardised power and hand tools to fabricate different parts of the sculptures. He uses a fairly traditional mason's mortar recipe which produces a 'rich' mixture of 3½ parts masonry sand, 1 part Portland cement, 1 part hydrated lime. Depending on what kind of product he is mortaring together – flue, tile, clay, pipe – he may cut back on the lime producing a more 'sticky' mixture. To fill in an interior cavity of a mortared wall or column he will use a 'slurry' of sand and cement consisting of 5 parts sand aggregate to 1 part cement. Harrison thinks it is essential that the work is 'tied to the concrete foundation with steel reinforcing rods'. All his work has internal reinforcing with rebar rods, usually 9 mm or 13 mm (⅜ in. or ½ in.) in diameter. This unifies the work internally and strengthens the whole structure. For both interior and exterior artworks he also utilizes an industrial strength epoxy PC-7 to adhere brick, steel, ceramic tile, etc. *Odyssey Stack* is constructed from reclaimed brick which is 'tumbled' in large-scale ball mills to soften the edges and visually age

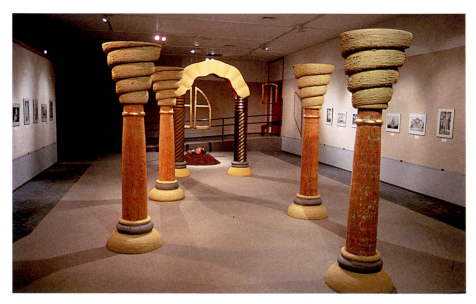

Art 'n Architecture, *site-specific architectural installation, turned wood, carved and surfaced styrofoam elements, powder-coated steel, cast ceramic elements, guilded window frames and lava rock, 15.2 x 7.3 x 3 m (50 x 24 x 10 ft). Holter Museum of Art, Helena, Montana.*
Photograph courtesy of Robert Harrison.

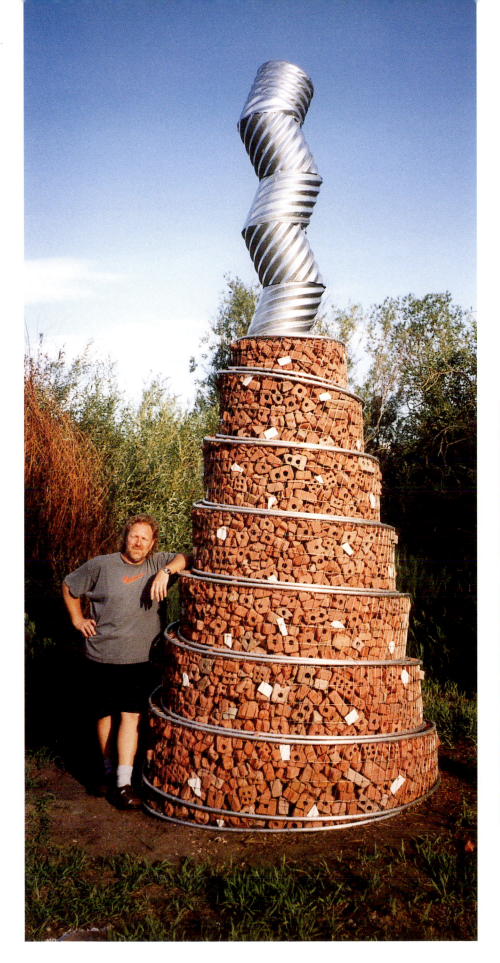

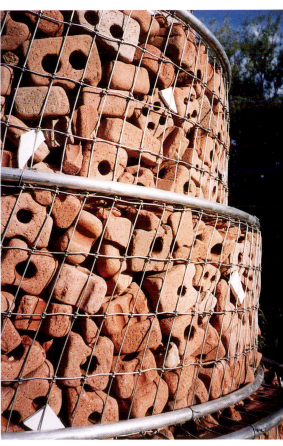

Above: Detail of Odyssey Stack *2001.*

Left: Odyssey Stack, *2001 is constructed from reclaimed brick which is 'tumbled' in large-scale ball mills to soften the edges and visually age the brick. Photographs courtesy of Robert Harrison.*

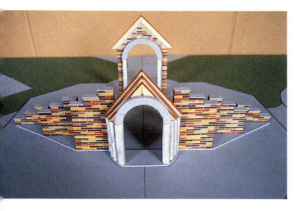

Above: Scale model of Gibson Gateway, *created by Robert Harrison.*

Below: Gibson Gateway *by Robert Harrison, in position.*

the brick. The brick is then stacked inside wire mesh and aluminium and copper tubing.

A major influence on his large-scale sculptural works has been the accessibility of facilities within those brick factories which have evolved into centres of artistic excellence: The Archie Bray Foundation, in Helena and the Bemis Centre for the Arts in Nebraska (formerly the Omaha Brickworks) are two. Gallery installations are another crucial aspect of Harrison's work, sustaining his artistic development. Within the gallery ambience he is able to control elements such as lighting and instil a sense of heightened drama and an almost magical and spiritual atmosphere. Many of these works are multimedia, constructed from brick, corrugated steel, adobe, wood, lava rock, gold leaf and other collected materials.

The *Gibson Gateway*, constructed from brick, mortar, concrete, steel, wood and ceramic, was made for the Paris Gibson Square Museum of Art, Great Falls, Montana in 1993, and has dimensions of 15 x 7.6 x 5.5 m (49 x 25 x 18 ft). The *Gibson Gateway* was constructed using scaffolding and wooden formers to create the archways.

The work for *Aurina* was carried out at the Archie Bray Foundation in Helena. Its foundations of concrete and metal bars are constructed

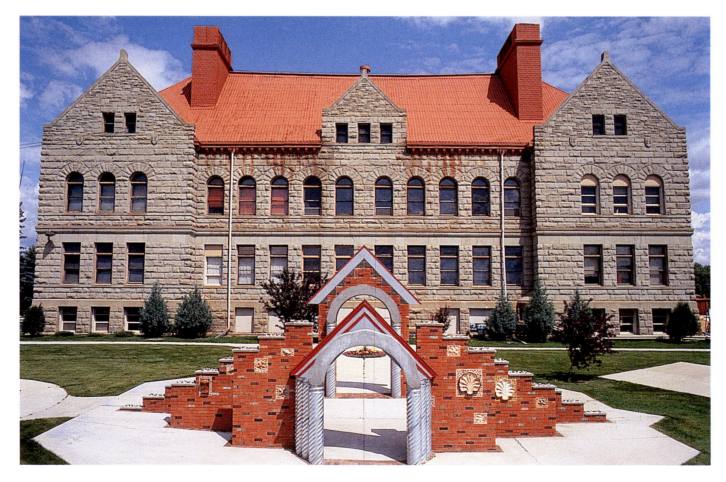

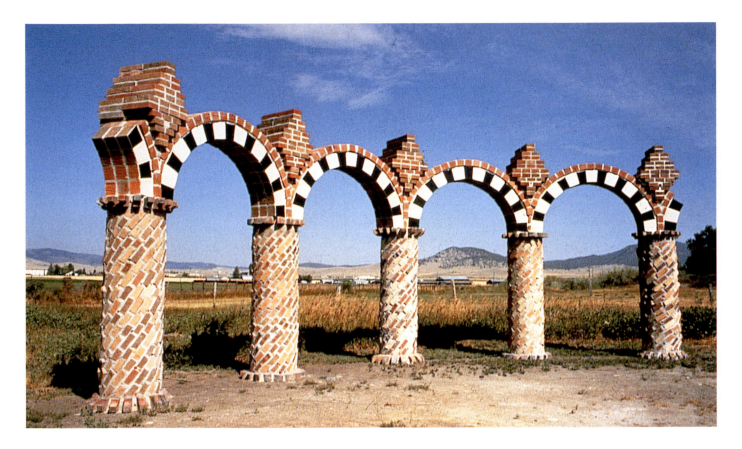

0.6 m (2 ft) deep. The columns are built of waxed cardboard sona tubes filled with concrete and scrap brick, covered with mortar, onto which were fixed rows of brick and tile. Some of the tiles used were actually over 100 years old.

Whilst resident at the Archie Bray Foundation in 1985, Harrison was inspired to create a permanent site-specific sculpture using bricks produced and reclaimed on the brickyard during its 100 year history, which became the *Potters' Shrine*. He built a roofless circular building 8 m (26 ft) in diameter and 4 m (13 ft) high with the brickwork echoing that of the original studio buildings. Its circular form and acoustical qualities are reminiscent of the brickyard's redundant beehive kilns, constructed before 1916. In the building of the structure Harrison became proficient in the art of bricklaying, so enabling him to construct walls and archways himself.

Potters' Shrine encloses a space both social and spiritual with architectural niches holding pottery and sculpture left by residents of the Foundation. Most prominent are a bust of Archie Bray Senior, sculpted by Rudy Autio in the 1950s, a figurative vessel by Akio Takamori and a changing assortment of pitchers, platters, vases and figures left by the many visiting artists to the foundation. It is a monument that offers each new resident a place to contribute a piece of their own work in one of its empty niches.

Aruina, *Archie Bray Foundation, 1988. Constructed of brick, and tiles (some 100 years old). Ht: 3.7 m (12 ft), l. 9.1 m (30 ft).*

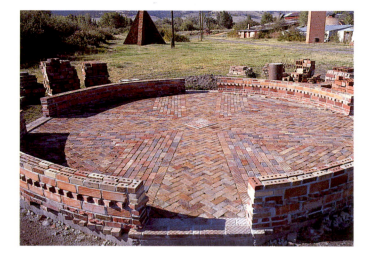

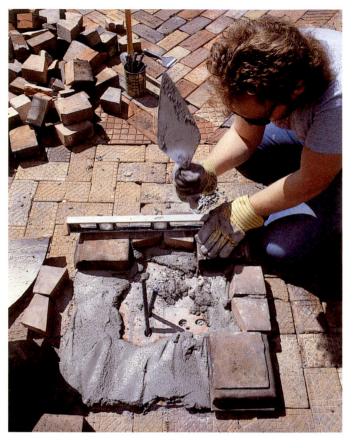

Above: Preparation of floor of shrine, laid on top of foundations.

Right: Using spirit level and trowel to cement bricks together and begin the central column.

Below: The Potters' Shrine, *by Robert Harrison.*

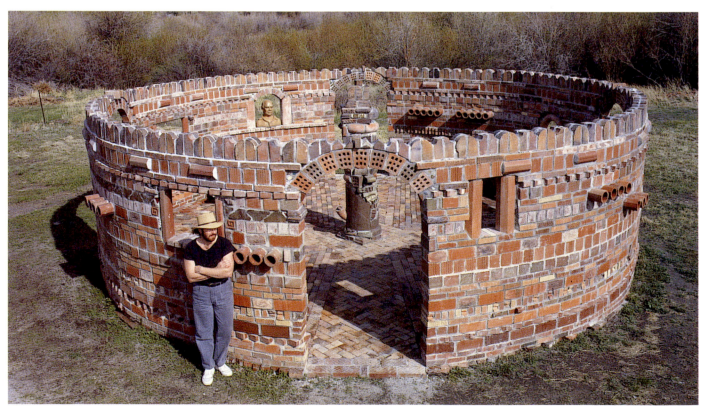

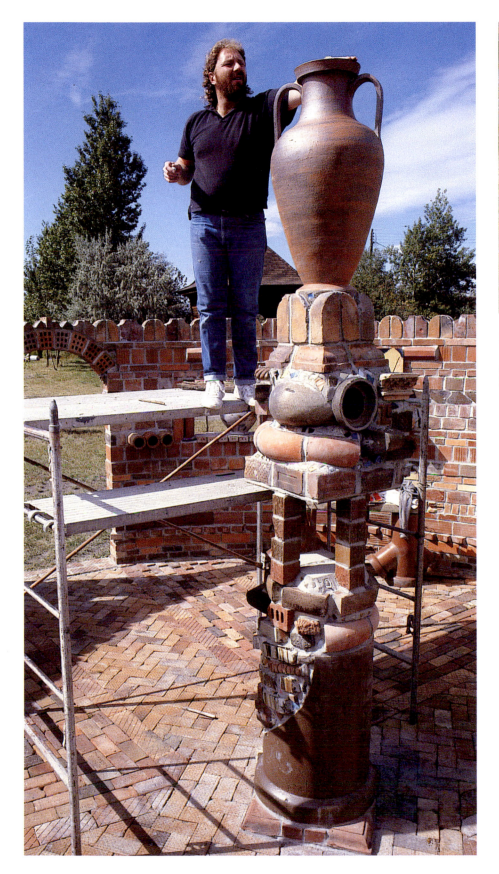

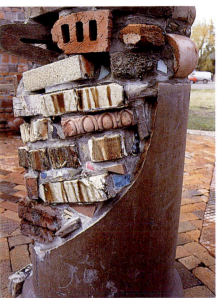

Left: Constructing the central column.

Above: Detail of the central column in the Potters' Shrine.

Michael Morgan (USA)

Morgan is an American who studied Ceramics at the University of Wolverhampton in the UK, where his interest in brick was fuelled by the then head of department, Jeff Salter. He was fascinated by the industrial wasteland which for him epitomised that period in his life and it has remained an important influence on his work after returning to the USA in 1992. Morgan's primary materials are rejected fired bricks and green brick which he hand carves. He uses photography as a vital element of his thought process, recording and documenting urban wastelands. One theme that runs through all his work is the representation of brick both as geometric 'brick' and amorphous 'clay'. The work attempts to reconcile the idea of function and accessibility with a playful exuberence, which is the essence of his work.

Keraunos Wall, created in 1994 consists of an organic 'S' shape brick wall laid and constructed in a series of spirals, featuring pilasters and planters. It relates to the archaic Greek spiral symbol, that mythically connects the earth to the sky. Morgan employed a mason and encouraged

Keraunos Wall, *dimensions: 2.5 x 7 x 1 m (8.2 x 23 x 3.3 ft).*

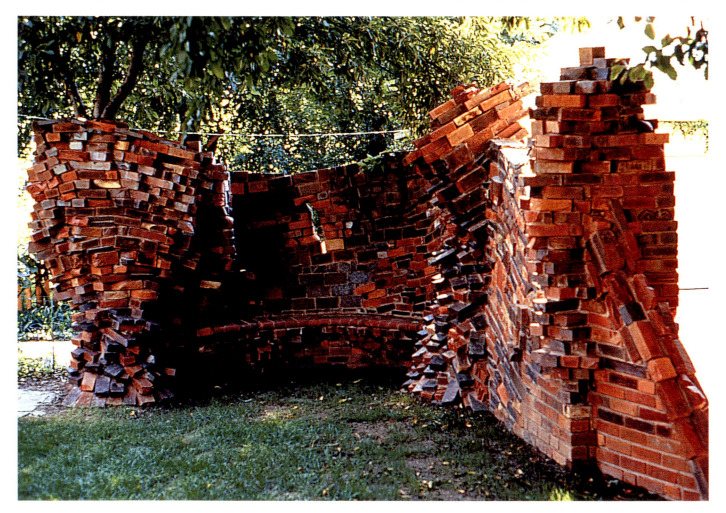

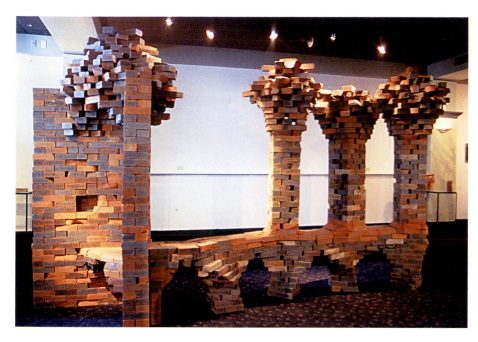

Left: Keraunous *seating area.*

Below: Cer, *(1996). Sited at Community Park in Lincoln. The design consists of seating for 5–10 pillars with planters on top set in an undulating wall that also acts as the back of the seats. The site of the sculpture is a 15 m (49 ft) semicircle.*

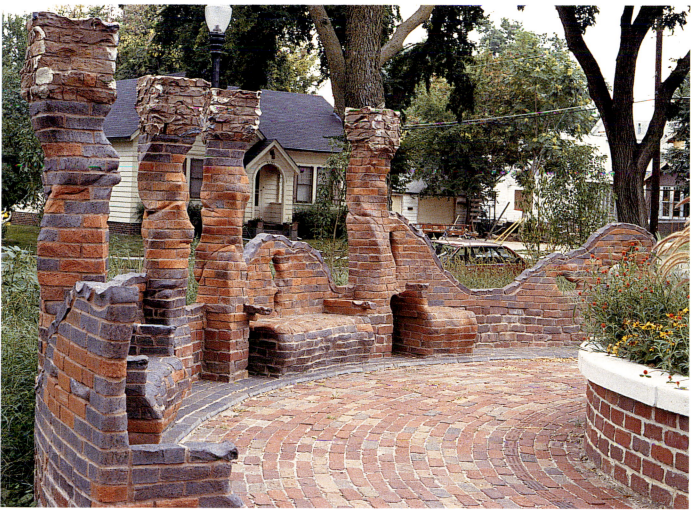

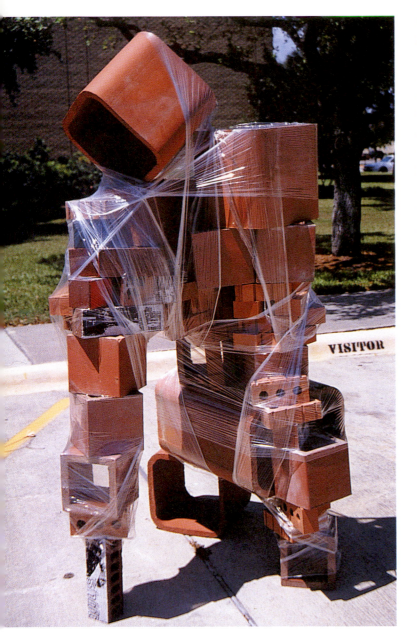

Visitor by Fred Spaulding.

Opposite: UTPA Arch by Fred Spaulding,
from glazed brick, flu liners and shrink wrap.
Dimensions: 244 x 61 x 305 cm
(96 x 24 x 120 in.).

him to dispose of his spirit level and lay bricks in wavy lines, in order to create spiral effects with the organic qualities he required. An unpredictable result was created through the use of a variety of bricks sizes, intermittently introducing a solitary brick at an odd angle. Morgan himself learnt the art of bricklaying from a mason, and will often not use the expertise of experienced craftspeople in the building process as he enjoys having a greater control over the final outcome. He usually digs and pours the concrete foundations himself. Construction tools include chisels, trowels, cement mixers, lifting equipment and spirit levels. On smaller works Morgan prefers (somewhat unusually) to assemble the artwork in his studio and transport mortared sections of the finished work to the construction site.

Tide Clock was created in 1999, using brick, brass and glass for the New Smyrna Beach (Florida, USA). Its dimensions are 2.3 x 0.46 x 0.46 m (7.5 x 1.5 x 1.5 ft). The four sections were completed at the studio and then taken to the site where they were assembled, rather than the whole structure being built on site. The first section was set in place using chain fall and straps; and the other three sections put in place and filled with non-shrink grout.

Fred Spaulding (USA)

Fred Spaulding currently teaches at Turrent County College, Northwest Texas, after gaining a BA from California State University in 1990. He is attracted to the physical process of working with clay and creates temporary installations using commercially manufactured bricks from a variety of clay bodies, which he combines with plastic shrink-wrap, and printed imagery. His imagery, printed onto the brick, explores his concerns with contemporary culture – a glimpse of a billboard before it is cut off by a passing truck, the curve of a highway overpass, the flicker of a television commercial. He is inspired to collect, explore, and combine fragments of experience and captures them in clay. He sees brick as a hard structural building material, yet with a great fluidity of form. The brick is a ceramic object with all the durability associated with artefacts, buildings and monuments thousands of years old – yet its forms can be rendered temporary through demolition and reconstruction.

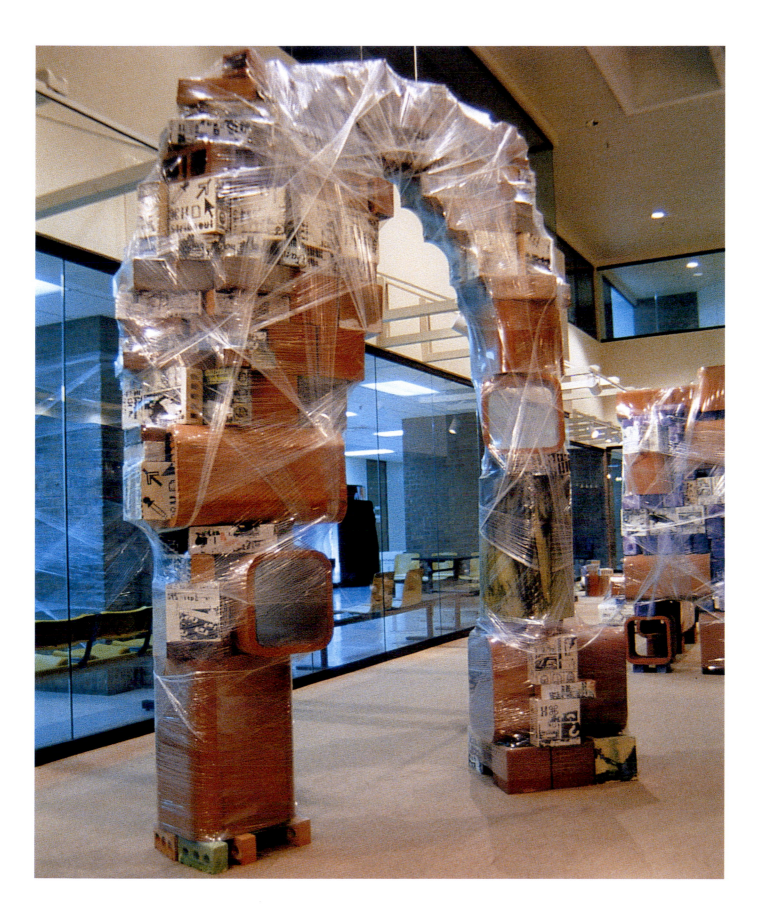

Brit Dyrnes *(Norway)*

Brit Dyrnes became interested in working with brick in the 1970s after a student project in Brattsberg Tegl, Telemark, Norway, one of the few remaining brick factories in the country. The majority of her works experiment with the visual and aesthetic qualities of bricks as a sculptural medium in the public domain. She uses a variety of bricks for her works, many recycled from old buildings and industrial sites. She also uses handmade soft mud bricks from Belgium, which have been thrown by hand into metal or wooden boxes in the factory giving them an individual appearance. These are then coal-fired to vitrification at about 1160°C (2120°F).

Dyrnes is particularly interested in creating monumental and smaller scale works, which articulate the colour and picture forming qualities inherent in the glazing and compositional qualities of brick. They are often interpreted as expansive mosaic surfaces. She uses bright slips and glazes which are painted onto the surface of the bricks using wide painter's brushes. The glaze she uses is a transparent glaze with metal oxides – iron, cobalt, copper or antimony – added in various quantities depending on depth of colour required. Some bricks are glazed thickly, others thinly to allow the colour of the bricks themselves to shine through. Glaze is applied to the bricks after firing with a brush or spray

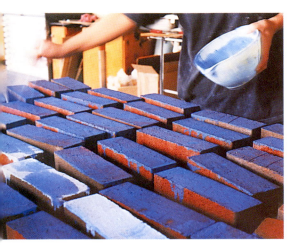

Above: Brit Dyrnes glazing bricks.

Below: Glazed bricks being wheeled into kiln.

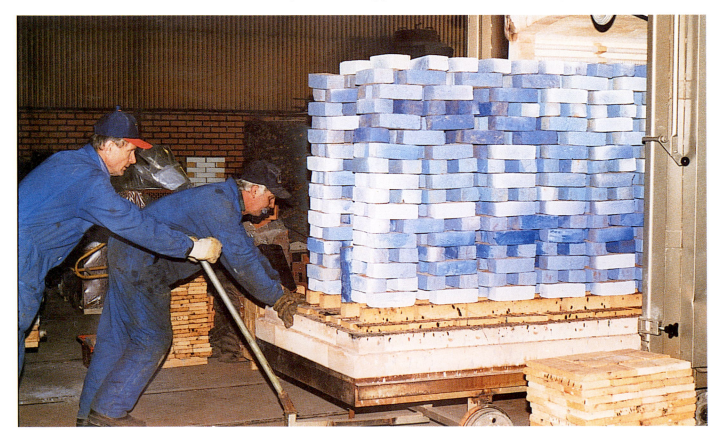

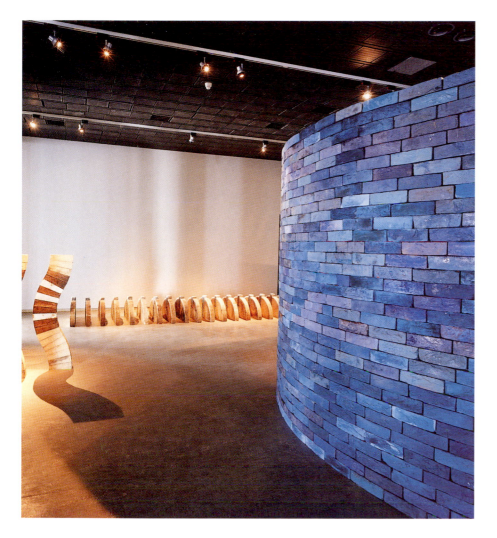

Left: Blue Cylinder, *1999, exhibition, Kundtindustrimuseum, Trondheim, Norway. Photograph by Roar Ohlander.*

gun and fired to 1100°C (2012°F). She often uses glaze supplied by the factory. Depending on the amount she needs to fire, Dyrnes uses either her own kiln or the factory kiln to glaze the bricks.

She works on site-specific commissions, working collaboratively with a multidisciplinary team consisting of a landscape architect, architect, bricklayer and artist. As a craftsperson she identifies with the term 'use-related' and many works have a clear utility aspect. Many of her works however are purely object-orientated installations appearing as pure form in the landscape.

Blue Cylinder, measuring 4 x 2.30 m (13 x 7.5 ft) was created in 1999, for an exhibition in Kundtindustrimuseum, Trondheim, Norway. Dyrnes had ready-made convex bricks from Belgium, transported to the Tegelbolaget brick factory in Ostersund, Sweden, to be glazed with cobalt blue and copper glaze and fired to 1100°C (2012°F). The factory no longer produces brick but it continues to glaze bricks for architects, and has the capacity to glaze 11,000 bricks per kiln. *Blue Cylinder* is about inner and outer space and about stacking components to make an abstract whole.

Coal-fired bricks with slips.

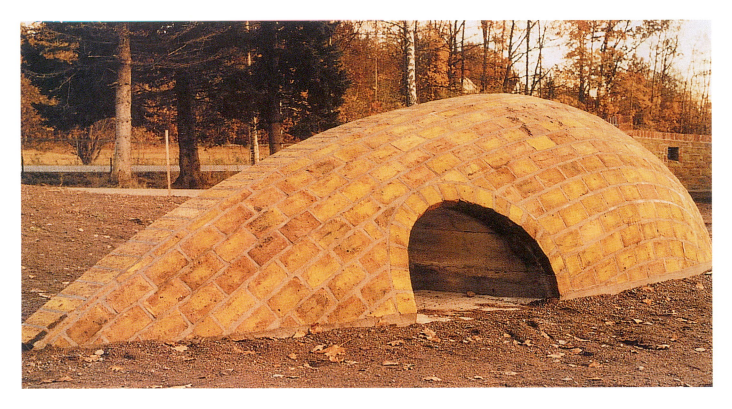

Ant Hill, *Vear School Stokke Kommune.*
Dimensions: 7.33 x 2.8 x 1.25 m (24 x
9.2 x 4 ft).
Photograph by Guri Sandvik, 1998.

Below: Kube, 2000, by Brit Dyrnes, yellow
glazed bricks.

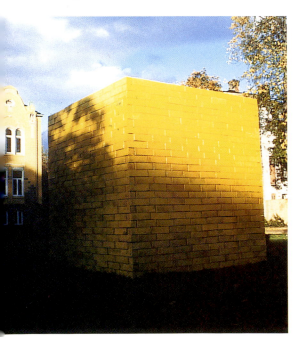

Ant Hill was created in 1998, for the Vear School Stokke Kommune in Norway and is a play sculpture. In 1990 the minister for culture put forward a directive that children's school environments and visual surroundings needed to be investigated. Dyrnes worked with the Centre for Norwegian Children's Research and with the school pupils and teachers. Perceiving the school as a meeting place she created structures that invite touch and interaction, playing with the hard material by building the bricks over curved formers to turn them into soft shapes. The bricks are unglazed from the Belgium brick factory.

Jacques Kaufmann (France)

Jacques Kaufmann is currently head of Ceramics at the Applied Arts School in Vevey, Switzerland.

He claims that brick is a cross-cultural world-wide material, and he uses it extensively in his conceptual landscape and gallery installations. His works could be described as architectural sculpture. As Kaufmann expresses it:

It is the function that makes the difference, architecture has a realistic function, sculpture is purely symbolic. The role of the sculptor is not in a realistic functional realm but in the imaginary.

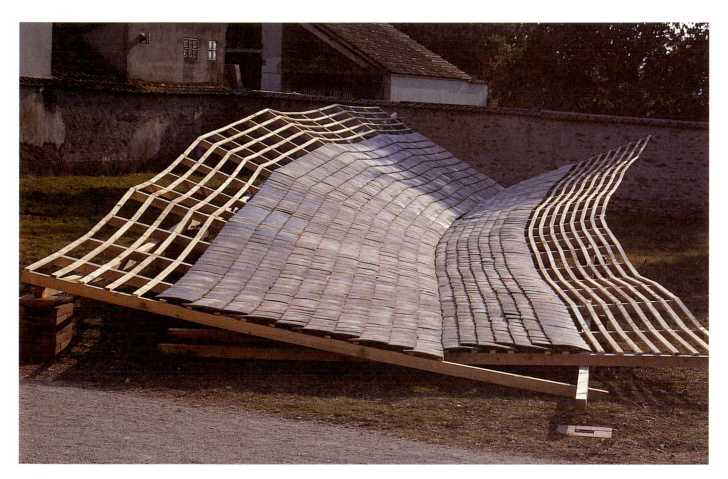

Above: Membrane, *Pontiguy, 1995. Skin of tiles over wooden structure, recalling traditional roof tiles.*

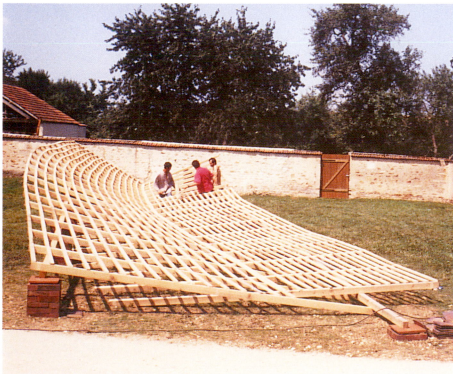

Left: Membrane, *constructing the supporting structure before the tiles are laid on.*

Kaufmann's first inspirational contact with the brick came when visiting the clamp kilns of Rwanda (see pp.29–30) in 1994–96. Here the vision of such enormous kilns encompassing the landscape confronted him with a scale never before encountered. The symbolic associations and inherent energy evidenced in this sight made brick a compelling material in Kaufmann's own work, previously studio ceramics. Brick, with its historic associations has become a vital component of his personal, creative vocabulary allowing him to create on a scale comparable with architecture, and enabling him to confront the manner in which the material occupies space.

Visually the brick can allow us to change our perception of an object, giving a sense of solidity when mortared and fragility when simply placed together. As a building block – an elementary particle – it becomes a metaphor for alienation, protection, strength and fragility.

Une Forme de L'infini, Exterieur, *Geneva 1994. Kaufmann allows the brick to escape from its form ressembling an undulating path. The form is an expression of infinity inside and waves outside.*

Kaufmann is also influenced by the American minimalists and by Merleau Ponti who put forward the idea that the artwork adopts its status as an object through the spectator's thoughts and visions. A spectator can bring many interpretations to the work, one may interpret it as

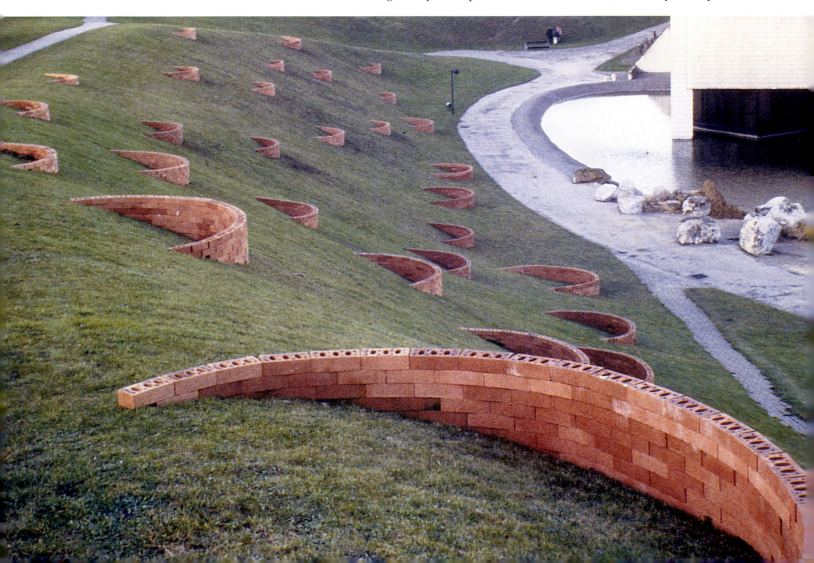

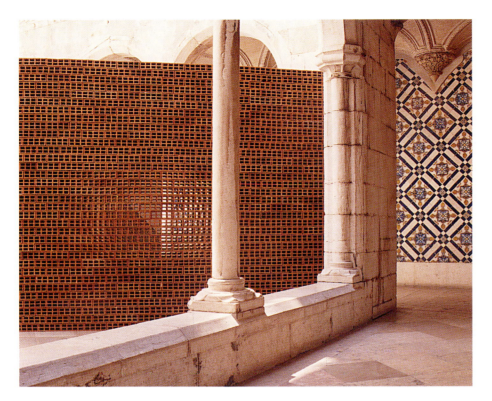

Left: Installation inside the Musèe Azulejos, Lisbon, 1998.

Below: Vagues, Une Forme de L'infini *by Jaques Kaufmann, installation in situ, Dunkerque, 1996.*

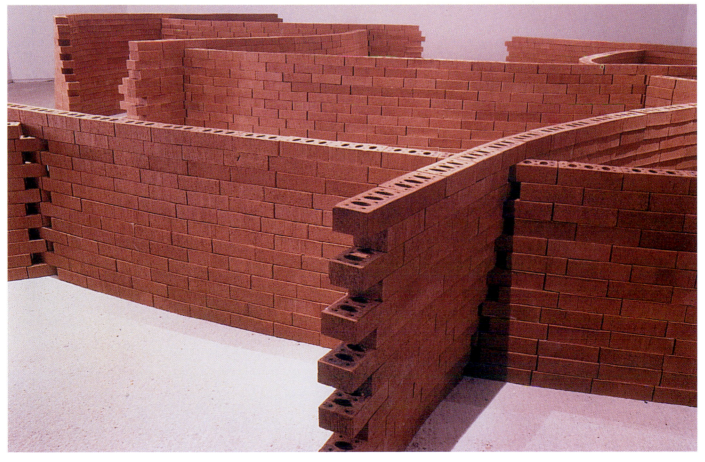

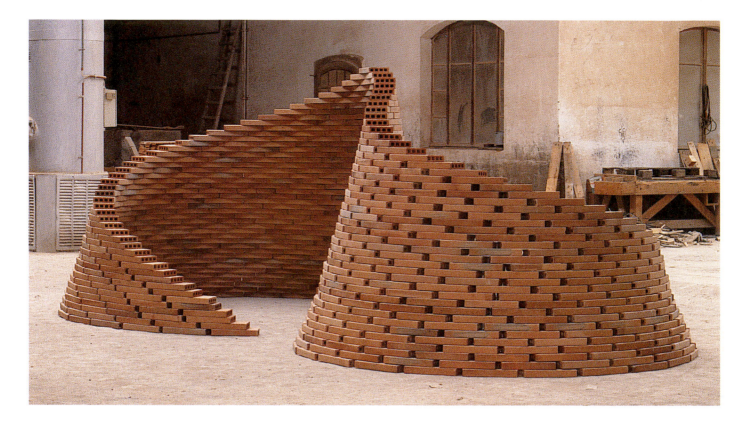

Une Forme de L'infini, *Geneva 1994*.

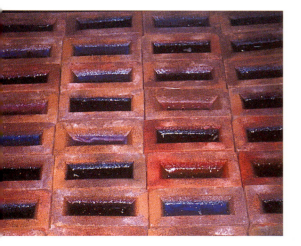

Jelly Floor *(detail), Blist Hill, 4 m x 2.5 m (13 x 8.2 ft). Light begins to reflect upon the jelly bricks.* Photograph by Nick Hedges.

an obstacle, another as a sanctuary or means of protection. 'Wall objects' can be perceived in several ways in Kaufmann's visual language – entire forms, as forms which visually explore texture and physical touch, and as forms created through manipulating the material's opaque and transparent qualities. He achieves this through using light continental bricks which consist mainly of holes, or heavy vitrified bricks mortared or glued together with an epoxy resin.

Kaufmann describes the brick as a fragment of a construction process which enables him to investigate space with a heavy material. The final form is the result of many combined factors. He does not follow any preconceived plan exploring intuitive notions through the process of doing. He feels that, 'one of the potentially expressive characteristics of clay is its ability to accept gesture, the direct imprint of energy. What remains is evidence of the encounter'.

Jelly Floor was made at the 1999 Creating the Yellow Brick Road symposium. Kaufmann's inspiration came from light shining through one of the windows of the brickworks at Blist Hill projecting onto pools of water collected on the old brick floor, reflecting depth and creating illusion. The atmosphere in the old brickworks, with its austere roof and dark space, resembled a cathedral built in honour of the Industrial Revolution. Kaufmann's idea was to bring light into the building as a homage to the men who had worked in these difficult conditions. His association, furthermore, of England as a 'land of humour and a

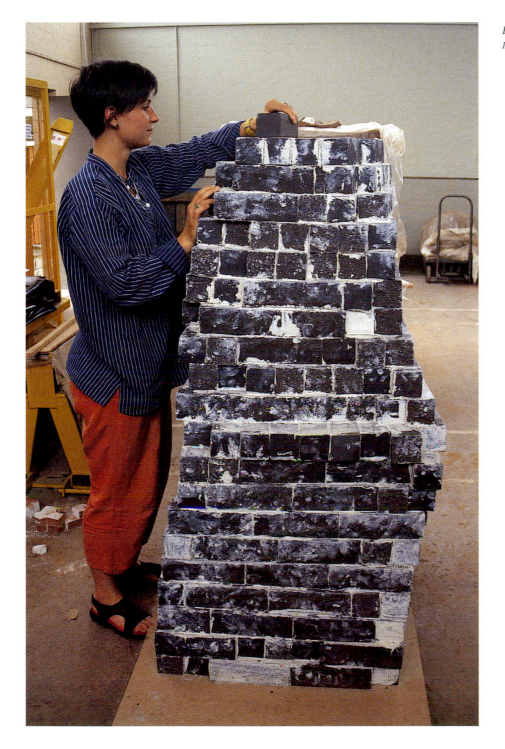

Bonding together bricks with epoxy resin. Photograph by Nick Hedges.

particular English food; jelly' allowed the mixing of two unrelated materials – brick and jelly. The work was constructed on the floor of the building using fired bricks from Blockleys Brick. Jelly dyed various shades of red and blue was poured into the indent of the brick and set, so it would reflect the light and create an illusion of depth as though looking into a deep pool reflecting the blood and tears spilt here.

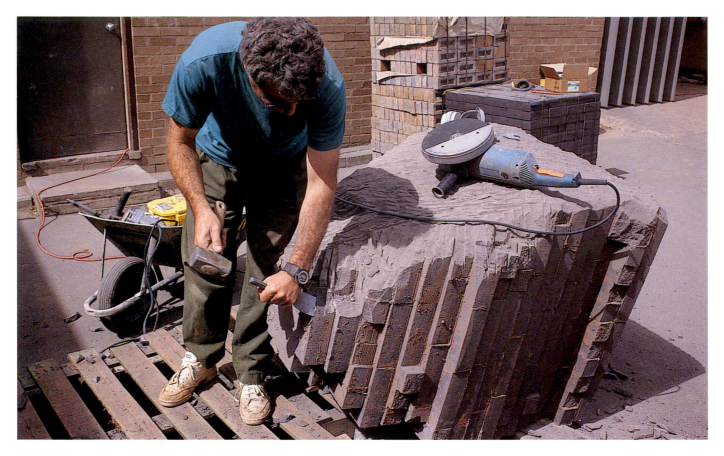

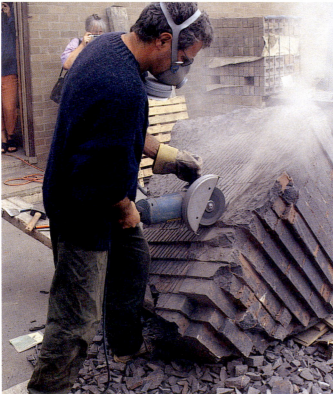

Above: Working on bricks with a hammer and chisel. Photograph by Nick Hedges.

Left: Working on epoxied bricks with a cutting machine. Photograph by Nick Hedges.

Using fired brick from the Blockleys factory, Kaufmann bonded together two cubes, each one tonne in weight and hollow in the middle to create *Black Water Block*. One cube was made from a hard black brick with a white epoxy resin, the other a brown flecked brick with a red epoxy resin. Each brick was bonded together in brick bonded layers with epoxy resin from Structural Adhesives to form a cube about 1 m (10.75 ft). He used an instant setting adhesive. When the epoxy was set the structures were worked with grinding machines and heavy-duty cutters. The grinding away of the surface transformed the hard brick material – creating a changing vista depending on the viewing angle – sometimes the surface seems to vibrate strangely in the light, as though turned into rippling, moving water.

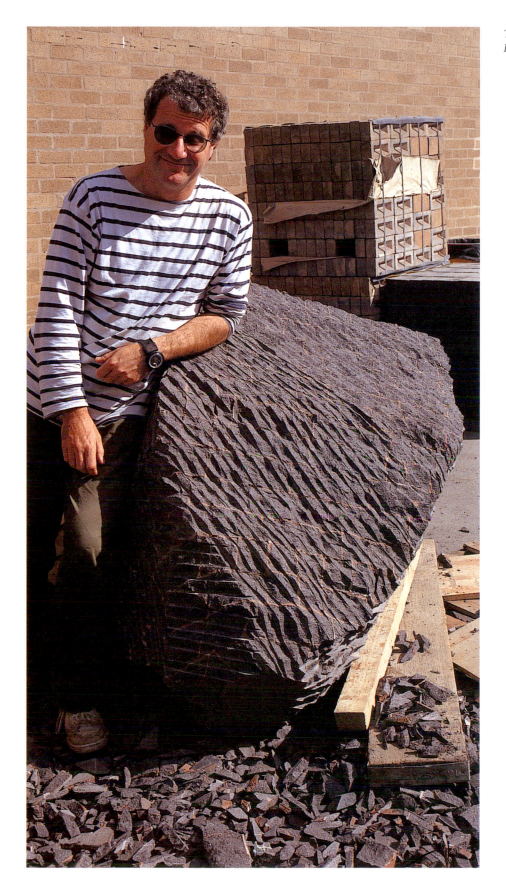

The finished block, Black Water *by Jaques Kaufmann.*

Couple *by Klaus Schultze, Beer Sheva, Israel 1995.*

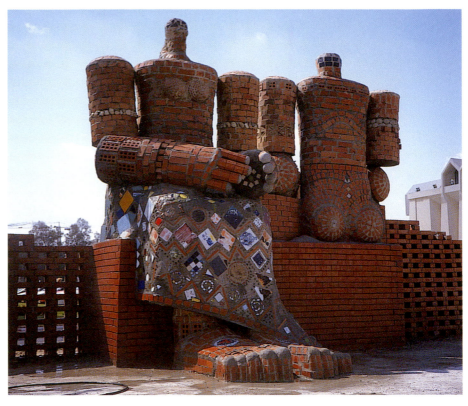

Klause Shultze (Germany)

Shultze discovered brick architecture in 1969 when visiting the Tuscan city of Sienna. Here he realised the potential of the brick module, seeing the possibilities of releasing brick from its usual geometric limits and opening up its sculptural possibilities. His work aims to recreate the elementary, primordial and naive simplicity found in the sculpture of ancient cultures, particularly those of Egypt, Crete and Samara – mythical gods and goddesses with disproportionately large heads and widespread arms. He is also inspired by 20th-century artists such as Picasso, Leger and Chilida; a strain of humour and illusion suffuses his work.

He uses French bricks combined with different clays – the bricks have carbon mixed in with the brick clay during the brick-making process. As carbon is a self-igniting fuel it burns away during the firing, resulting in a light brick with an irregular appearance. The bricks, together with individual sections of reclaimed and recycled bricks, often found washed up on the shores of lakes or salvaged from derelict building sites are glazed with a variety of coloured glazes and turned into mosaic, so forming an integral part of Shultze's sculptural composition. Shultze works on permanent site-specific environmental sculpture. His work is constructed on site using concrete foundations and concrete inner structures over which the outer skin of brick mosaics are built and mortared together. The mortar often incorporates small stones and pieces of broken objects.

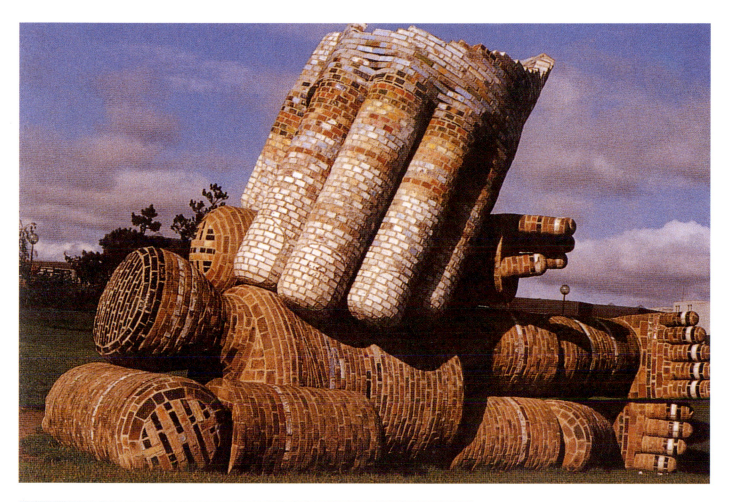

Above: The Divine Hand *by Klaus Schultze, St Quentin en Yuelines, France, 1975. Partially glazed, dimensions: 720 x 550 x 210 cm (283 ½ x 216 ½ x 83 in.).*

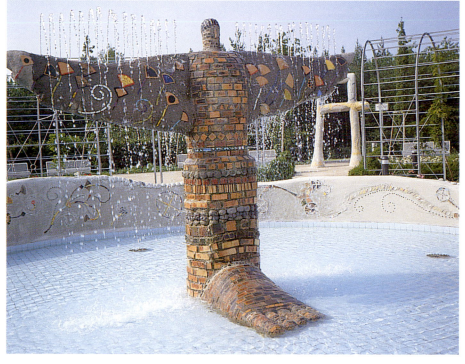

Left: Klinikum Nimnery *by Klaus Schultze, 1993–94.*

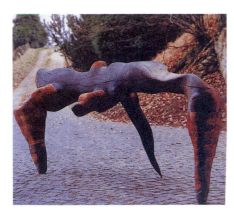

Untitled *by Franz Stähler, brick and wood, dimensions: 2.65 x 0.7 x 1 m (8.7 x 2.3 x 3.3 ft).*

Untitled *by Franz Stähler.*

Franz Stähler (Germany)

Franz Stähler creates architectural and environmental works from bog oak, a black stone known as Diabas and reclaimed brick salvaged from abandoned farms and houses. He chooses these materials because of their connection to load-bearing building components such as wooden buttresses. In many of his sculptures the oak contains and enfolds the brick. His work refers back to architectural movements such as the Gothic, Art Nouveau, and Expressionism, with an underlying theme being the strong links with the earth and with nature. The 'spirit of the place' is important to him, as is the inspirational landscape of his native Westerwald, eroded and scarred with clay pits. He uses brick to contribute to a new ceramic language.

He combines his materials using adhesives and abrasives. Reclaimed brick is cut into thin sections with a brick saw and fused with epoxy resin into a conglomeration of separate components. The resulting forms are combined with other materials such as wood and stone and transformed into integrated pieces through polishing and glossing. His work has been described by the historian and art critic Enzo Biffi Gentili as timeless fossils, as though the product of an ancient process of natural forces, eroded by winds, smoothed by waters, heated by the sun, frozen by many winters.

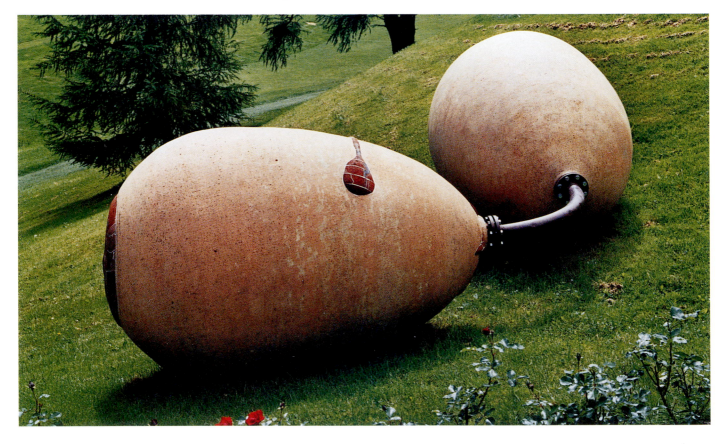

Bas-relief murals and surface decoration

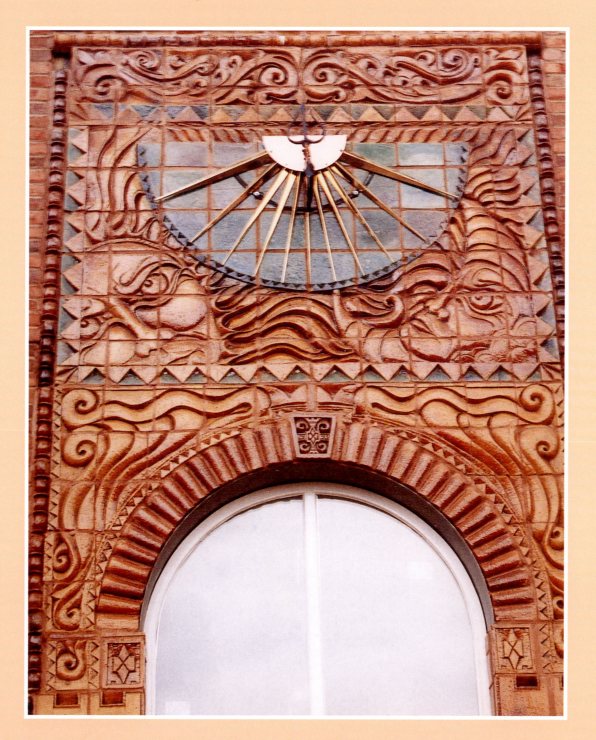

Eleanor Wheeler's sundial for sheltered housing, Wadam Street, Ryhope, Sunderland, 1993.

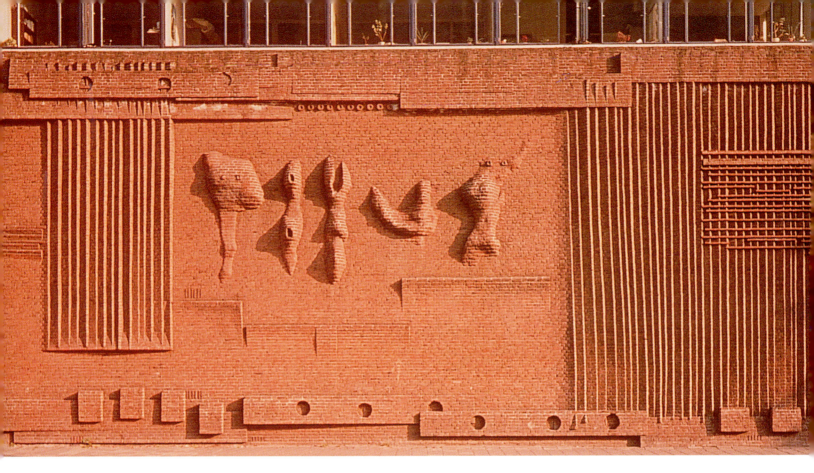

Above: Henry Moore, wall relief, Bouwcentrum building, Rotterdam, 1955. Photograph courtesy of the Henry Moore Foundation.

Below: Henry Moore, detail of wall relief, Bouwcentrum building, Rotterdam, 1955. Photograph courtesy of the Henry Moore Foundation.

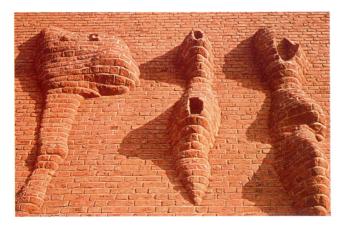

There are many ways to decorate bricks, including carving directly into them, manipulating the surface of green or fired brick, press-moulding the brick clay to produce decorative panels, or decorating the brick with slips and glazes. Bas-relief – sculpture in low relief – is the term given to brick with some element of raised decoration on its surface, and in brick-making it is one of the most important means of creating decoration. This chapter will look at various methods of creating bas-relief, and at the work of certain brick artists who employ such methods in their work.

In 1955 Henry Moore was commissioned to create a sculpted brick wall for the façade of the Bouwcentrum building in Rotterdam. He was inspired by the traditional ornamental brickwork, which characterised much of early Dutch Architecture. In 1963 the Swedish sculptor Eric Hogland created the sculpted brick walls in the interior of the church in Linkoping, Sweden, depicting the twelve apostles. This was some of the earliest carved integrated brickwork by a contemporary artist in Scandinavia and was inspired by the Gothic and Medieval cathedrals of the region.

Recently there has been a heightened awareness amongst architects and clients alike of the need to decorate buildings. In the UK, with the current policy of '1% for art' and lottery funding for prestigious new buildings, many contemporary practitioners have been commissioned to create carved decorative brick panels for the sides of buildings. Historically bas-relief has been a medium through which artists have been able to

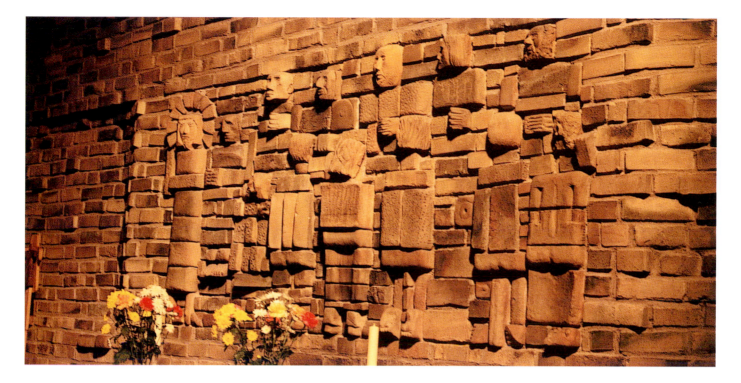

integrate their work into the fabric of a building often enabling them to convey important symbolic messages with contemporary social and political associations. In England, artists using bas relief tend to follow a long-standing historic tradition.

Scandinavian artists Ulla Viotti and Lillemore Peterson have explored the potential for the contemporary integration of brick into buildings. Both of these artists work in a very experimental way – manipulating the brick using a variety of tools and instruments – very different to the traditional and exceptionally skilled carving methods of UK artists such as Christine Ward, Eric Kennington and Jeff Salter.

Usually architects will approach a brick company with an idea for a carved brick panel. The factory will then contact an appropriate artist. Commissions tend to fall into two categories: either an artist is commissioned to create a totally unique work, or to reproduce a work designed by the architect. Of course some artists may successfully approach the architect or developer first with an appropriate design.

There are a number of methods used to create bas-relief:

1. Carving directly or manipulating the green brick in the factory.

2. Modelling the panel, from which the plaster moulds are then made. The relief is hand-pressed into the moulds, using soft reconstituted brick or architectural clay body.

3. Carving the ready-fired and mortared wall directly (either in the artist's own studio, or on to the side of an already constructed building).

From The Thirteen Apostles *by Eric Hogland, Linkoping Church, Sweden.*

Carved and manipulated bas-relief using green unfired brick

Jeff Salter (UK)

In Britain a number of companies work with contemporary artists to produce decorative panels made using green brick. One such artist is Jeff Salter, a British freelance artist who works on decorative panels incorporated into new or existing buildings. Companies contact him when approached by architects who require specialist carving or relief work. He works in the 'specials' department of Ibstock Brick, Cannock and Blockley's Brick, Telford. Salter constructs a wooden easel on which he places green blocks ready for carving. The easel needs to slope backwards slightly, so that the bricks are stable and do not fall forwards. Original freehand drawings are copied using a pointed instrument (a pencil is sufficient) onto the green brick panel. Drawing and photography are an essential part of Salters creative process, for his commission at Branhams Pottery this involved careful documentation of the machinery and the workers. The placing of the joints is taken into account: a joint, for instance, would not run through an eye, and the drawing will be adapted to allow for this. He uses blocks measuring 42 x 42 x 42 cm (16.5 x 16.5 x 118 in.) and they can be as large as 75 x 75 x 45 cm (29½ x 29½ x 17¾ in.) if need be. He uses a variety of sharp loop and modelling tools to carve the relief, which at some point may be as deep as 12.5 cm (5 in.) Salter uses a variety of methods, building onto the panel with soft clay if he needs to add on small sections, or adding on with brick block which is cut and then hammered on with a rubber mallet.

Jeff Salter's initial drawings from which he works.

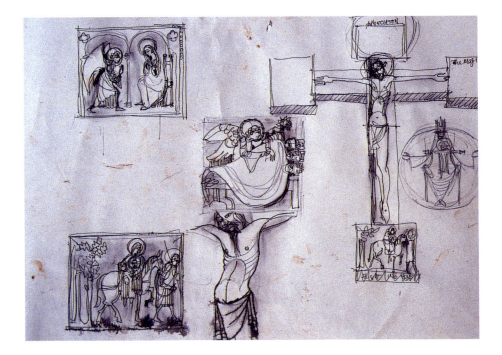

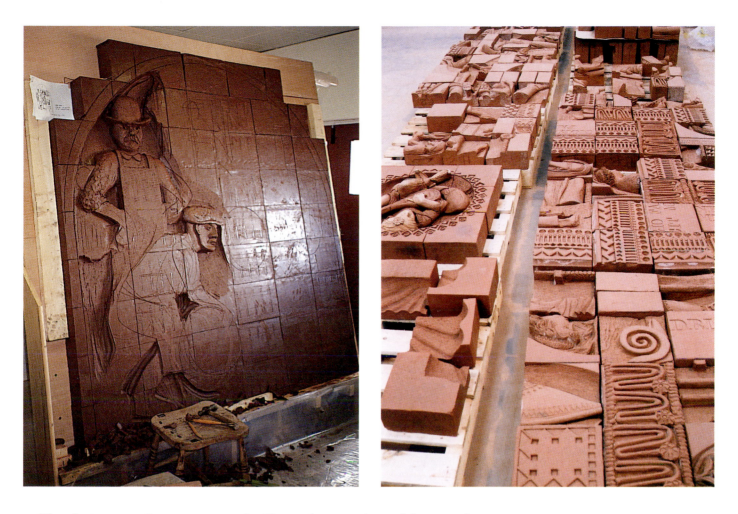

The factory environment can facilitate the creation of large-scale works where crucial equipment is available, such as forklift trucks to lift tonnes of bricks. Specialist knowledge can also be sought from a small number of men who have acquired skills passed down over decades.

Salter points out that there are many problems inherent in the construction of decorative panels in buildings, for example, it is necessary to leave a space in the finished brickwork for the carved panel to slot into. This often raises problems: a circular brick panel can become oval or too small if the bricks overfire or encounter drying problems and the bricklayers are unable to fit them successfully into the required space. It is also possible that the bricks at the bottom of a sloping easel can become compressed during the carving process. This problem can be rectified by dividing the panel into two and placing each half on a separate easel to be carved separately. When the two sections are carved, it will be necessary to take two layers of brick from each section at the point where they should meet, these will be put back together and remodelled so that the carving flows.

When constructing on site 3 mm (⅛ in.) joints are laid using epoxy resins. The panel or frieze is built starting at the bottom and working

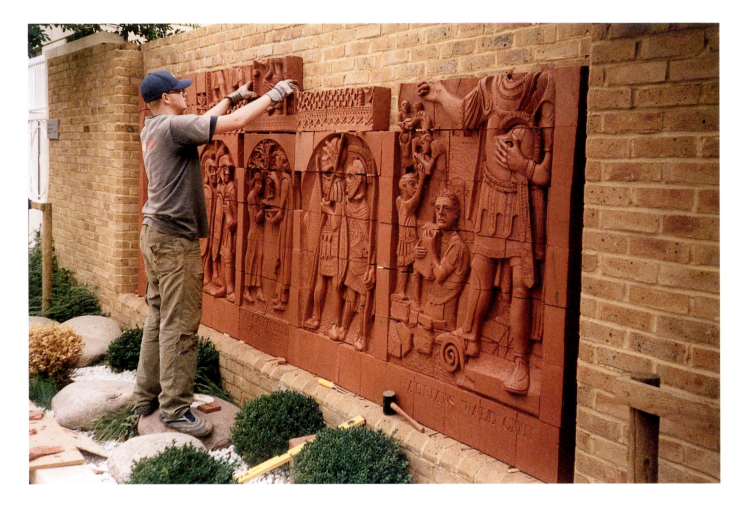

One of Jeff Salter's murals being installed.

upwards. Ideally a brick frieze should be built as the building is erected to ensure a successful fit. The reality, however, often falls short of ideal. Salter admits that much of his work is 'last minute badges on buildings, architectural afterthoughts and sops to planning authorities. Rarely has it been an integral feature of collaboration, rather than infills and add-ons. Architecture rather than sculpture is often regarded as "High Art" – sculpture on a monumental scale.'

Ulla Viotti (Sweden)

In 1983 Ulla Viotti completed the installation *Tingsfrid* for the Nykoping Courthouse in Sweden. The walls are constructed from handmade bricks which, whilst soft, were thrown onto the floor and then attacked with instruments such as large files and heavy hammers. The results were then fired, before being constructed into walls in the hallway of the courthouse. The walls reflect the ancient history of the town with its references to the historic province of Sodermanland and the brick walls of the old fortress of Nykopinghus. Symbolic rows of flints and bricks are carved with messages for peace. Inset bricks form associations with archaeological finds, stone axes, Viking shields and law books.

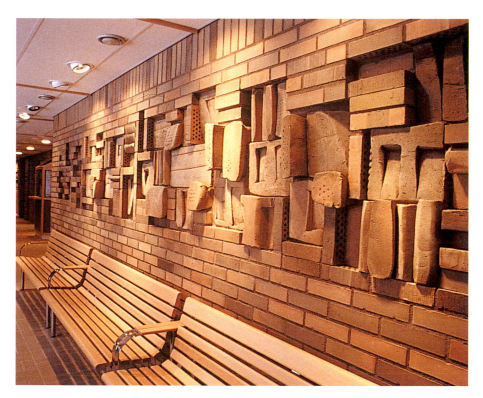

Tingsfrid, *wall panel by Ulla Viotti, Nykoping Courthouse, Sweden, 1983.*

Below, left: Ulla Viotti, work under construction set out on the floor to decide upon initial design.

Below, right: Ulla Viotti, installing mural in Nykoping Courthouse, Sweden.

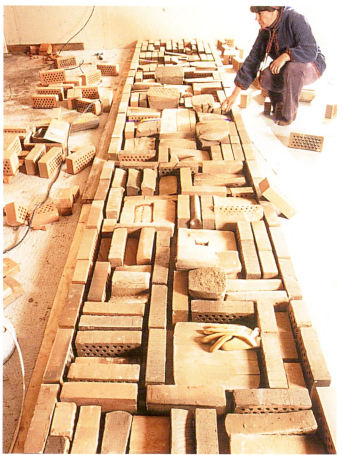

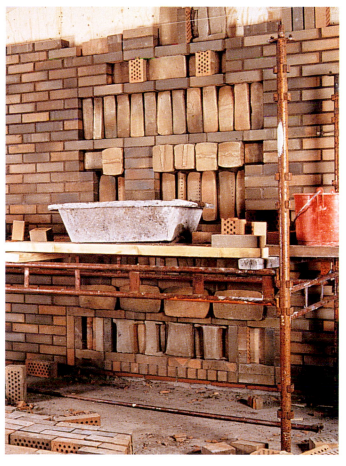

Hand-pressed bas-relief

David Mackie (UK)

David Mackie is a Cardiff-based freelance artist who works with companies such as Ibstock Hathernware producing glazed and terracotta brick decorative panels for site-specific environmental projects. Mackie hand-models his relief work from which he produces plaster moulds. Hathernware provides the architectural brick clay to hand-press into the moulds and have collaborated on a number of commissions, in some instances developing the work to Mackie's designs. His site-specific public commissions are inspired by themes of identity and place. The decorative panels at Bute Town Garden, Cardiff were designed during community workshops, and the drawings subsequently modelled three-dimensionally back in his workshop. Mackie also works from green brick and tile to produce mosaic flooring and reliefs. He has the green brick delivered to his studio where it is cut to his design. Larger commissions will be returned to the factory for firing and smaller commissions fired in his own electric kiln.

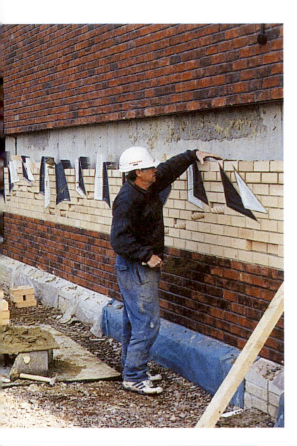

Left: Installing Sails *by David Mackie, 1999. Glazed panel, Adventurers Quay, Cardiff. Made in conjunction with Ibstock Hathernware.*

Below: Finished mural of Sails *by David Mackie.*

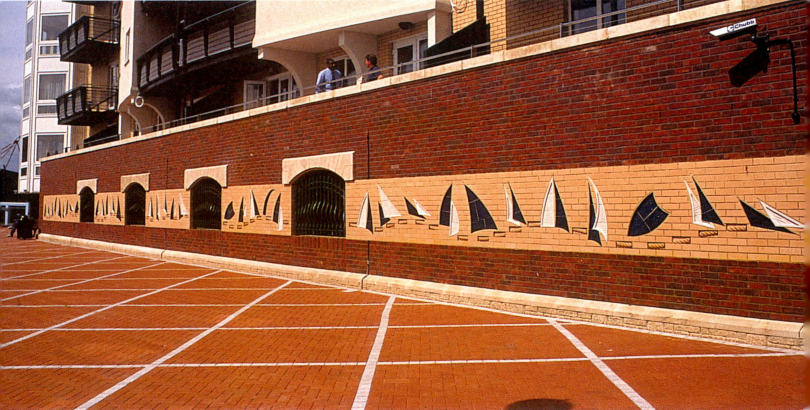

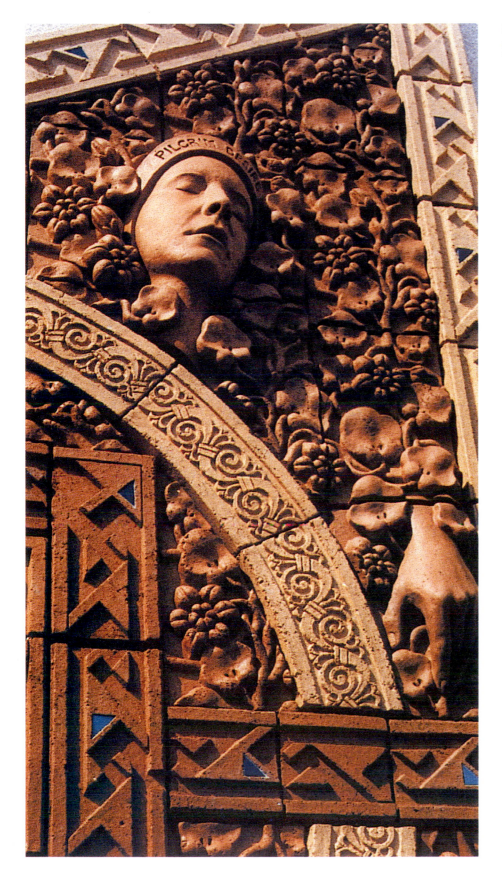

Finger Maze *by David Mackie. Terracotta and carved brick relief, Blaina, Gwent, South Wales, 1992.*

Bas-relief murals carved from fired brick panels

Walter Richie (UK)

Many sculptors prefer to use direct carving techniques on a fine quality hard solid brick, a technique akin to stone carving. The late Walter Richie, one of the UK's most renowned brick sculptors, was one such. His frieze *The Creation* for the Bristol Eye hospital comprises five carved brick panels at pavement level, each measuring 4 m high (13.3 ft) and 7.5 m (25 ft) long. The panels explore the theme of creation and are carved from Ibstock Red Rustic brick fired to 1140°C (2084°F). The bricks were transported to the artist's studio in Kenilworth. Here he had special wooden panels on which he supported the brick panels which were permanently mortared together prior to carving. All joints were laid flush with a high bond mortar of 1 part cement, ¼ part lime and 3 parts sand. Richie developed a technique using gentle and careful pulverisation and abrasion with the aid of sharp flat chisels, fine picks, files and rasps to carve the brick which is rendered brittle and liable to fracture if struck with force. An illusion of depth can be created by carving only 25 mm (1 in.) into the brick. Each frieze was transported to site at convenient

Walter Richie, The Creation, *Bristol Eye Hospital, finished wall with panels in situ. Photograph courtesy of B.D.A. (Brick Development Association), Great Britain.*

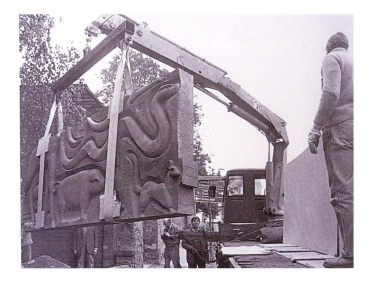

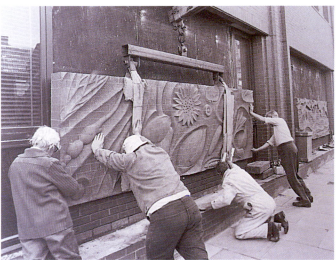

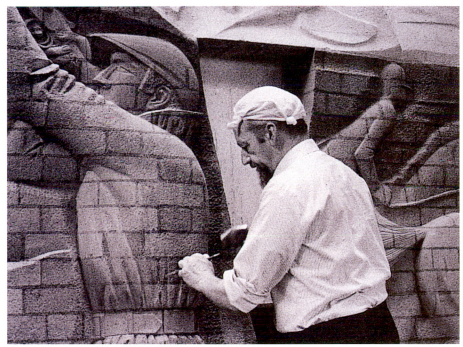

Above, left: Walter Richie's panels being transported from the studio to the hospital.

Above, right: Work being lifted into place at the Bristol Eye Hospital.

Left: Walter Richie at work on panels outside his studio, at Sport on The Ridings.
Photographs courtesy of B.D.A. (Brick Development Association), Great Britain.

.

stages for the building contractors. To facilitate transport, panels were laid with weak mortar joints at course levels. This enabled the frieze to be dismantled into smaller sections if need be without affecting the structure of the whole. Holes were drilled through joints when the carving was completed to enable straps to be inserted allowing the panels to be lifted into place.

Katherine Lane (USA)

American artist Katherine Lane employed a technique derived from studying ancient Chinese tomb sculptures of the Han period to create the frieze on the biological laboratory building of Harvard University, USA.

Lane works directly on the brick wall of the building with the aid of scaffolding. She first produced maquettes one third the size of the final works. Stencil enlargements were then made and the designs were traced with chalk directly onto the building walls. Electric pneumatic tools were used for carving techniques and the depth of each cut was checked against the plaster model maquette. Mistakes were rectified by replacing bricks and re-carving.

Decorating brick with slips and glazes

A number of contemporary artists use glaze and slips, engobes or terra sigillata to decorate the surface of their brick artworks. A brick clay such as the Etruria Marl from Dennis Ruabon will take glaze very successfully, but other brick clays may be much more difficult to glaze. Many artists use the stains and colours already available within the factory and it is always a good idea to talk this through with the technical manager of the

The Circle, Bermondsey, London. Housing development architects CZWG (Cambell, Zogolovitch, Wilkinson & Gough). Photograph courtesy of B.D.A. (Brick Development Association).

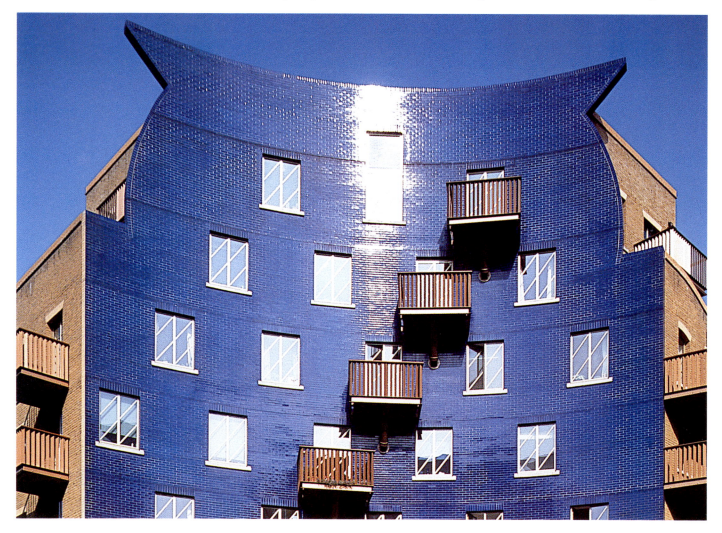

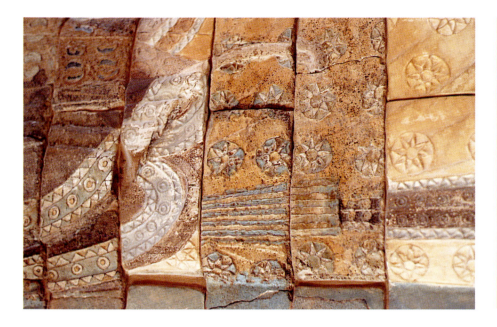

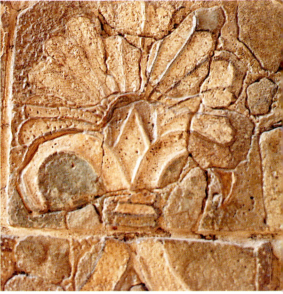

works. In this section I have listed some of the recipes which artists developed or altered for use and have found successful. Scandinavian artists Ulla Viotti and Brit Dyrnes work with the brick industry to develop predominantly cobalt blue glazes for their brick sculptures. German artist Klausze Shultze works with a variety of slips and glazes which he uses on the surface of his reclaimed brick sculptures. In Europe, centres of excellence such as Tommerup in Denmark and Struktuur 68 in Holland, have a particular interest in developing the technology to produce a range of glazes for architectural use. This has lead to a major revival in the use of glaze on large-scale artworks within the environment.

The earliest known glazed bricks were the Babylonian brick friezes, which had a vitreous coating of an antimony-based lead glaze (antimony was used to opacify the glaze). The glaze was applied after the first firing. The moulded relief formed a series of enclosures in which the glaze could pool and prevent the mixture of colours. Oxides such as cobalt and copper were added to the glaze. The brick was then fired to a high temperature, the brick having the same shrinkage as the glaze to prevent crazing of the surface.

Two manufacturers in Britain leading the development of glazed brick for architectural use are Shaws of Darwen and Hathernwares of Leicester. British artist David Mackie has worked extensively with Hathernware to produce a range of glazes for his relief panels. Pauline Monkcom has worked with black manganese brick floor tiles from Dennis Ruabon to create glazed flooring. Before glazing the tiles Monkcom sandblasts them, then glazes them with a reduced copper silver lustre glaze. After the glaze has been fired on the surface, they are then sandblasted again to create paler grey lines. British artist Claudia Clare and Swedish artist Gunilla Bandolin use slips and engobes

Above, left and right: Detail of the Syrian brick wall shown in the Louvre, Paris.

Below: Ibstock brick clay with terra sigillata fired on Staffordshire Blue Brindle and Staffordshire Blue. Samples by Ruth Gibson.

Right: Claudia Clare decorating brickwork panel with coloured slips. Slips consist of: 50 China clay, 50 ball clay with additions of oxides and body stains.

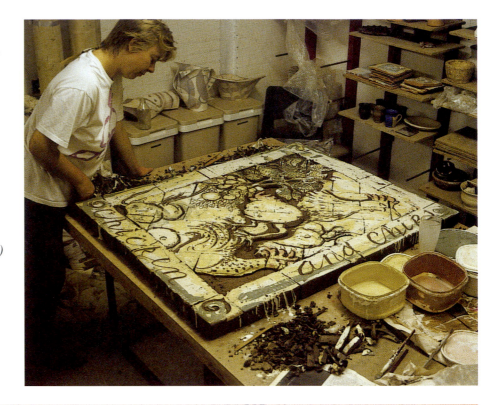

Fossil Fern glaze recipe

(In-glaze lustre using Potterycraft frit)

Borax frit P2955	33
Borax frit P2953	33
High Alkaline frit P2962	33
Copper carbonate	2
Tin oxide	4

Below: Fossil Fern *by Pauline Monkcom.*

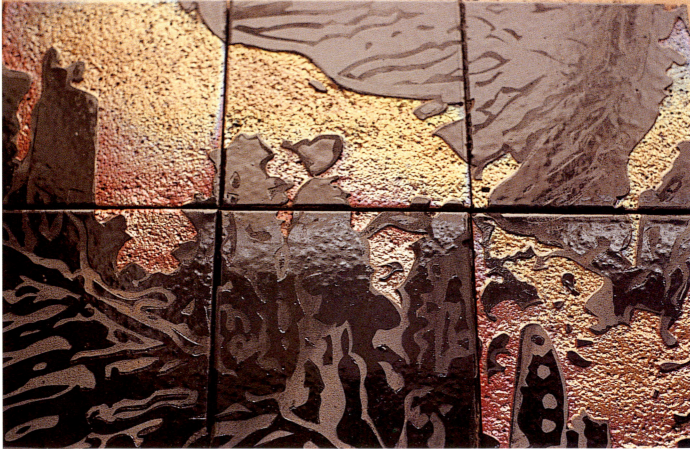

painted onto the brick panels/ sculptures with large brushes, when the brick is leatherhard. Glaze can be applied to the bricks raw (before firing) or after the bricks are fired, and then re-fired.

Glazing and printing bricks

American artist Fred Spaulding uses coloured glazes to print imagery onto bricks. He glazes two sides of the brick with a background of white majolica. Photographs are then scanned into the computer and adjusted for high contrast. The images are then printed out onto clear plastic transparency film, which is used to burn an image onto an 86 mesh silk screen. A commercial low-fire black glaze is used to print onto the brick. Initially this glaze will be too thick to go through the 86 screen so it is pushed through a 200 mesh screen to make it finer. The glaze is then transferred onto the brick using the 86 mesh. Overglazes are also used to add colour.

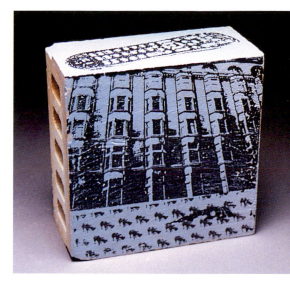

Above: Remote – Fac *by Fred Spaulding, glazed brick, 10 x 10 x 20 cm (4 x 4 x 8 in.).*

Majolica glaze (Fred Spaulding)

(Fires at cone 04, 05, 06/1020°C /1868°F.)

Ferro Frit 3124	60
Gerstley Borate	5
Custer Feldspar	8
Nepheline Syenite	6
EPK	10
Zircopax	17
Bentonite	1

Below: Bloom *by Fred Spaulding, glazed brick, 10 x 31 x 10 cm (4 x 12 x 4 in.).*

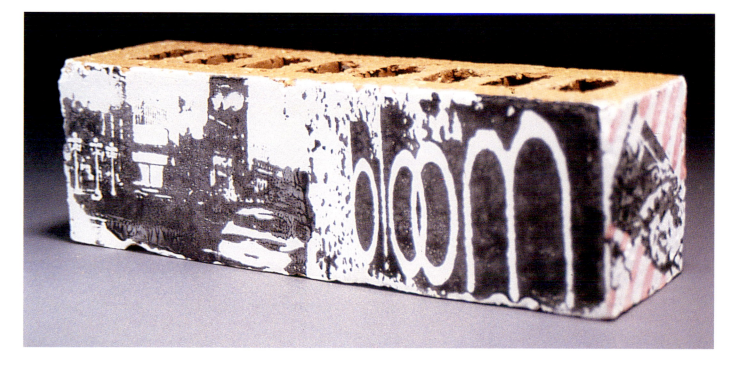

Right: Confluence *by Caroline Court, beads of glaze, Welcome Centre, Harper's Ferry National Historic Park, West Virginia, USA, 1999.*

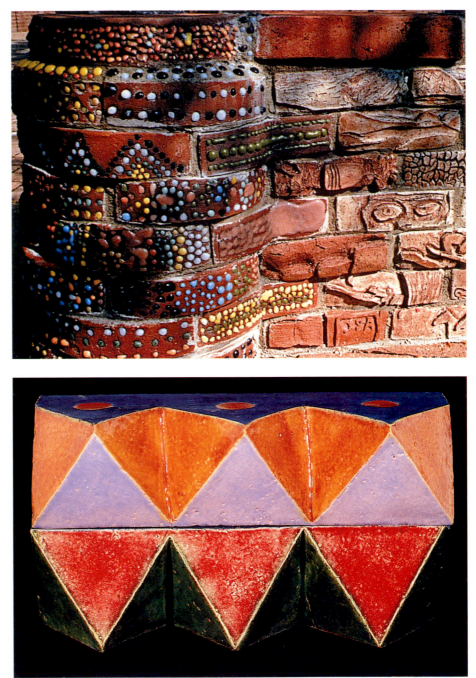

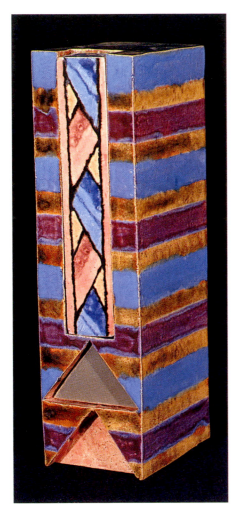

Above, left: Deco Brick, *by Susan Tunick, hand-carved glazed brick, 6.5 x 23.5 x 9 cm (2 ½ x 9 ¼ x 3 ½ in.).*

Above, right: Susan Tunick, hand-carved glazed brick, 6.5 x 23.5 x 8 cm (2 ½ x 9 ¼ x 3 ¼ in.).

Caroline Court has developed an ornamental bead using 100% nepheline syenite to which can be added oxides. One of the central themes of her work is the coming together of many parts to form a unified whole. The ornamental bead which can be made by unskilled and skilled hands takes this metaphor onto the brickwork.

New York based artist and writer, Susan Tunick, glazes bricks for her site-specific enviromental artworks which are developed in collaboration with architects.

Carved and glazed relief works

Eleanor Wheeler works exclusively in glazed, decorative carved brick panels. She uses glaze to enrich the surface of her site-specific architectural works. Her inspiration comes from the Arts and Craft Movement and historical architectural craftspeople such as Eleanor Coade.

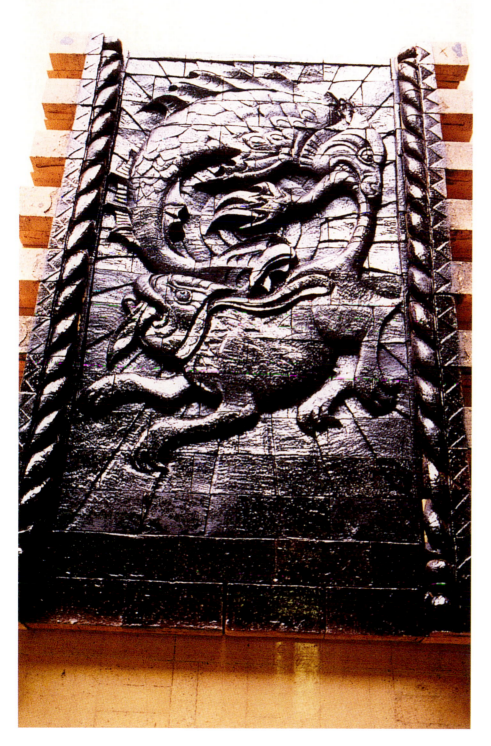

GRRR! *by Eleanor Wheeler, 2 x 1.5 m (7 x 5 ft), 1995. Detail showing manganese glaze.*

Detail from a gateway by Eleanor Wheeler, 1994. Iron slip wash, and earthenware glaze, 2.4 x 1.2 m (8 x 4 ft).

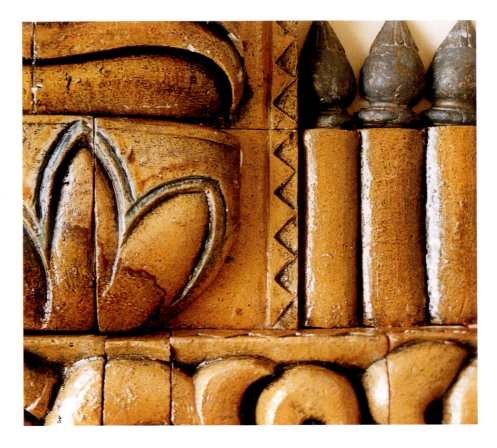

A simple iron or manganese wash is applied to highlight colour and texture. This is usually on Redlands Victoria buff, pre-fired to 1130°C (2066°F). Potclays earthenware glaze is sprayed over the top with the addition of copper carbonate, iron oxide, or manganese and re-fired to 1060°C (1940°F).

Sculptor Sebastien Boyesen also works with glazed bricks. On his piece *Blue Wall* in Pontypridd, Wales, he collaborated with potter Joe Finch and Ibstock Brick, Cattybrook. The project consisted of three murals linked by decorative brickwork with 12,000 hand-glazed bricks incorporated into the overall design. The clay used was Ibstock's buff clay, and the slips and glazes created by Joe Finch are detailed below:

Brick glaze		**Green/Blue Slip**		**Blue Slip**	
(Fires at 1140°C/2084°F.)		*(Fires at 1140°C/2084°F.)*		*(Fires at 1140°C/2084°F.)*	
Feldspar	12	Hyplas ball clay	67	Hyplas ball clay	82
Whiting	9	Feldspar	9	Potash feldspar	12
China clay	9	Cobalt	2	Cobalt oxide	6
Flint	16	Copper oxide	22		
Borax	42				
Ball clay	9				
Tin oxide	3				

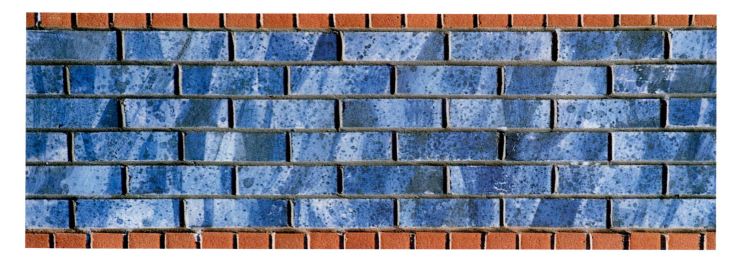

Elahna Shaw (from Wolverhampton University) has been working on a series of glazes for brickwork sculpture. She has been working directly with information from Shaws of Darwen (one of the leading manufacturers of glazed brick).

Their modern glazed bricks are produced by applying an underglaze colour to the raw brick and refiring with a matt or gloss glaze over the top. This provides a wide range of colours for architectural use.

The following glaze recipes originate from Shaws of Darwin, but Elahna Shaw has altered them. Glazes A and B date back to the 1930s and are both oxdised. Glazes C and D date back to the 1920s and are both reduced.

A percentage of oxide was added to each glaze, experiments were carried out with red iron, rutile, cobalt carbonate, manganese, copper and nickel.

Sebastien Boyesen, detail of brick wall, Pontypridd, Wales.

Glaze A
(Oxidized 1170°C/2138°F.)

Cornish stone	75
Talc	5
Whiting	2.5
Flint	11
Tin oxide	6.5

Glaze B
(Oxidized 1170°C/2138°F.)

Lead sesquisilicate	20
Borax	15
Sodash (sodium carbonate)	15
China clay or brick clay from Baggeridge Brick (blue black)	18
Silica (sand)	22
Dolomite	10

Glaze C
(Reduction 1180°C/2156°F.)

Soda feldspar	44
Borax	17.7
Barium carbonate	18
China clay	2.4
Silicon carbonate	9.8
Whiting	7.3

Glaze D
(Reduction 1180°C/2156°F.)

Soda feldspar	56
Flint	23
Colemanite (Gerstley Borate)	25
Barium carbonate	10
Zinc oxide	12
Nepheline syenite	1.5

Barium glazes on brick

Collinette Sansbury, from Wolverhampton University experimented with a series of barium glazes on brick. These worked more successfully on fired brick and were low-fired barium glazes.

Low-fired barium glaze

(Fires at 850°C/1562°F.)

Lead biscilicate	50
Lithium	35
Ball clay	1.5
China clay	1.5
Barium	12
Copper	2

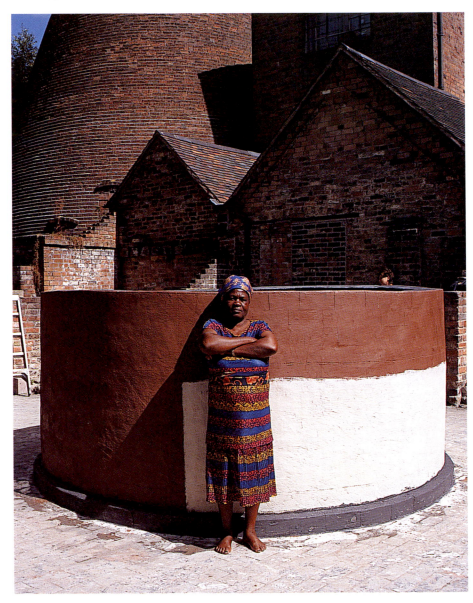

House, by Mmangake Moloi (Zena), from the Creating the Yellow Brick Road symposium, 1999. Zena is a traditional house decorator in Botswana and works for the National Museum and Gallery of Botswana as a demonstrator. Photograph by Nick Hedges.

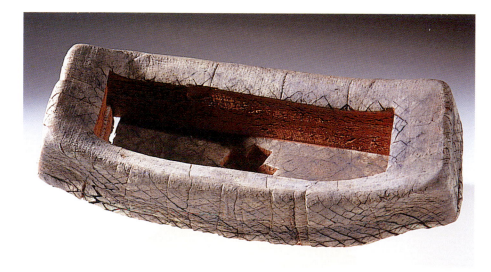

Brick with glaze and slip by Bill Baker.

Slips on brickwork

Bill Baker has conducted a series of experiments with the application of glaze and slips to the surface of brick. He uses powdered glazes and oxides thrown over the brick and then beaten into the surface.

Swedish artist Gunilla Bandolin has used slip extensively on her figurative brickworks, applying it direct onto the green brick. Botswanian artist Zena, a traditional house builder and decorator, also paints slips onto brick. A simple slip which works well on brick can be made from 50% China clay and 50% ball clay, with an addition of 10% flint depending on the brick, and oxides (e.g. cobalt, iron or manganese) can be added.

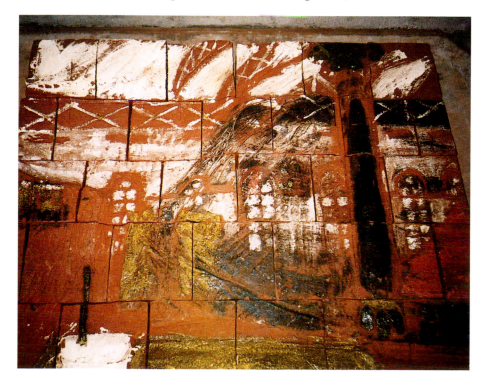

Piccadilly by Penny Hampson, use of glaze and slips on Blockleys Hadley Red bricks. Clear earthenware glaze with 10% underglaze stain added to glaze – applied on top of coloured slips.

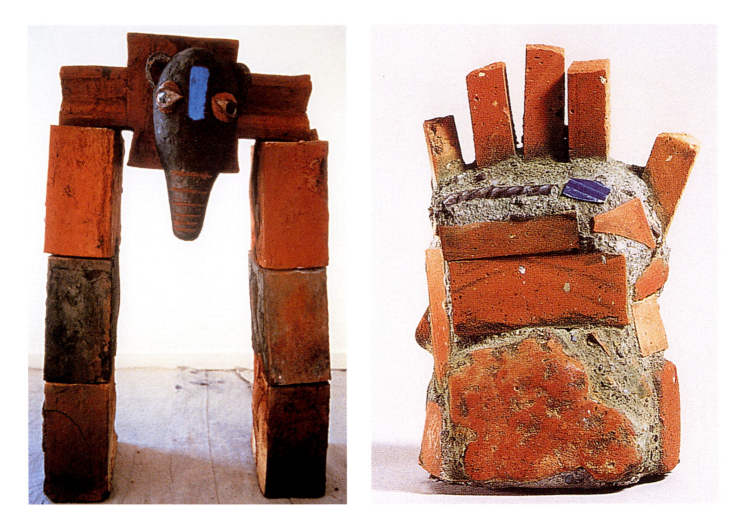

Above, left: Gunilla Bandolin, coloured slips on brick.

Above, right: Hand by Klause Schultze, 1997.

At Blockleys Brick I used manufactured stains added to sand which was then worked into the surface with metal kidneys and damp sponges. I also worked at Hathernware using a variety of Jasperware slips on brick clay.

Jasperware slip recipe

(Fires at 1140–1160°C/2084–2120°F.)

Barium sulphate	64.5
Bentonite	3
China clay	10
Fine molochite or calcined china clay	22.5
Gum arabic	2 tbls per bucket

Depending on colour wanted, try additions of:

1. copper	0.5–1
2. cobalt	0.5–1
3. manganese	5
4. copper	6

Contemporary multimedia artists and architects using brick

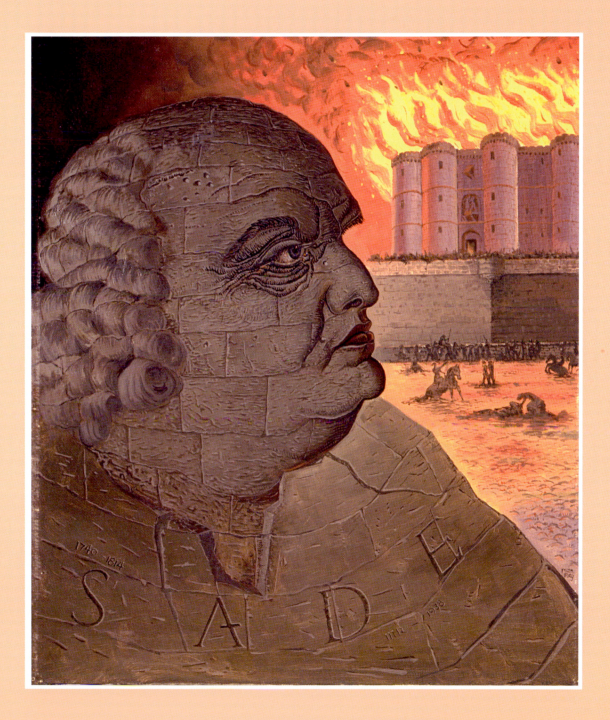

Portrait of the Marquis de Sade by *Man Ray, 1938. Man Ray's painting shows the Marquis painted out of bricks emphasising his ability to change his identity as often as he wished, becoming a phantom figure. Photograph © Man Ray Trust/ADAGP, Paris and DACS, London/Telimage 2003.*

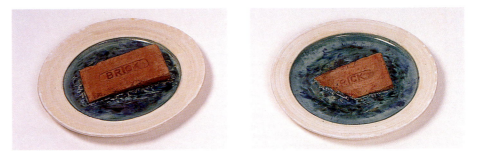

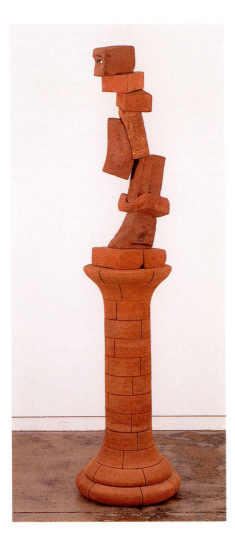

A number of contemporary international multimedia artists and architects have also employed brick in their architecture and artworks. As artists and architects have begun to re-examine traditional visual culture, so they have experimented with new and established materials and processes, in an attempt to forge new and expressive visual languages. Brick has played an important role in this quest.

The artist Carl Andre was a relatively recent example of an artist so engaged, when in 1972 he outraged a large section of the British public with his 'pile of bricks' exhibited at the Tate Gallery. It is probable that the antagonism was as much triggered by his exalting the humble brick as it was by the simple, minimalist creative statement he made.

The American artist Robert Arneson was one of the major innovators of ceramics as a fine art medium in the 1960s.

When artists invade a craft medium, they deliberately make work that is non-functional as a way of showing that, though the medium is associated with a craft, the work is art.
(Becker, Art Worlds)

He produced a series of impeccably crafted plates with a large brick placed directly in the centre, slowly sinking into the surface as the series progressed, denying all possibility of function.

In the early 1960s Picasso's clay work also took a new direction when he saw the sculptural potential of a number of discarded industrial brick fragments and transformed them into heads.

Above: Brick Self-Portrait *by Robert Arneson, 1981. Unglazed ceramic, 172.5 x 38 x 38 cm (68 x 15 x 15 in.).*
Collection of Byron and Eileen Cohen. Photograph © estate of Robert Arneson/Licensed by VAGA, New York. Courtesy of George Adams Gallery, NY.

Above, right: Sinking Brick Plates *by Robert Arneson, 1969. Glazed terracotta, 7.5 x 48 x 48 cm (3 x 19 x 19 in.) each (5 plates).*
Collection of Harry W. and Mary Margaret Anderson. Photograph by Ian Reeves, © estate of Robert Arneson/Licensed by VAGA, New York. Courtesy of George Adams Gallery, NY.

Right: Equivalent VIII *by Carl Andre, 1966. Dimensions: 13 x 87 x 229 cm (5 x 34 ½ x 109 ¾ in.).*
Photograph © Tate Gallery, London/DACS.

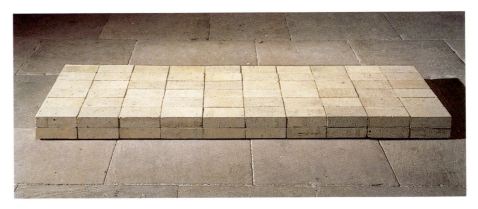

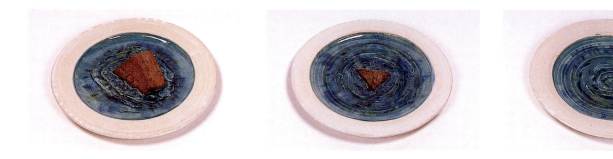

Surrealists painters such as Hans Bellmer and Man Ray have exploited the visual associations inherent within brick. Bellmer used brick in his paintings to comment on a particular state of dreamlike illusion, where brick is transformed and given soft organic human qualities. Ray uses it as a metaphor for identity change in his picture of the Marquis de Sade.

Recently a number of international artists have begun to exploit the potential of brick as an exciting new material with a prestigious and intellectual visual language of its own. Women artists such as Lorna Green are also exploring brick as a part of a new female sculptural language, its accessibility within industry and small modular size allowing large-scale sculpture to be constructed with apparent ease in comparison to stone carving and welding.

Below: Jubilee Square, Leeds General Hospital, by Tessa Jaray, designed in collaboration with Tom Lomax.

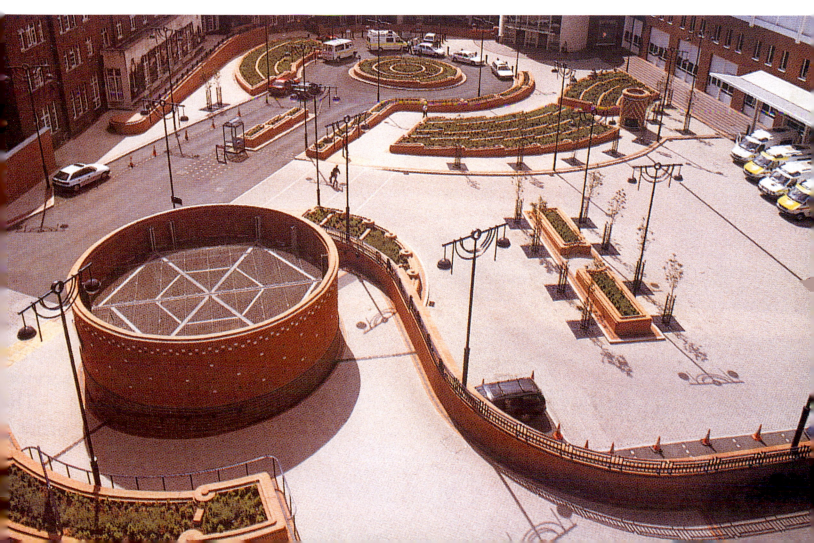

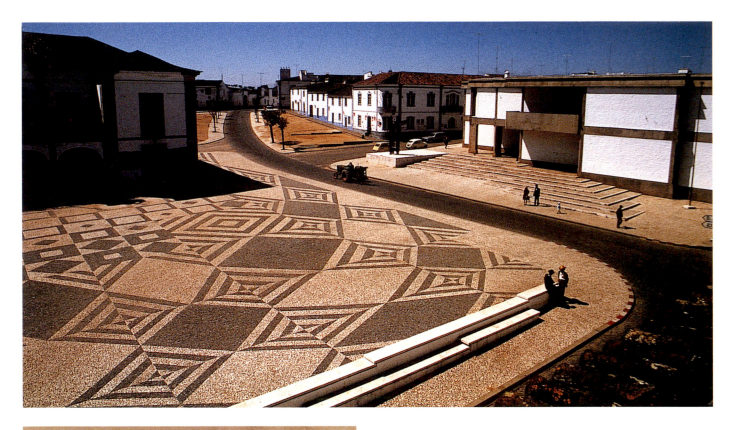

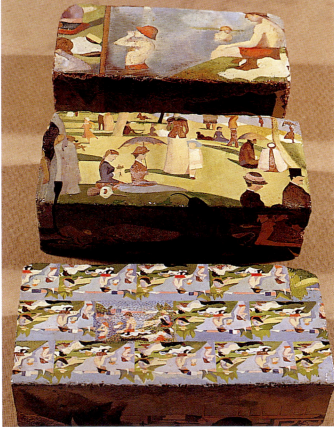

Above: Redundo Square, Portugal, 1968–70, by Eduardo Nery. One of several site-specific designed paving areas.

Left: Miniature brick paintings by Frances Crichton-Stuart.

Painters and textile artists such as Tessa Jaray (UK) and Eduardo Nery (Portugal) have dramatically changed our perception of brick paving and flooring within the built environment. Frances Crichton-Stuart has used the brick as a vehicle for her paintings exploiting the brick as a miniature canvas to produce exquisite paintings. In 1986 Anthony Gormley produced a maquette for a 60 m (200 ft) high *Brick Man* to be built in Leeds. This was based on his desire to work with earth and build a collective body, but the project never materialised due to lack of funding.

This radical, innovative and experimental use of brick is having major implications for ceramic practitioners, as familiar parameters extend and project into unfamiliar territory. The repercussions of this have meant that the status of the brick as a vital component of our visual language has stretched far beyond its function as a simple building block.

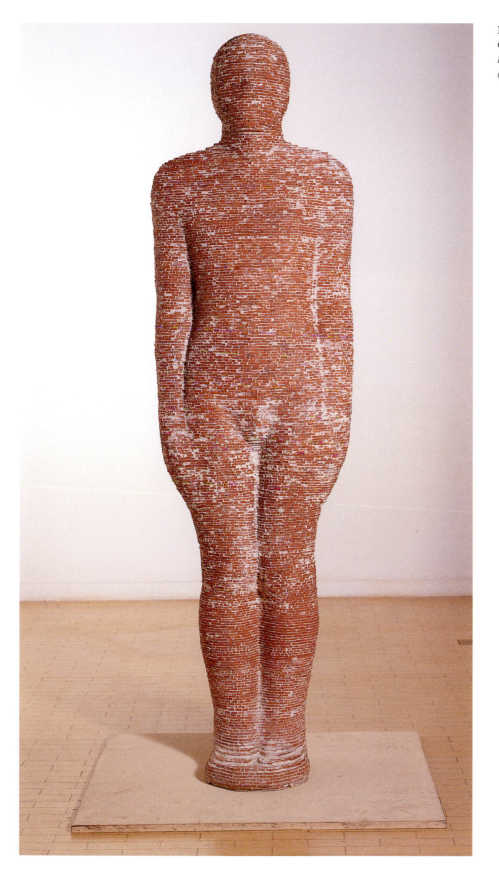

Maquette for Leeds Brick Man *by Anthony Gormley, 1986. Height: 60 m (197 ft).*
Photograph © Leeds Museums and Art Galleries (City Art Gallery) UK/Bridgeman Art Library.

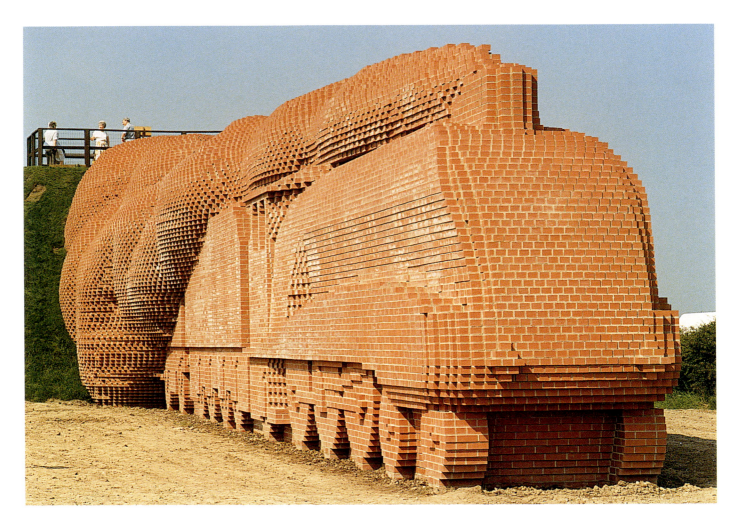

Train *by David Mach, 1998.*
Photograph by Paul White, courtesy of The Brick
Development Association of Great Britain.

David Mach (UK)

David Mach is an important international artist whose choice of material is vital to the success of his work. The use of recycled materials has had an immense impact as a vehicle for his ideas, enabling him to create huge columns from newspaper and buildings from rubber tyres. Recently in his quest to extend this expressive visual language he has started to employ brick in his sculptures. Recent works include buildings that give the illusion of pumping themselves out as though constructed from swollen brick. He intends to develop the radical use of brick within his sculpture, redefining, experimenting and making new statements about its function.

In Holland he is working on a scheme to make an entire landscape cut out of brick. The possibilities of using brick to redefine the landscape, creating curved spaces and entire walkways within the urban environment are limitless. Collaboration with industry, architects, engineers and clients are important elements within this development.

Train was created in 1996 in Gateshead to celebrate the opening of the

Stockton to Darlington Railway, built by George Stephenson. Conceptually the development of his site-specific sculpture relies on discovering locations to which he is able to respond. The idea for the train materialised after Mach accidentally disembarked at Darlington station, the birthplace of the British steam engine. The concept was further developed during his time at the Royal College of Art. A successful lottery bid meant that he was able to develop the project for a 60-m (20-ft) long brick train made from 185,000 bricks. To promote the idea Mach worked on a series of collages, depicting a variety of English country scenes and showing different classes and nationalities of the public enthusing about the train.

Initially he produced a scale model, which planned in detail the exact location of every brick. Mach feels that scale-models are incredibly important for clients and public alike to visualise a project intended for the public arena. He collaborated with an architect and engineer on the design of *Train* and many long conversations ensued, several just deliberating on the colour of the mortar in-between the bricks. Landscaping and lighting were identified as potential problems. Intensive lighting altered the visual appearance of the brickwork rendering it completely flat. The lighting needed to be much less harsh to enhance its three-dimensional quality.

On the building site Mach supervised the construction of the train without any desire to build it himself. An interesting relationship developed between the bricklayers and the artist. The former continued to view everything with scepticism and the artist constantly delivered orders concerning aesthetics. Eventually, however, the craftsmen invested themselves in the process of making and acquired a great respect for the work. Mach was constantly asked if he was 'making a model of a train' to which he would reply that no he was making a sculpture. For the public the recognition factor was important – they wanted the sculpture to be obvious as a train. *(Taken from David Mach's lecture at Creating the Yellow Brick Road symposium, 1999.)*

Alberto Duman (Italy/UK)

Alberto Duman is an Italian born artist/designer/sculptor, who works internationally on a number of site-specific commissions. He is co-director and member of the artist group 'Pulse' that organises art-related events in public spaces. Duman shifts across defined artistic boundaries exploring and experimenting with a wide range of processes and materials. Recently he has become interested in the dynamic visual language of the brick and has built up an invaluable relationship with the London-based brick company Hanson Brick. Duman feels that in the diversity and complexity of contemporary practice, links with the industry are numerous and inevitable.

Processes and technologies are widely shared at both ends and the resulting cross-fertilisation must be accepted as a challenge for a mutual growth and further understanding of one's own strength. It seems to me a mutual understanding that the positions are different and have to stay that way. What takes place is a transaction of skills and/or services, which has obviously different weight and importance for the two parties. If the industry can help in the making of a piece, it will do so without involving itself too much into the thinking of the artist. The artist in return will try to appreciate how far industry's demands can be met without compromising the newly established relationship.

In the last two years Duman has constantly focused his attention towards projects which are site-specific in character and public in their siting. He chooses to work on a temporary timescale and with a vast array of materials, solutions and devices. In this unrestricted approach he tries to bring together disparate elements and languages suitable for the particular occasion. Methods and experiments are always documented. Social context plays a strong part in his work, as well as adherence to the architectural surroundings. The readings of his work in this arena became varied and unexpected and confronted with a broader sense of 'culture'.

Initially Duman collects information and history relevant to the location. This investigation is then filtered through his personal understanding of the situation and reduced to its essence. He always aims at simplicity, directness, and emotionally charged results. He attempts to position himself more in the senses of the possible viewer than in his

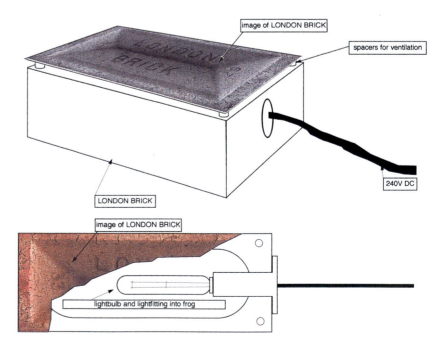

Drawing of Monument *showing method of inserting lighting.*

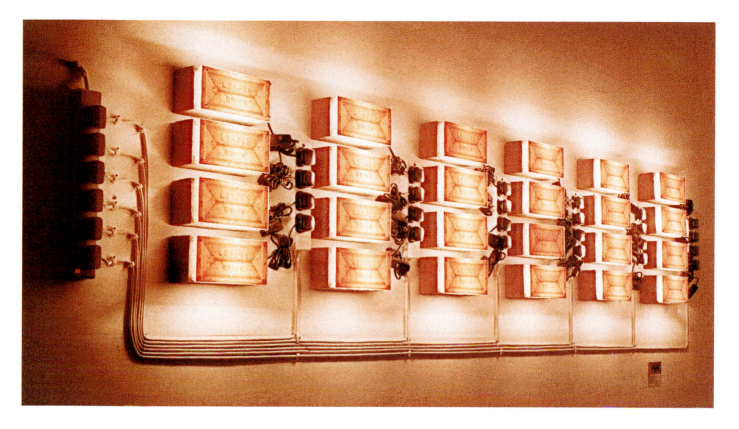

Monument, *image of the finished work, by Alberto Duman.*

own, and asks himself what could make a difference in this situation, with the hope of finding the right answers.

As part of the exhibition 'Designers Block', supported by *Blueprint* magazine and featuring art and design works under one roof – that of an old disused brewery in the East End of London – Duman created *Monument*, at the Monument Gallery, (located at the East End brewery in London). This installation was based on a device by which every brick turned into a lightbox image of itself. By drilling a 25 m (1 in.) hole into the side of each brick, a light fitting was inserted into the frog (the depression in the back of bricks that is filled with mortar), which then backlit an exact image of the same brick, scanned and printed on transluscent paper. This familiar object, the brick, was turned into an apparition, a two-dimensional image of itself thus questioning its functionality and three dimensional existence. A batch of 24 bricks was made and fitted to the wall, leaving the wiring exposed. The final result was a wall of glowing bricks. Initially Duman had planned to cover up an entire wall with a total of 500 bricks but limited space forced him to think otherwise. Hanson Brick, producer of London Brick, sponsored the work.

The Creating the Yellow Brick Road symposium in 1999 provided an experimental ground for the development of a site-specific work, created in direct response to the industrial setting at Ironbridge, birthplace of the Industrial Revolution. For this symposium Duman created *Voto*, located in the remains of one of the oldest brick factories in the country (now

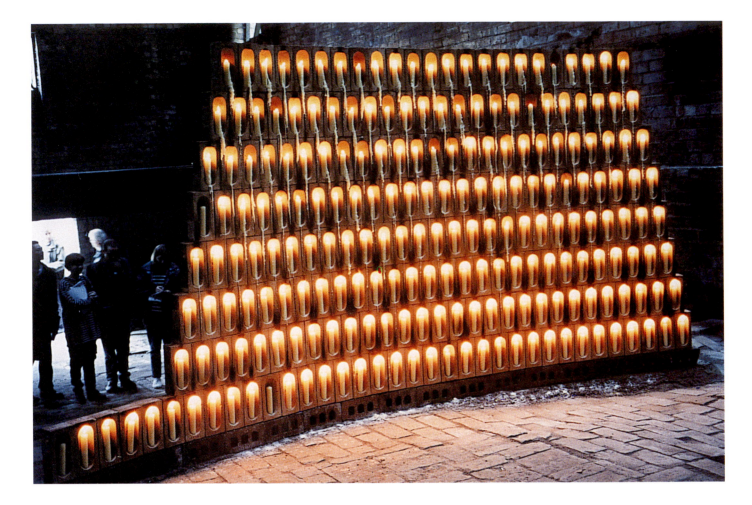

Above: Voto *by Alberto Duman, Ironbridge Gorge Museum, Blist Hill, 1999.*

Below: Detail of the remaining structure of Voto, *with wax dripping, after candles have been burnt.*

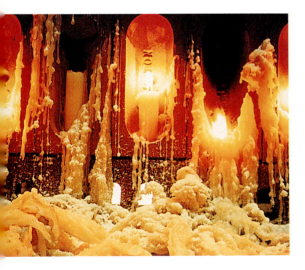

at the Ironbridge Gorge Museum). *Voto* employed bricks and candles to create a kind of time-based ritual, both to celebrate and mourn a bygone era. A circular/conical section of a wall was built on an elevated platform, as if on an altar. The result was a free-standing structure, initially hiding the inner space. Only small gleaming holes at the back of each brick created glittering dots, as if in a computer processor. As one rose onto the stage/altar, the other side of the wall was revealed to show the source of the flickering – 250 candles recessed into the frog of each brick. Each element itself was like a small architectural unit. In about an hour the candles at the top, given the high rising heat completely burned out, leaving a black smoked surface on the brick. Within two hours all the candles were gone. The result was the remains of the ritual, with the wax drips at the feet of the structure and all over the brick wall. The smell remained in the space and a sense of funereal ceremony left as a testament. The religious sense went beyond any doctrine, as if the building was a kind of industrial church.

After initial difficulties a dialogue evolved with Hanson Brick who sponsored the project providing the 400 bricks which were drilled to Duman's specification and delivered to the site. This sponsorship was essential for the making of the piece.

Lorna Green (UK)

Lorna Green is a sculptor who works in many media but finds that brick has the essential visual dialogue she needs to comment upon contemporary issues. She works mainly in the public arena on site-specific/environmental projects. Many of these include the re-design of landfill sites – in both urban and rural landscapes – and both permanent and temporary functional earthworks and sculptures. Her sculpture is site-specific in that it relates totally to a site and considers the relevant history, economy, landscape and mythology of the area. Materials utilised are pertinent to the project (wood, stone, earth, plants, bricks, steel, cement, bronze, water, glass, plastics etc.) and are often local or used already in local buildings.

Lorna Green participated in the 5th Women's Art Historians Conference in Hamburg in 1991 and her continued association with the principles established there has been a catalyst for some of her most profound sculptures. One of the aims of this conference was to set up a dialogue between artists and art historians. Running parallel with this exhibition's central themes, was the proposition that women have developed their own sculptural language, partly through selecting their own materials, such as beads, fabric, rope and plaster. The basis for this choice is their manageability in contrast to other more macho working processes chosen by the steel welder or monumental mason.

Installation at Leeds Castle, 1989, by Lorna Green, Maidstone. Dimensions: 25 x 5 x 1 m (82 x 16 x 3.2 ft). Constructed from 5,000 Kentish bricks based on the contours and forms suggested by nearby Leeds castle.

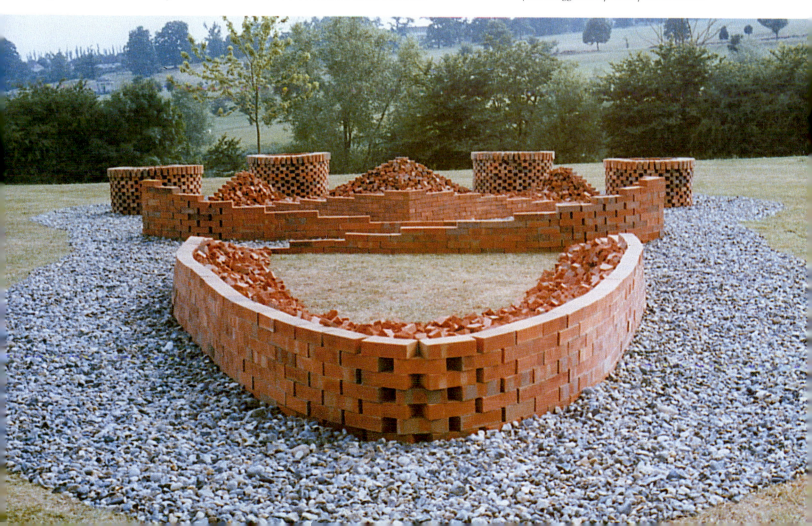

Brick is also a manageable module allowing easy construction of large-scale structures. Reflecting upon this hypothesis it is interesting to note that many women are taking this material on board to enable them to construct large-scale sculpture and comment on a wealth of issues such as the role of gender in the perception and conception of space and architecture.

Helen Clifford (UK)

Helen Clifford is an artist whose work crosses a number of boundaries. She is at ease within the contemporary practice of ceramics and sculpture. Her work is concerned with notions of memory and transformation, explored through the collecting, cataloguing and burning/carbonising of significant objects – site-specific, usually domestic in nature. She considers the firing of these objects to be ritual based in that the firing process and the kiln itself are of great significance in the transformation of the objects. The kiln as a house/home has developed. Clifford's site-specific 2.5 m (8 ft 3 in.) -high structure, *Chimney*, took its inspiration from the bottle-kilns overshadowing the site. She chose to work with

Below, left: Helen Clifford, work in progress overshadowed by the bottle kiln at Coalport, Ironbridge Gorge Museum, 1999. Photograph by Nick Hedges.

Below, right: Chimney, after applying manganese slip. Photograph by David Jones.

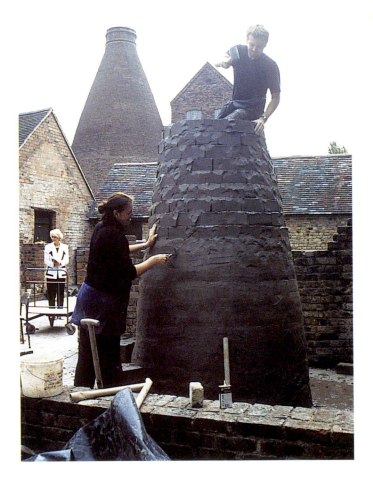

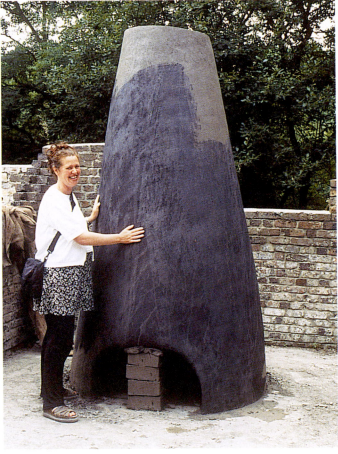

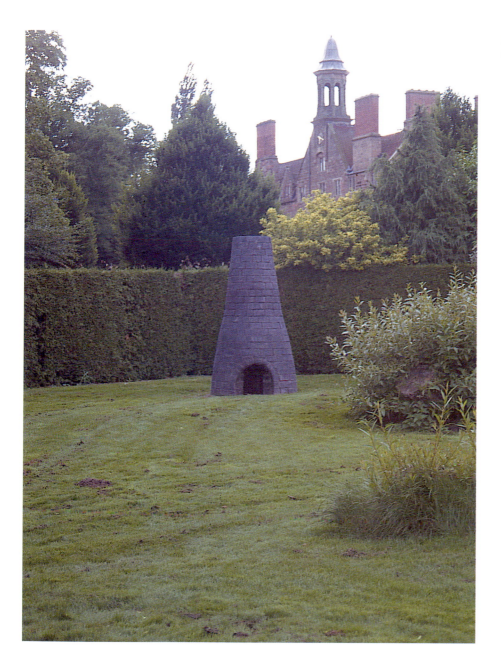

Helen Clifford, finished piece at Rufford Country Park, 2003.

'rough grey' green bricks from Baggeridge Brick which fire blue/black. The idea was to progress from the firing of the actual objects and to explore the notion of the heart of the home structure (the hearth/fireplace and chimney) and to define in more sculptural ways the essence of the site of transformation. The structure evolved as a tall, thick-walled, dense object with a squat fire-place opening, leading to a small intimate space where a smouldering fire was lit. The exterior was a blackened, scraped and smoothed, rounded conical form. The structure had a sense of something very protective in form; of concealment within a hidden interior. Parallels can be made with ancient dwellings and earth mounds conjuring up a primal site used for ritual activity.

Architects

In the 21st century the links between architecture and art are becoming ambiguous. Operating independently as most architects and artists do, it is interesting to observe the breaking down of previous well-established parameters. Architect Tim Ronalds has constructed The Landmark entertainment centre, Illfracombe, using cone-shaped brick structures, dramatically situated on the seafront. The building is a monolithic, functional sculpture. Conversely, Danish artist Per Kirkeby creates architectural brick sculptures perceived as buildings of no function and German artist/architect Erwin Heerich, creator of the galleries in the Insel Hombroich Museum, Germany, creates functional brick buildings conceived with sculptural considerations. American artist Charles Simonds creates life architecture/living structures, which he presents as miniature buildings constructed from tiny bricks, in contrast to the large architectural blocks which form an important element in the architectural installations of Spanish artist Miguel Navarro.

Shifts in contemporary attitudes to the way we perceive art and architecture have led to the recognition of the work of artists such as Jacques Kaufmann, Ulla Viotti and Robert Harrison. Their sculptures are rich in architectural illusion and set up a visual and conceptual dialogue with architecture.

It could be argued that the revival in the creative use of brick has developed as a result of some of the architectural consequences of Postmodernism, opening up as it did the question of ornamentation. It was suggested by some that Modernism in its quest for the 'essence' destroyed ornamentation and decoration. Artists and architects had to be original and heroic, using only modern materials such as concrete and aluminium. For many the buildings and sculptures they created were devoid of any human dimension and lacked warmth and decoration. To the general public the materials employed were often stark and featureless. Brick however has always been associated with colour, pattern, decoration and warmth, the latter a most important feature in a northern climate. The use of brick as an inexpensive building material has also certainly contributed to its revival in architecture:

New styles are emerging from the necessity to use inexpensive materials and to respect budgets more rigorously than in the past. Today's architectural Utopias are pragmatic, and quality architects are coming to terms with the economic aspects of their art, ensuring that their influence is on the rise. (Philip Jodidio, Contemporary European Architecture, *Vol.3, 1995)*

Recently millennium projects have been the catalyst for prestigious new building projects with large budgets. A number of architects such as Tim Ronalds and Peter St John, architect of the Walsall Gallery (in the

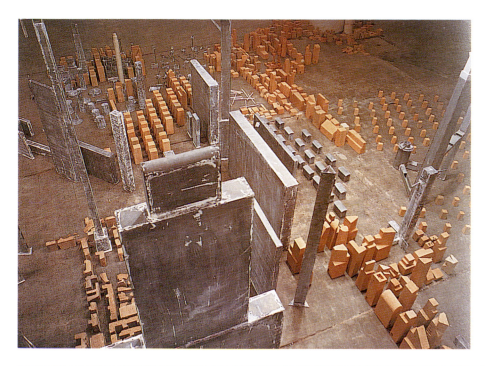

Left: Miguel Navarro, La Ciutat, 1984–85. Zinc, terracotta, refractory materials.

Below: Charles Simonds, Wilted Towers, 1984. Unfired clay, dimensions: 28 x 58 x 58 cm (11 x 23 x 23 in.).
Photograph © ARS, NY and DACS, London 2003.

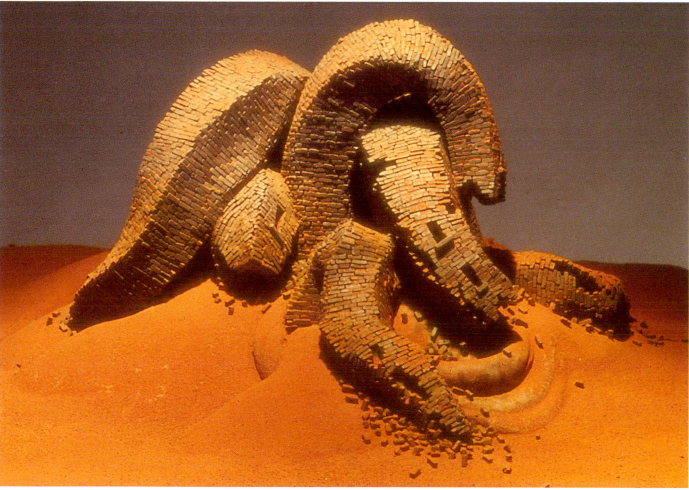

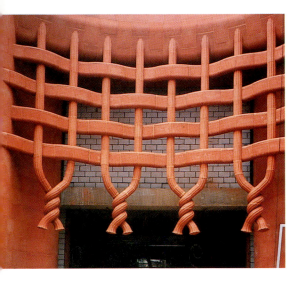

Entrance to De Barones shopping centre in Breda, in the Netherlands. Created by CZWG architects in London and Ibstock Hathernware, UK.
Photograph courtesy of Ibstock Hathernware.

UK), have started to look at brick and ceramic products in an attempt to make connections with historical fabrics, and to deliver to the general public higher and higher levels of stimulation through the use of materials.

In 1985 the Spanish architect Rafael Moneo used brick to build the National Museum of Roman Art in Merida in Spain. Located on the site of an ancient ruin its function is to exhibit a growing collection of Roman artefacts. His brickwork alludes to Roman architecture and provides subtle links to the existing environment. The building incorporates the foundations of part of the old Roman city. The museum's exterior evokes the solemnity and regularity of the Roman brick wall, its segments laid in delicate formal rows.

Within the museum Moneo has constructed parallel brick walls crossed with grand arches. Above, through large, distinctly modern skylights the sun beams directly into the galleries, illuminating richly detailed brickwork that recalls the past. 'The building designed to house artefacts, becomes an artefact itself.' (From *The Museum Transformed*, see Bibliography.)

Today there is often a fundamental problem with architectural products in that there is a total separation between those in industry making the product and the architects designing them. Peter St John, of Caruso St John, architects of the new Walsall Gallery, and Daniel Leibeskind, architect of the Victoria and Albert Museum's spiral extension (using clay tiles), both went to German manufactures for the terracotta and ceramic cladding on their buildings. They feel that the brick industry in Britain does not produce the range of quality brick that architects want to use. Many architects see British industry as inflexible and unable to respond quickly to production demands. However, technocratic, modern societies like Germany and Japan have invested in new methods of production and exciting new products.

In the UK, however, Ibstock Hathernware have collaborated on a number of innovative architectural projects, such as the De Barones shopping centre in Breda, in the Netherlands with the architect group CZWG (Cambell, Zogolovitch, Wilkinson & Gough). At the entrance to the centre is an open-weave terracotta curtain, complete with twisted tassels hanging above the heads of the shoppers. Architect's impressions were converted at the factory to full scale sculptures. The bricks are threaded onto a weave of metal and fixed in place with an epoxy resin. Another major project for the Ibstock group was the Hotel Kawasaki in Tokyo where the developers enlisted major craftsmen from all over the world to develop various aspects of the building. The 'specials' department at Ibstock Brick, Cattybrook, was employed to develop a range of specialist architectural features.

The American artist and writer Susan Tunick points out that collaboration between artists and architects is a problem which needs to be addressed. Most artists and architects still tend to work independently of

each other, and she feels that collaborative projects would benefit both. During 1986–87 she initiated a project in the city of New York 'Firing the Imagination', with a group of architects and artists who worked together in teams of two and three to develop architectural/artworks experimenting with green bricks to be fired and placed within the city. The project looked at the differing nature of the creative processes in art and architecture and the realities of the production process and budget were assessed. The resulting works were never realised. Tunick hopes to re-develop this collaboration internationally constructing small teams of artists, architects, and industrialists from different countries.

Tim Ronalds (UK)

The Landmark entertainment centre (Ilfracombe, Devon) is one of the most inspirational brick buildings of the 1990s. The scale and volume have created a dramatic inner space, but the outside is slender with eggshell proportions and the white bricks reflect the summer and sand. Windmill bases and the Stuart Crystal glass-making kiln at Worsley inspired his structures. The awesome curved volume is perfect in its construction and follows the same design as the unsupported kilns built by bricklayers in the 19th century. The clay used is German clay; Ronalds finds that the British white clays are yellowish rather than pure white through the addition of the mineral, vanadium. Ronalds perceives brick to

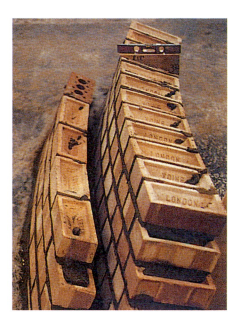

Above: Construction methods for the cones, showing cantilevered bricks.

Below: Tim Ronalds, The Landmark entertainment centre, Illfracombe, Devon. Photographs courtesy of the Brick Development Association of Great Britain.

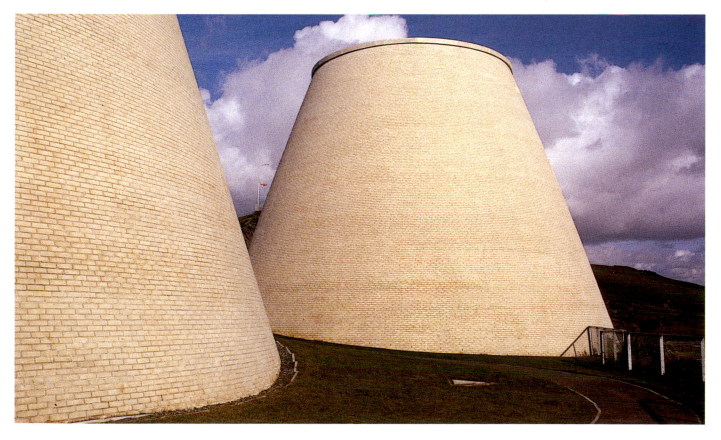

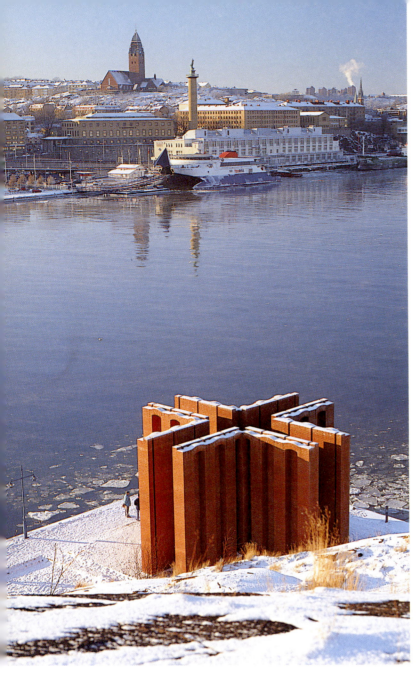

Göteberg, by Per Kirkeby, 1990. Dimensions: 600 x 630 x 420 cm (236 x 248 x 195 ½ in.). Photograph © Jens Markus Lindhe.

be a highly adaptable and durable material, which has remained relatively cheap.

The single-skin cones of the buildings are 20 m (67 ft) in diameter, and 30 m (98 ft) high. The structures consist of an underground structure, a watertight cavity and outer cone. The building consists of a parabolic arch where the two cones intersect. The inherent strength of the structure, like those of the kilns, is in the shape; it will withstand winds of hurricane strength. The single-skin brickwork slopes at an angle of 72%. St Paul's Cathedral in London is also a brick dome leaning at an angle of 72%. This is an ancient method of construction well used in architecture. The intellectual appeal was in the challenge of building a structure that was strong and monolithic in its proportions yet delicate in its construction.

Per Kirkeby (Denmark)

Per Kirkeby is a painter and multimedia artist who also works in brick. His work hovers between the realms of sculpture and architecture and can be found in locations across Europe. His abstracted brick forms are steeped in architectural symbolism and relate closely to Byzantine architecture; structures such as the old city walls of Constantinople; and early Christian churches such as Chora which made a deep impression on him after a visit to Turkey in 1977. The cross and the labyrinth often determine the form of the high walls and buildings he constructs.

He sets up a visual and conceptual dialogue with architecture, which serves to accentuate the irrational non-functional nature of the sculpture. (Andrew Mead, Architects Journal, 29 Oct 1998.)

In 1998, Kirkeby was commissioned by the Tate Gallery in London to construct a 4 m (13.3 ft) high, 30 m (98 ft) long brick wall to be exhibited alongside his paintings. It was constructed from 20,000 bricks supplied by Ibstock Brick, and consisted of four walls, running along the centre of one gallery, through which visitors were encouraged to wander and confront several different perspectives of his paintings.

People say bricks are not art, bricks are bricks. But then paintings are just made of paint, but you can use them in a way that what comes out of it is art. (Kirkeby, The Times newspaper, 1998.)

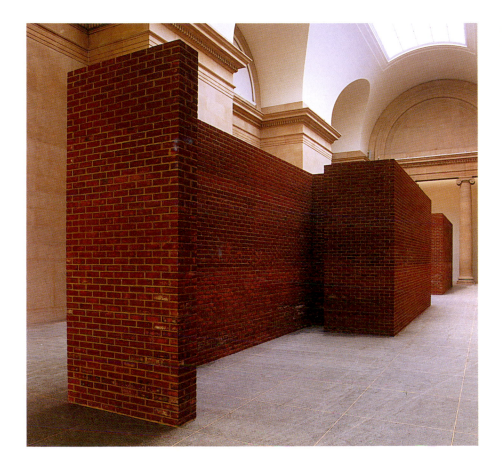

Left: Per Kirkeby, wall installation, Tate Britain, 1998. Photograph © Tate Picture Library.

In 1990 Kirkeby was commissioned by the city of Amsterdam to execute a sculpture in the East Harbour as part of the regeneration programme. The sculpture contains seats, sheltered from prevailing winds, and it gives some scope for play, although any functional roles within the sculpture are incidental and not primary. Kirkeby feels that 'the best games are played in a place where there is nothing but a wall. You can play ball up against it without making anybody angry because they live behind it'. In positioning his work Kirkeby engaged with the place and reacted to two old brick warehouses. The slot of space between them reveals the old harbour beyond. The parallel walls of the sculpture focus directly on this space, defining a cross-axis that creates a passageway between two high rising walls. From this one can find a viewpoint from which, in perspective, these walls and the warehouse end-walls align. To the side of one wall, as requested in the brief Kirkeby was given, is a shallow pond, which he has formed as the sculpture's virtual shadow. Like most of Kirkeby's sculptures it is made of local bricks laid in stretcher bond, but does not attempt to blend with its surroundings; the only bricks in the vicinity are different in colour and employed in a more decorative way. (For more information on Per Kirkeby, there is an excellent book – *Brick Sculpture and Architecture Catalogue Raisonné*, see Bibliography.)

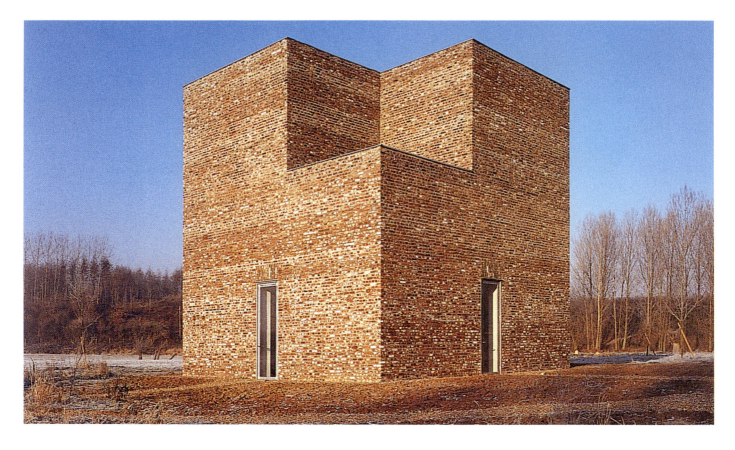

Brick gallery at the Insel Hombroich Museum, Germany. Photograph courtesy of the Insel Hombroich Museum.

Erwin Heerich (Germany)

The sculptor/architect Erwin Heerich has designed a series of brick buildings, which form the privately run museum, Insel Hombroich. Each individual gallery forms part of an architectural installation in the dramatic countryside of Neuss, Germany. The installation is both functional (each brick gallery houses the private collection) and sculptural.

Each of Heerich's structures is designed for its specific location with an awareness of the spatial impact and is first realised as a bronze maquette; these are on show at the museum. Many of his famous works are in card, metal or wood but these buildings differ in that they are hollow vessels, functional buildings with a strong inner dynamism asking to be entered. The outer appearance of the structures is austere in comparison with the inner space in which the painting and sculpture are exhibited. The changing light plays an important part in the vision of the work, dramatically altering our perception of its shape and relationship to the environment. Inside the effects are dramatic as shadow and light floods through skylights, and glass walls.

Each brick structure is an abstracted form, which contrasts dramatically with the surrounding natural environment. One structure is a brick cube 10 m (3.3 ft) in dimension, with two diagonally opposed corners turned to the inside with the effect of dividing its cellular inner room into two upper parts similar to the cleavage of a cell in nature.

Technological intervention

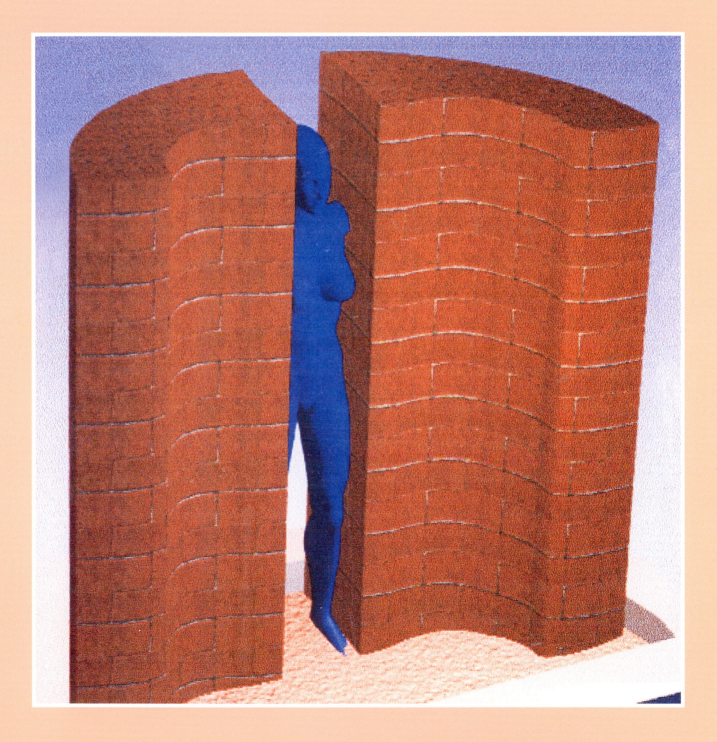

Computer generated image, showing a created shape with applied brick formation, in order to visualise an idea.

The development of CAD/CAM technologies and 3D modelling packages

Recent technological inventions can be of great use to the artist in the development of creative ideas. For many artists, working in the brick industry provides access to the latest computer technology. A number of companies use 3D modelling, animation and Photoshop to develop their design potential and companies are more than willing to allow artists working on projects into their factories to use the facilities (see *Mythical Beast* project, Chapter Four).

A number of artists are currently using 3D packages such as True Space on the cheaper end of the scale and 3D Studio Max at the higher, to mould 'wire-frame' objects which can be translated into information for *routing machines* to produce objects or their mould negatives. Freeform modelling packages produced for example by SensAble technologies are also available, which allow the artist to physically interact with the model through the use of a hand-held sculpting tool. 3D packages offer a greater freedom for the artist to carve, push, pull and generally sculpt in a more organic manner. Take for instance developing an idea for a moulded brick wall. Basic modelling attributes are as follows:

See pictures opposite:
1. The shape in 2D.
2. Sweeping or extruding (lifting a 2D shape into 3D space).
3. Twisting/bending.
4. Deformation. Rounding off edges using 'Nurbs' (Non-Uniform Recursive 'B' Splines) technology.
5. Boolean operations which allow objects to be joined to or cut from other objects. This object subtraction allows an object to be subtracted from blocks, producing a negative mould object. Perhaps the most intuitive function allows points or faces from the basic wire-frame model to be pulled or pushed in any direction and to any depth or height.
6. Building up structure, to create 'Wave Wall' (see p.158).

Deforming wire-frame
This is currently used in industry to animate character expression and movement and bears most similarity to the sculptor's method of working. Worked in conjunction with a programmed 3D router the implications for the artist are enormous. The main advantages are;

• Viewing a work in 3-dimensions before committing time and material expense.
• Applying different brick formations and textures before production.
• Applying known temperature/colour variations before firing.

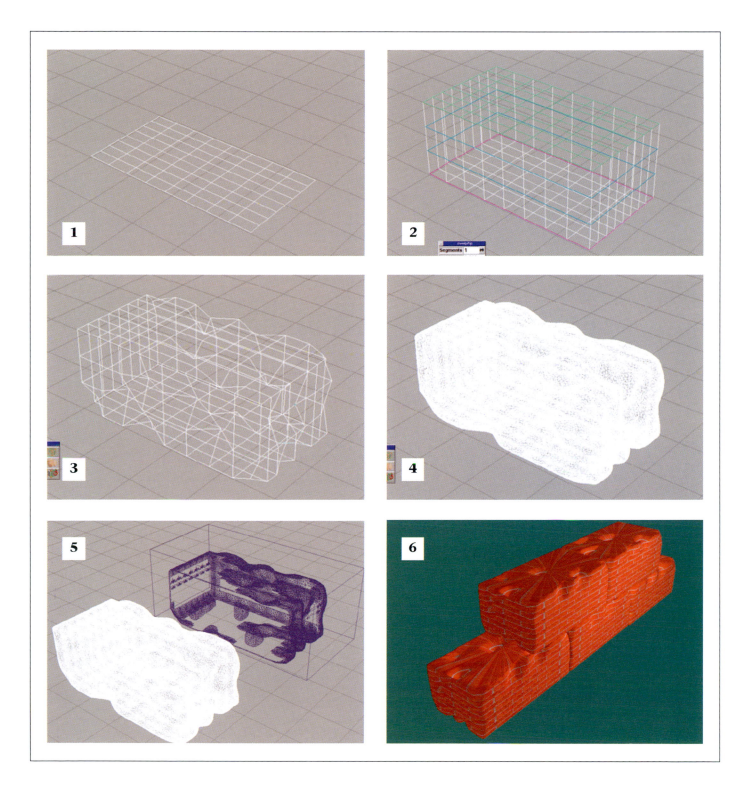

Freeform modelling

The artist feels as he creates digital sculptures using Freeform modelling tools. The technology allows artists to interact with their computers via haptics or touch, resulting in a more natural and intuitive modelling method.

'Wave Wall', a virtual reality.

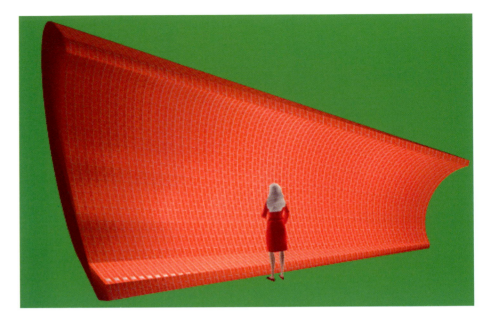

Hypothetical and virtual environments and object scale

Using programs such as Photoshop a virtual model can be scaled and placed upon a photographic shot of the proposed or hypothetical place setting, giving the client a very 'real' idea of how the object will look on site. The artist is also able to produce a virtual maquette, which can be viewed from all angles. An animation can be made giving the impression of walking around the object and given the correct 'camera' position a sense of scale can be implied. Constructional stages can be animated and set within a virtual version of the proposed site to aid project planning and time management. The artist is given a powerful presentation tool with which to create something to submit to the client.

Drawing or model-making cannot explore the potential for ideas to the same depth as the computer can in the same length of time. The virtual reality, classed as 'Creative Rapid Prototyping' can be represented within minutes. In CRP, material costs and time spent in producing successive physical prototypes can be radically reduced because no real object is produced until the creative alternatives have been viewed virtually. It is not uncommon for a miniaturised prototype to loose its impact and qualities when it is scaled up; sometimes some ideas simply will not scale up. With the use of virtual objects and environments and animated 'walk-through' a sense of scale can be truly felt and very expensive potential errors can be rectified before money is committed to a project. In 2001–2002 Ulla Viotti, Jacques Kaufmann, Fritz Vehring and a group of students worked on an innovative 'virtual' project with the German brick industry to develop a strategy for siting artworks in brick across the city of Oldenburg, Germany.

A springboard to the unknown

It is, however, in the realms of the unknown and non-preconceived ideas that this new technology has its greatest potential. The computer mimics our actions using a slightly different rationale to that we might use. By the imposition of mathematically deduced methodology on the creative act, an unpremeditated result often appears and these results can prove remarkably interesting – a source of inspiration in themselves. The computational results can act like a springboard into the unknown.

Here are some examples of applying brick textures to complex modelled objects (see pictures below).

1. I take a simple shape.
2. This has been swept upwards in to 3D, twisted and curved. A simple ovoid plus facial features placed alongside. The completed shape has then been given a skin of a brick texture.
3. A second profile is taken.
4. It is twisted and half looped.
5. In the third example the same profile type has been treated variously including raising to a point and tapering whilst being stretched.

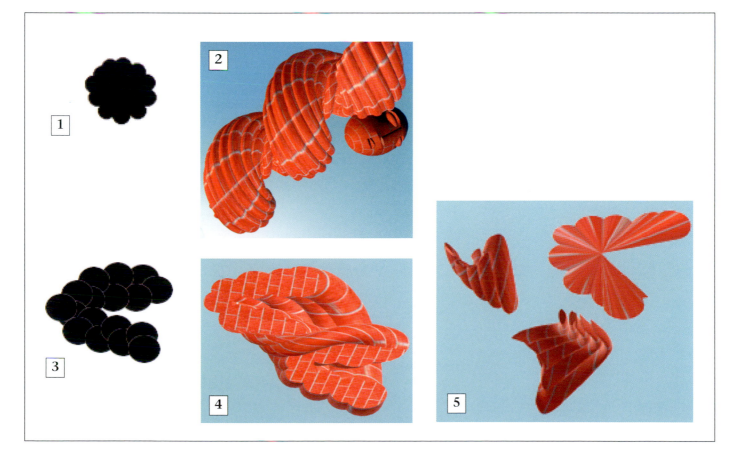

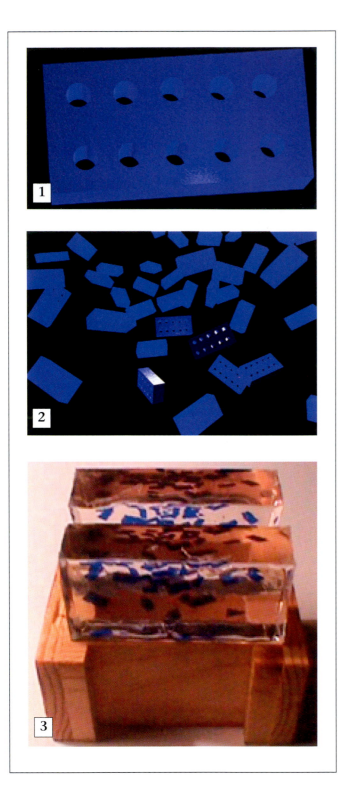

In the following examples by Jacques Kaufmann, the artist has had a very different approach to the new technology.

1. He takes a 3D modelled brick as shown.
2. Kaufmann then makes a large number of copies and sets them in infinite space in random rotation and position.
3. The image is then printed onto transparent paper, which is put in the cast of a clear resin brick shape made from a constructed mould. The ongoing idea is to produce a large number of these 'bricks within bricks' that will be displayed in an as yet undecided format, perhaps set inside an even larger brick and so on.

Justin Marshall CAD/CAM and industry

Marshall studied as a fine artist before completing a Masters degree and PhD in Ceramics at the University of Wales Institute in Cardiff. Whilst studying for his PhD he fostered relationships with industry, and worked within companies developing new strategies for the integration of computer technologies into traditional design and production practices. Marshall feels that the symbiotic relationships between artists and industry can create new forms of practice, 'which may redefine both the idea of a craftsperson and the types of product which industrial manufactures can produce'.

He found through his own research that identifying new products or artworks through an investigation of available technologies, skills and processes with the possibility of making small additions and adaptations, was a more fruitful approach to a collaborative situation than attempting to carry out a fixed preconceived goal. A rigid approach can restrict the possibilities of the maker to take best advantage of the facilities available and can create disappointment when things do not perform in the manner expected and the desired results are not attained.

In a project with Allied Insulators his work took the form of decorative columns, of various sizes, produced using the extruder and vertical turning processes available in the factory. With the help of new tooling (produced by using CAD/CAM technologies), and a restructuring of the

production sequence, this decorative work was simply and economically manufactured. Through the process of CAD/CAM, objects and products can be created that have unique qualities characteristic of that technology, or that are deeply complex and time consuming. This technology can have a direct effect on the production of one-off pieces and specials. It can also be applied to other functions within the production range.

Marshall finds there are several advantages to working in industry. He develops ideas that require industrial machinery such as the tile press and large-scale extruder for brick shapes. Pre-tested clay bodies are available with controlled drying and firing. Professionals are available with greater experience of both the market and the technology of brick and terracotta production. Artists also have time to investigate the potential of computer technology with regard to three-dimensional aspects of brick and terracotta work.

The relationship between the industrial process and the end product can be seen as flexible, dynamic and creative, not static. The employment of processes and technologies are part of a creative process of designing

Mould-formed tile, Justin Marshall. This tile works on the play of light throughout the day, which at times will throw the sculpting into relief.

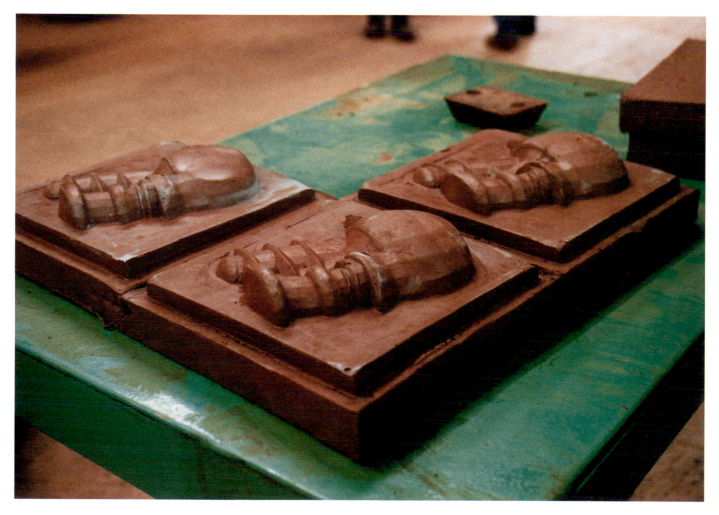

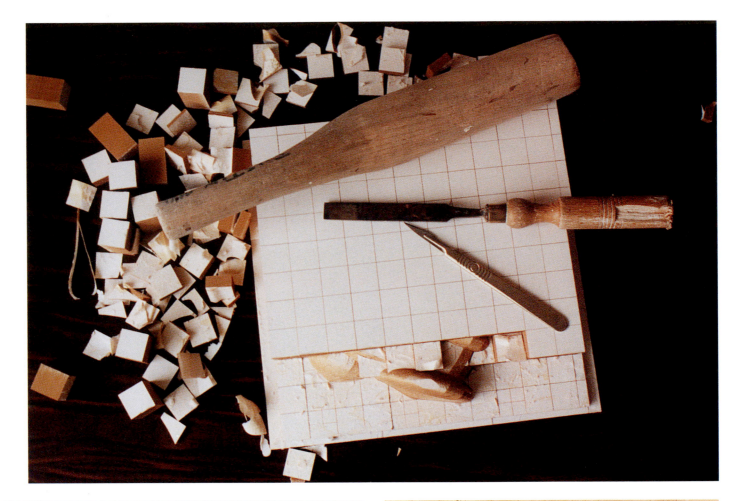

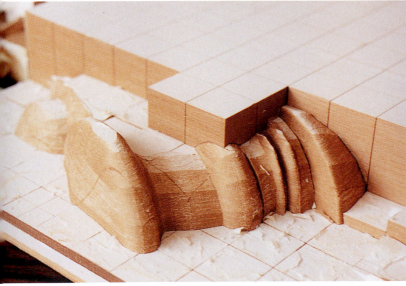

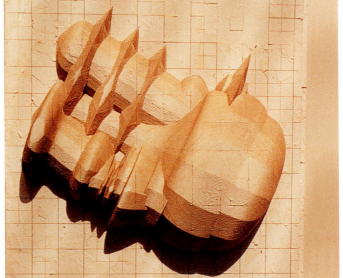

This page: Marshall used 3D modelling together with a laminated object manufacturer and a Macintosh computer to develop a mould for his 3D tile. It was then used to press the tiles on the Favoli tile press at Ibstock.

The shape is developed on the computer and sent to the LOM

(Laminated Object Manufacturer) which builds up layers with long thin sheets of pre-glued paper or plastic across the base plate.

A laser cuts through each layer as it is laid down, the waste around the shape is cross hatched for easy removal. This continues until the shape is built up. Finally a shape is revealed, from which a resin mould is made.

through making and the finished product embodies the conversation between the technologies employed and the intentions of the maker.

(Justin Marshall, 1998.)

Pressed tile design – collaborative CAD/CAM project

Marshall worked with Ibstock Brick, Cattybrook, using extruded blocks, which were then pressed in a tile press manufactured by the Italian engineering company Favoli. This press can produce large volumes of regular tiles – of a maximum size: 35 x 21.5 cm (14 x 8 in.) – quickly and efficiently and has the ability to exert up to 50 tons of pressure. This manufacturing process can be combined with a mould produced by employing CAD/CAM technologies.

CNC router technology

As part of his practice-based PhD Marshall also explored the creative potential of a CNC router or milling machine, as well as the LOM (Laminated Object Manufacturer) which allows the direct translation of CAD design work into 3D material output. There is potential within this technology to produce low-relief artwork in the form of a mould or, in the case of the CNC router, by the direct cutting of clay. It can also be used to cut complex die plates for extrusion and dies for dust pressing.

CAD/CAM technology in the creation of *House Triptych*, 1999

For the Creating the Yellow Brick Road symposium of 1999, Marshall created *House Triptych,* a symbolic triptych carved from Blockleys Brick charcoal brick in which Marshall took further investigations into 3D object making and the relationship between 2D and 3D. A dynamic is set up between the relatively abstract nature of the form and the 2D surface through which the building can be identified, an issue directly related to Marshall's PhD, in which his modelling with the 3D package on the computer directed his work into 3D drawings. The physical houses are like wire-frame drawings. The use of computer generated imagery has enabled the project to be explored as mock-ups which could be experimented with on the computer.

The houses are built using green blocks measuring 30 x 23 x 11 cm (12 x 9 x 4 in.) stacked and carved and then painted all over with a white slip consisting of 50% china clay and 50% ball clay. Computer-

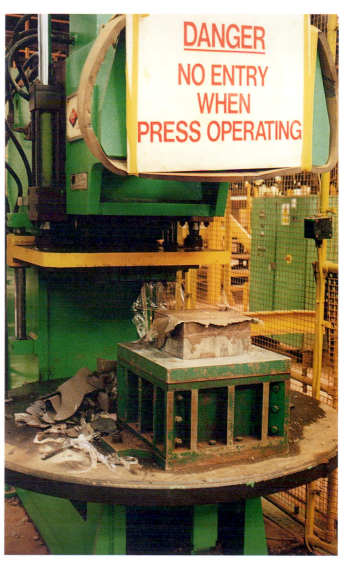

The Favoli Press at Ibstock Brick. A tile being pressed – cling film was placed between the mould and clay before pressing. Tile width: 2 cm (¾ in.).

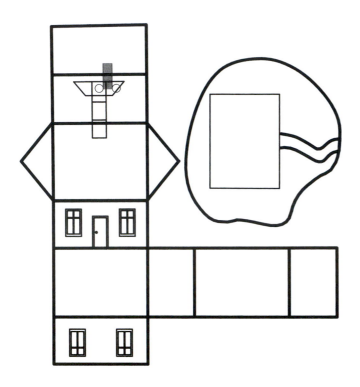

generated line drawings of the house depicting windows, doors and the roof were enlarged on a photocopier then wrapped around the three simple painted brick house forms and the lines traced onto the forms. The lines were then cut through with a sharp modelling tool to show the black brick beneath. The piece is about wrapping a 2D image onto an object, not projecting an image. Marshall produced a number of small cardboard maquettes to generate ideas for the hand-carved piece. These were made directly on the computer as flat plans and then printed and folded into 3D house forms. Plans were also worked out on the computer calculating the exact number of bricks needed in each layer. The use of computer-generated imagery with basic handcutting techniques became an essential element of the work, as it used both traditional methods of construction and new technology. The symposium gave Marshall time to see the potential for expanding his ideas within an architectural form.

Flat plans for House *designed on the computer.*

Below: Cardboard models produced from flat plans on the computer.

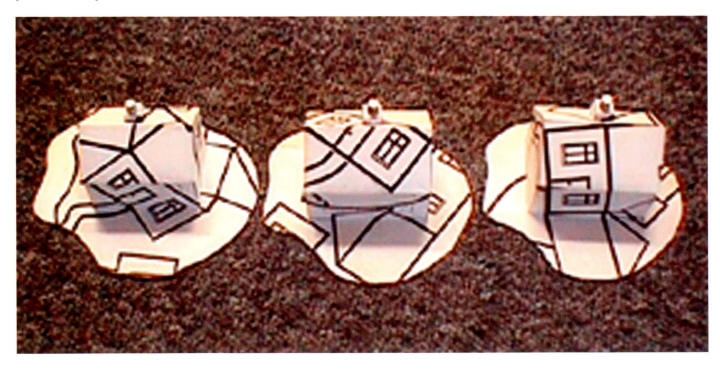

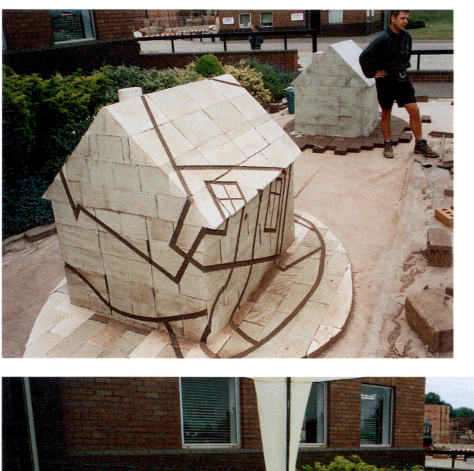

Left: Justin Marshall House Triptych, *Creating the Yellow Brick Road symposium.*
Photograph by Nick Hedges.

Below: Justin Marshall House Triptych, *Creating the Yellow Brick Road symposium.*
Photograph by Nick Hedges.

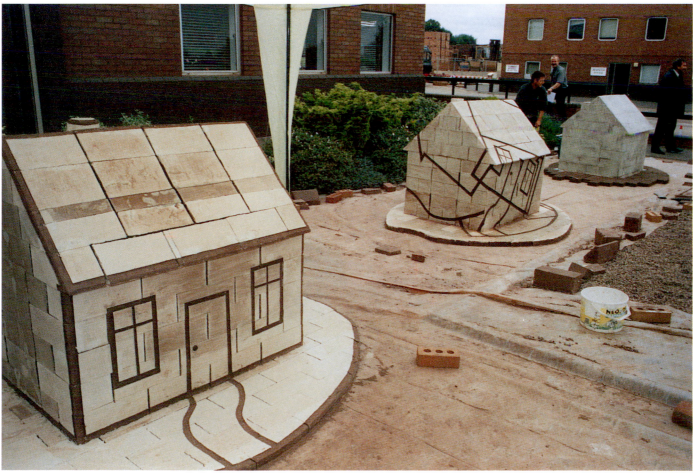

Artists, education and the brick industry

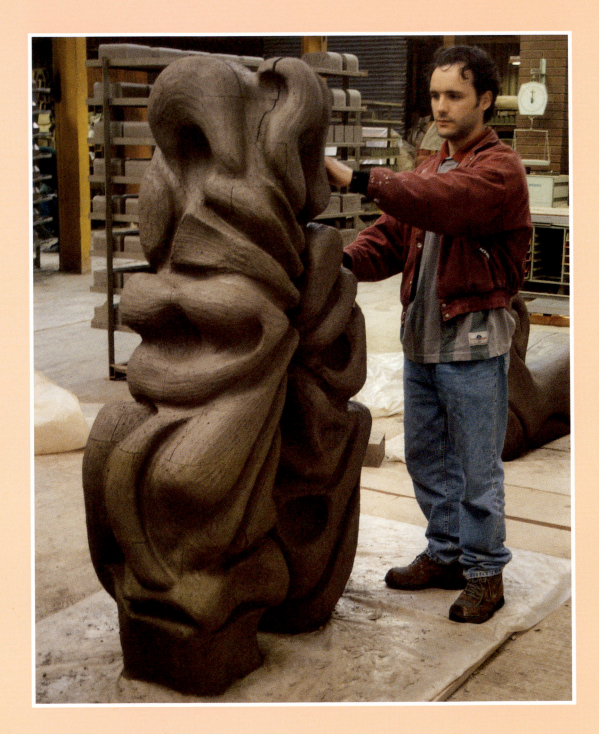

Bill Baker with his sculpture on a placement in the Baggeridge Brick factory, 1999.

International artists and practitioners such as Ulla Viotti and myself have inspired a major revival in the use of brick. Inspired too by current movements in the art world to re-examine the use of new and traditional materials and processes, many artists have started to work within the brick industry. This has also had major implications for education, enabling students to take advantage of facilities and space within the industry to complete large-scale artworks. A number of schools of art and design within the new universities have developed connections with individual brick companies and are now actively placing students within them.

Initially approaching the factory

The majority of artists approaching brick companies with a large-scale project have found they have been positively welcomed onto the shop floor. The factories have provided space, materials, firing expertise and a wealth of knowledge about the making process acquired over centuries by company craftsmen. Artists approaching a company initially need to find out the manager's name by phoning the company. It is then standard procedure to write to the manager setting out the project, followed by a phone call within the week, to negotiate whether the project might have a future. If a meeting is subsequently arranged it is important to take along designs, maquettes and a carefully planned timetable to discuss with the manager.

When I first began to develop work within brick factories I had an unrealistic idea of the time it would take to complete a project. Staff at Ibstock Brick still pull my leg about the few months it was going to take to complete *Mythical Beast* – it eventually took a year! In order to sound professional it is advisable to work out an approximate time scale. It is also very important to discuss costs for use of the facilities. Many companies charge £100 per week for studio space. On top of this you will usually be charged about £40–£50 per palette of bricks (1 tonne/0.98 ton) and a firing fee on top of this. Transport will also be extra. However many factories will sponsor community and school projects, but it may be necessary for the school to approach the factory for this, rather than the artist.

Benefits for the artists

Many contemporary artists have found that working with brick factories has helped shape and empower their work in numerous ways. Not only does this collaboration provide extra working space and resources but it also provides an opportunity for a permanent exchange of information and knowledge. The horizons of what is possible have increased enormously.

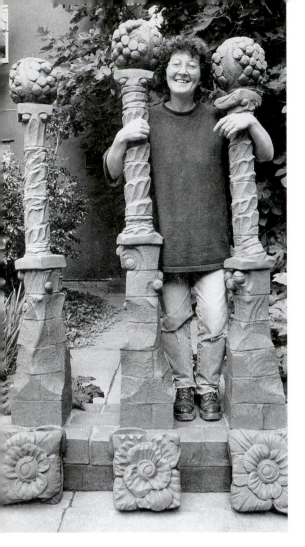

Pauline Monkcom, Brussel Sprout Colonnade,
Courtesy of Ibstock Brick, Cattybrook.
Photograph by Anna Jauncey.

I personally feel that the relationship I have built up with various factories in the past ten years has contributed significantly to my current concerns and practice. This liaison has meant that the work I create is firmly rooted in a craft tradition and creates a secure cultural and historical platform on which to build, develop and benefit from centuries of acquired knowledge and experience. This security has provided a sound basis for experimentation and innovation, a situation which is normally not possible for an artist who has a small and modestly equipped studio.

British artist Pauline Monkcom who has worked with both Ibstock Brick and Dennis Ruabon put it this way:

There are many reasons for choosing the factory environment; space, access to clay, large kilns and specialist equipment are just some. More important than this however are the people who work there, the wealth of knowledge and expertise, late night conversations with the kiln watchman, the sense that whatever the question there's probably someone working in a shed somewhere whose grandfather used to know how to do exactly that.

Monkcom appreciates the fact that working within industry there exists alternative structures, other relationships with ceramics, to those with which she is already familiar in the studio. It could be compared with stepping into a parallel reality where things are familiar – but slightly odd at the same time.

Scale is not an issue in industry. There is a sense of enormous, relentless throughput of clay and clay products. No longer a shrink-wrapped measured commodity, clay is scooped out of hillsides by the truckload and pressed, stamped and sliced into shape at breathtaking speed. Making art in a factory environment feels less of a marginal activity.

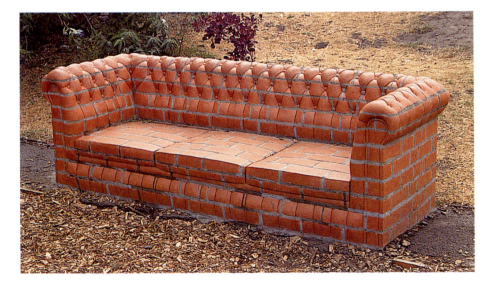

Rodney Harris, Chesterfield, *carved brick,*
St. Werburghs School, Bristol, made with
Ibstock Cheddar Red brick.

For Monkcom this lack of preciousness evokes an incredible feeling of freedom, to experiment with new ways of working and to work on a much bigger scale, whilst minimising the inevitable fear of making big and costly mistakes. Experimentation is not an option: it's a necessity. The different problems of coarser clays, different consistencies, and clay in pre-formed blocks or bricks demand different solutions. The result is a much freer approach to shaping the clay. It requires carving with clay wires and big loop tools, hitting and twisting the bricks using bits of wood and metal pipe allowing clay and tools to make their own contribution, rather than have complete control over form and surface.

Rodney Harris, another British artist, uses brick factories for practical design advice, materials, sponsorship and firing/making facilities.

If the support they can provide is always acknowledged, and the interaction carefully nurtured, a mutually beneficial long-term relationship can be established. Many commissions including restoration work are secured through Ibstock Brick. I also have the opportunity to display my work in the factory premises and commissions have been secured this way from architects.

Working in industry can also feed back into studio practice, as Bill Baker, a student from Wolverhampton University, discovered during a placement at Baggeridge Brick. He found he gained a tremendous insight into the numerous possibilities of working with brick, which gave his studio work a freedom and confidence which he had not before encountered.

He developed a working methodology, which relied on processes based around force, tension, pressure and direct manipulation of the clay. The initial inspiration for these processes came directly from his placement in industry, watching the clay being forced into wooden moulds or forced through the metal dies of the brick extruder. The basic method he uses is as follows:

Methodology drawing of Bill Baker's piece.

1. Several bricks are bonded together, covered with glaze powders and beaten into a suitable size with a wooden batten.

2. The resulting form is then secured with ropes and clamps into a negative framework constructed from wooden blocks, which are moulded with the use of carpenter's tools.

3. Metal fragments are then embedded into the wooden framework and their identities forever preserved in the final form.

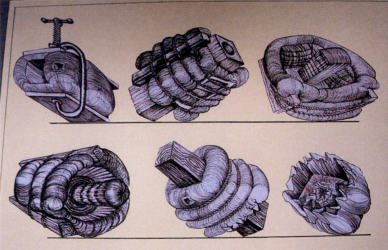

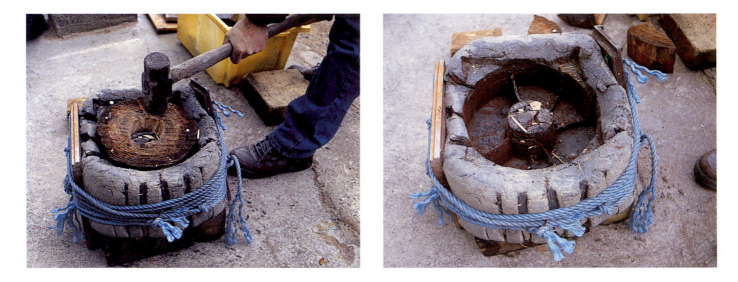

Above, left: Several bricks are bonded together, covered with glaze powders and beaten into a suitable size with a wooden batten. A wooden former is hammered into the centre.

Above, right: The wooden former is removed from the block.

4. A wooden structure is placed on top of the encased clay form and driven into it by force with a sledgehammer. This forces the clay downwards and outwards embedding itself in the encasement.

5. Finally the former is removed leaving its impression in the brick piece.

Benefits for the company

The artist-factory collaborations benefit both parties. As John Troth, retired managing director of Dennis Ruabon, Wrexham, explains:

> *When we experience artists transforming square bricks into remarkable shapes it vastly expands our understanding of the medium. Working with artists feeds back dramatically in terms of our own design consciousness. It enables us to look at our own materials and ask ourselves what we can do to develop our own approach and design dimension.*

Artist, Rodney Harris, employed on an 'ad hoc' basis by Ibstock Brick to design moulds for the production of special blocks agrees:

> *An artist can develop and expand the potential and versatility of a product. Imagery produced by artists working in brick is a very important marketing tool.*

Often as a result of observing artists and students working on techniques that were previously unknown to them, factories take on commissions that they would have never previously considered. Artist David Mach also feels that industry can benefit from collaborating with artists. He feels that in the past, in Britain, the brick industry and the public have not been prepared

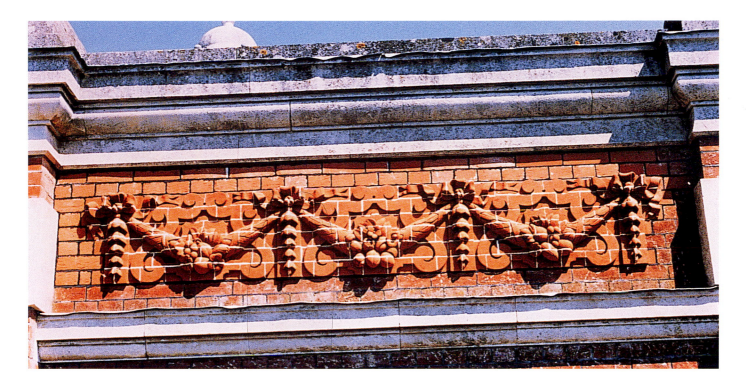

Rodney Harris, reproduction blocks produced at Ibstock Brick.

to spend money on innovation preferring instead to play safe; 'lets mimic history and keep to what we know' (from Creating The Yellow Brick Road).

From the earliest stages of working with Ibstock Brick in the 1980s, I realised that the presence of artists/students in the factory was extremely beneficial to the factory in that the workers there became closely involved with the projects, giving them a sense of ownership. Consequently they took great pride in what went on, treating each piece with great care through all stages of the making process. In the case of the Ebbw Vale Garden Festival, the men even named *Mythical Beast* 'Billy' and watched 'his' progress at every opportunity, organising a site visit whilst the work was being constructed at the festival site.

Sponsorship of artists has a major spin-off for the company. *Nine Benches* (*see* p.55) in Cardiff Bay lead to one of the largest projects Dennis Ruabon have ever been involved with resulting in the company supplying the Cardiff Bay area with pavers – bricks designed especially to cover vast areas of exterior walkways and plazas – over a ten-year period. The benches initiated a great deal of positive public relations for the company.

The brick manufacturing companies, having lost that in-house design expertise traditionally supplied by master craftsmen and sculptors employed by the factories, see great benefit in building up a register of artists, who can be approached when special commissions arise. Restoration work is another area for which freelance artists are often called in. Ibstock Hathernware used artists for some of the restoration work on the Natural History Museum and the Hackney Hippodrome.

Education and industry

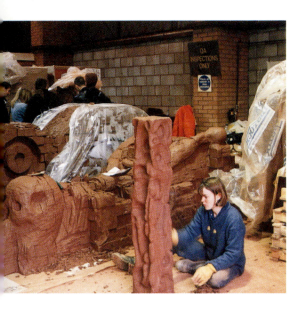

Above: Students working in the factory at Ibstock Brick, Cattybrook on 1st year project.

Below: Michael Thomas (one of a group of 2nd year students) working on a site-specific project in the factory at Ibstock Brick, Cannock.

Education and industry could do much more to feed from each other, giving students a greater confidence that industry is an exciting and innovative place to be and in which to build a career. Educational establishments often have a stereotypical tunnel vision view of industry – a throwback to the 1930s and 1940s.
(John Troth retired Managing Director, Dennis Ruabon Brick Company)

Working in industry on a placement can expose students to the endless possibilities for innovation and experimentation with new and traditional industrial processes and technologies. This collaboration can benefit the future of architectural ceramics within education, challenging the somewhat restricted view held by many students and teachers, of what constitutes contemporary ceramics practice.

There is always a risk as well as a challenge in placing relatively inexperienced students in a demanding industrial environment. Students often take industrial placements for granted, not understanding that the demands of production take priority over their own project needs. One has to be circumspect in selecting students who need to be well briefed before entering an industrial environment.

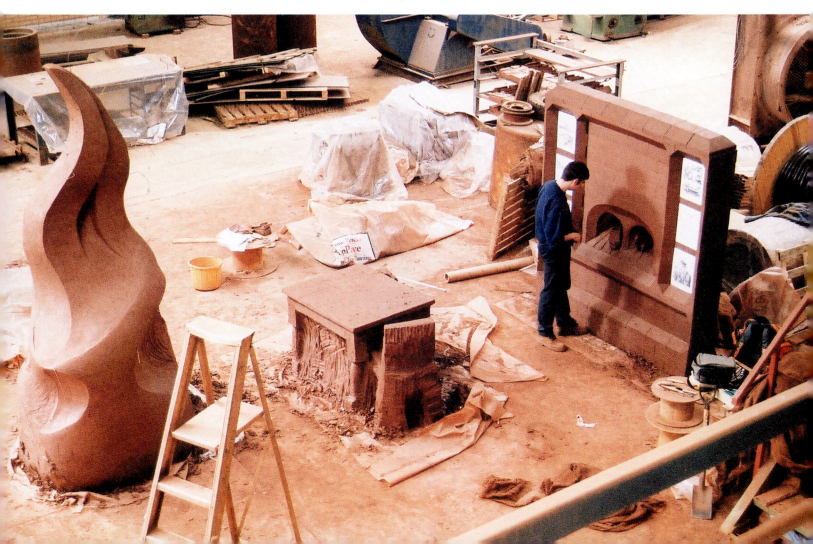

John Troth feels strongly that his company should be committed to education. He is the Chairman of the Careers Service Company in Mold, North Wales and also chairman of the governors of the Northeast Wales Institute. He has always encouraged students to work in the company and believes that:

Experiencing a factory situation changes the student's perception of industry. Students gain a respect for working practices, especially those on the shop floor. One of our first students came from the Northeast Wales Institute to work on a project and finally ended up working for the company for five years. She designed and made murals, designed floor tiles, developed a series of mural panels for prestigious public buildings and a sensory seat for a tactile garden for blind children.

Troth believes that the world of education could benefit from knowledge of the wealth creation process, with students working within industry beginning to gain a financial understanding of how the economy is run. An ideal situation would be for a company such as Ibstock Brick or Dennis Ruabon to employ up-and-coming artists fresh from university. In the 1830s design schools were set up with the idea of training designers for industry to improve the aesthetic qualities of products and to also

First year project, Translations, *St Fagan's Museum, South Glamorgan. In certain situations the brick factory will deliver blocks to site. Students developed site-specific pieces.*

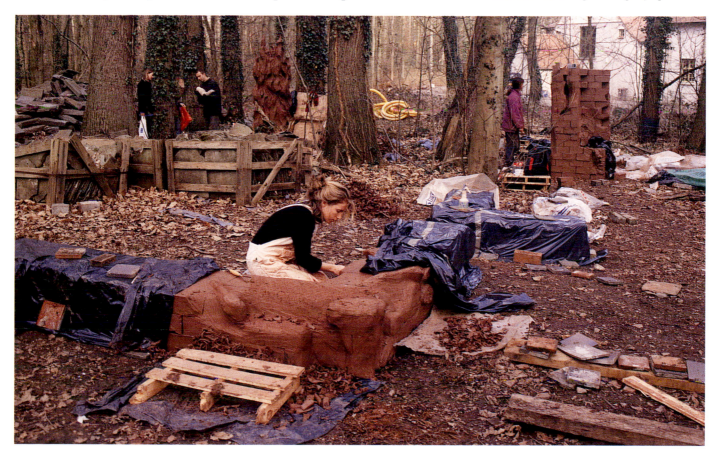

increase exports of British goods. This had the effect of improving the whole economy.

During the 1890s, as part of the Arts and Crafts Movement, institutions such as the Royal College of Art and other successful institutions developed links with industry and with local technical schools that taught basic building skills such as bricklaying. In the early 20th century, collaboration between art schools and industry reached a new high. Art school graduates entered industry as modellers and became responsible for 'specials' departments. In some cases these artisans then returned to take up lecturing posts in art schools and in turn taught trainee modellers who were sent back into the industry (see *Terracotta Revival* by Michael Stratton for further information).

In the 1960s 'specials' departments closed down in most factories. Education and industry became separated and lost touch with what each other had to offer. The building boom in the 1980s started to redress this as factories who now had no craftsmen saw the potential for artists to design 'specials' and create one-off features for buildings.

My own links with the brick industry, first established with *Mythical Beast,* serve well to illustrate the potential for students being supported and encouraged by industry. Upon leaving the RCA in 1989, I was appointed a Research Fellow in the Centre for Ceramics Studies at the University of Wales Institute, Cardiff, at which time I was able to work on the project within the 'specials' department of Ibstock Brick, Cattybrook. This evolved over a year of experimentation and innovation, in which many of the institute students were also involved. It was at this point that I realised with the facilities available – technology, studio space, production line, firing capacities and skilled craftsmen – the parameters of ceramic practice could be substantially expanded.

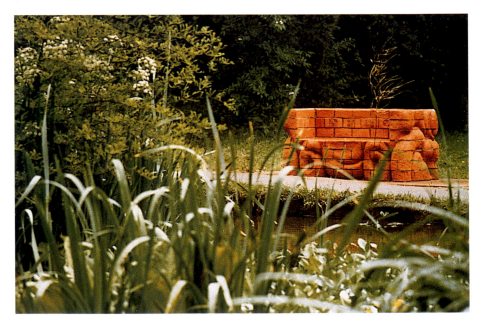

Bench by Bettina Baumann, in situ at Cefn-non Park, Cardiff, 1996.

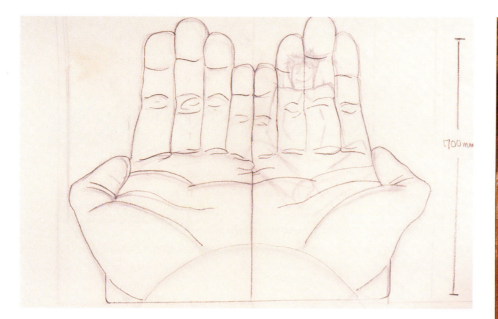

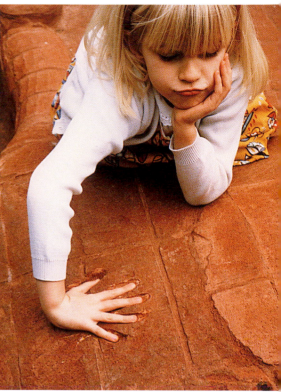

Above: Presentation drawing to Cardiff Bay Arts Trust, by Kelly Booth.

Right: Detail from Hands Seating, *Grangetown Infants School, Cardiff, 1997. Plaster mould-making, and drawing workshops were run as part of project, to create prints of children's hands.*

Below: Kelly Booth, Hands Seating, *in situ at Grangetown Infants School.*

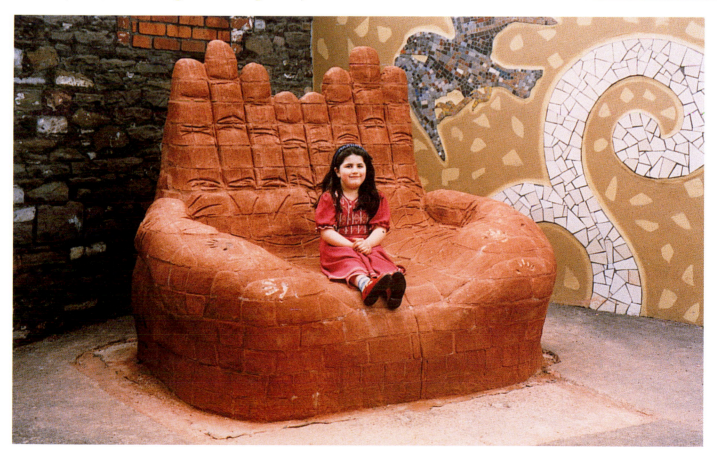

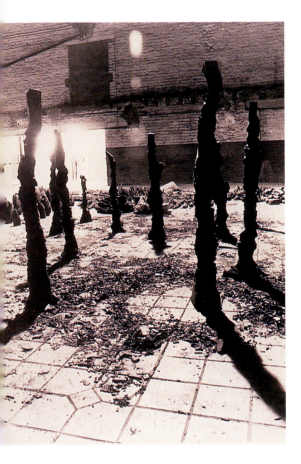

Will Moss, work in progress, using discarded bricks from extrusions at Dennis Ruabon.

Available to both the students and myself were skilled craftsmen who were able to open our eyes to the potential for creating large-scale public sculptures within industry. We were able to use the company's computer to work out complex designs, bricklaying techniques, brick sizes for extrusion on the production line etc. It was also relatively straightforward to have 4,000 bricks of an individual design manufactured within 24 hours. A project on the scale of *Mythical Beast* would have been totally out of the question with the facilities normally available within education.

Over the past ten years in my capacity as a senior lecturer, I have initiated a series of industrial placements for ceramic students within the brick industry, placements that have given them the opportunity to experience industry and which have also proved to be extremely beneficial to the companies involved. Currently, Ibstock Brick, Baggeridge Brick, Blockleys Brick, Red Bank and Dennis Ruabon accept students on placements and an MA bursary at the Blockleys Brick factory in Telford is now in place.

Industrial placements are usually linked to specific modules within the university curriculum, often site-specific and possibly linked to environmental and social issues, or focusing on a specific location, building or museum collection etc. Occasionally I set up the teaching module as a real competition in collaboration with one of the art agencies who may have already identified a potential commission. These modules give the students the opportunity to develop site-specific, large-scale artworks within the brick factory. Students are encouraged to approach the factory, initially for sponsorship, and then to approach clients such as the local authorities and architects to try and get work sited at their chosen locations. As part of the module students are taught to make a presentation of their ideas to the group as they would to a real client.

After responding to such a module and developing work at the Ibstock Brick, Cattybrook factory, student Bettina Baumann presented her idea to the Cardiff Parks and Gardens and was successful in siting her work in Cefn-non Park on the outskirts of Cardiff. Another student, Kelly Booth successfully won a competition to develop seating for a Cardiff primary school, which included running workshops to create plaster prints of the children's hands to be impressed into the seating – large carved brick hands based on friendship, in which children could nestle (see p.175). They both supervised the installation of their own work. The scale and nature of the projects gave the students an excellent insight into site-specific work, the problems and the organisation needed. (Note that planning permission is normally required for such projects.)

Other students respond to module briefs in experimental ways. Will Moss worked at the Dennis Ruabon factory with discarded brick thrown into the skips after extrusion. His installation is a direct attempt to deal with this waste material in an innovative and creative way.

Health and safety

Health and safety issues are paramount and once in the factory environment, students are required to be vigilant about signing in and following factory regulations. Establishing whether the university or company has insurance liability is also very important. It may be necessary for students to arrange their own insurance. Masks, polyester overalls, boots and, often, helmets need to be worn when working on large-scale artworks. Sulphur dioxide fumes can be dangerous when working next to brick kilns and specialist masks need to be worn. Additives to brick clay can be lethal – these can include barium carbonate, or potassium nitrate, to stop scumming on fired brick.

Professional and research careers linked to the brick industry

Many of the students with whom I have had contact in the Centre for Ceramics Studies in Cardiff and The University of Wolverhampton are now professionally established as practitioners within architectural ceramics and public art. Two in particular, Eleanor Wheeler and Rodney Harris, are now actively pursuing careers in architectural ceramics/public art. Both are working and liaising with factories throughout the country. Eleanor Wheeler has produced some major public commissions in Britain, and has successfully completed a PhD in architectural ceramics. Justin Marshall is working closely with Ibstock Brick in the development of work using CAD/CAM technologies, CNC router and milling machines to produce artwork for moulding or direct cutting of machine extruded bricks and tiles (see Chapter Eight).

From my experience as student, research fellow, practitioner and teacher, I am convinced that there is enormous potential for collaboration between industry and education. Industrial experience challenges the contemporary, conventional and somewhat restricted view of studio based ceramic practice. Through the exploration of industrial techniques and methodology students can play a crucial role in reinventing both traditional materials and attitudes to architectural ceramics in the 21st century. By welcoming students onto the shop floor, supporting and sponsoring local community and school projects, industry can play an exciting role in creating opportunities for artists to work in a public context.

Specialist art centres, workshops and symposia

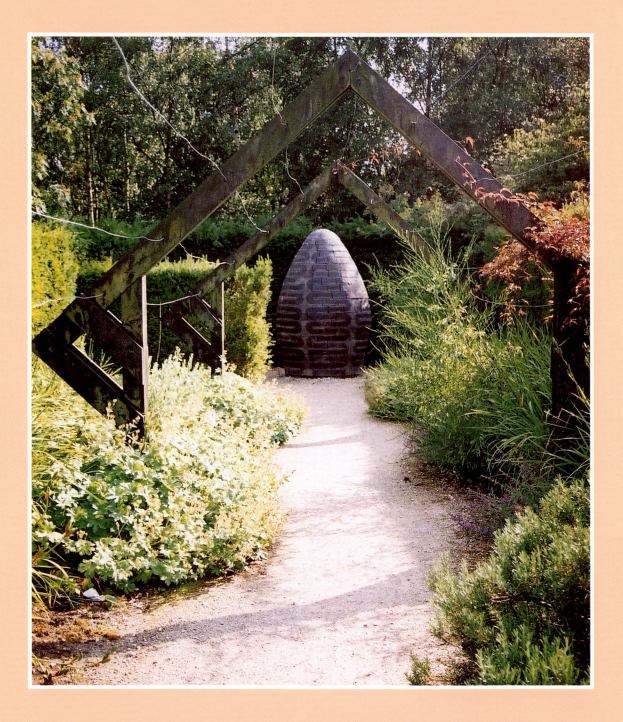

The finished Egg Form by Peter Randall-Page, in situ at Rufford Country Park, 2003.
The bricks were produced at Blockley's Brick, Telford. See pp.185–87 for methods of construction.

Artists wishing to develop large-scale ceramic sculpture have a number of alternatives to using the brick industry. In America, Scandinavia and Europe, a number of specialist art centres and workshops have emerged with specific expertise for facilitating and constructing large-scale ceramic projects. International symposia may also provide the chance for artists to explore and experiment with large-scale artworks.

Art centres

Over the past 20 years, a number of art centres have been set up in America within the confines of old brick factories. These centres have residency programmes, which will often give the artist a grant/scholarship for a period of time and allow the artist to explore their medium as they choose. The centres supply the artist with material, equipment and expertise, and the artists are then expected to use these facilities to experiment and to develop their own methods and ideas with a freedom impossible if having to earn a living. Three of the major American foundations are the Archie Bray Foundation, the Bemis Centre for the Arts, and the Kohler Arts Centre.

Archie Bray Foundation, Montana, USA

Formerly the Western Clay Manufacturing Company, The Archie Bray Foundation in Montana is the oldest ceramic residency program in the USA. A list of the resident artists who have worked at the foundation since 1951 reads like a guide to the history of contemporary ceramics. The foundation, an important part of a post-war ceramic revolution in the United Sates, was first started as a pottery by the factory owner, Archie Bray, himself, on the brickyard premises.

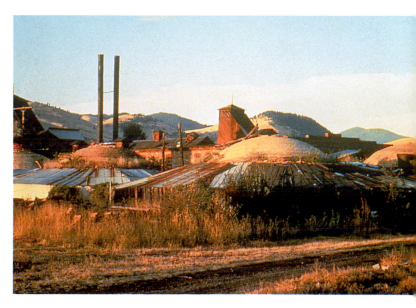

Beehive kilns, Archie Bray Foundation, USA. Photograph courtesy of Robert Harrison.

*In the early 1950s, ceramicists working in the United States began to develop a style and approach very different from their European peers, reflecting the post-atomic age, influences of Zen Buddhism and abstract-expressionism. The distinctions between art and craft, function and object were challenged. Clay acquired fine art status and moving beyond the studio ceramic artists began to develop large scale, site-specific works.
(From the Archie Bray catalogue.)*

The eminent American ceramicists Peter Voulkos and Rudy Autio were employed in 1951 as brickyard labourers after graduating form Montana State College. Working in the brickyard during the day building the original studios, they produced their

own work in the evenings. The brickworks closed down in the 1960s but the pottery stayed open. In 1970, Dave and Judy Cornell came from Penlan School of Crafts to take over. A wood-fired kiln was built, buildings were renovated and the clay business, all that was now left of the former brick company business, expanded. Even plans to transform the old beehive kilns into museums were discussed. Then in 1984 the property was sold to the foundation and new studios were built. Residents were inspired by the remnants of the brickyard to create highly experimental, permanent and temporary site-specific sculpture on the site. In 1985, resident artist Robert Harrison began such a project, which would take him a full two years to realise. This was the start of Harrison's long association with the foundation.

Residents at the Archie Bray Foundation come from all over the world. Renewable residencies at the Bray run anywhere from 3 months to a year, 18 residents are accepted for the summer and eight in the winter. In the words of Rudy Autio, 'There wasn't anything impossible in ceramics after you had been at the Bray'.

The Bemis Centre for the Arts, Nebraska, USA

The centre was established by Ree Shonlau in the old Omaha Brickworks in 1981. Shonlau had previously worked with important international ceramic artists such as Betty Woodman and Jun Kaneko on large-scale projects. The Centre offers residencies for established and emerging artists, as well as exhibitions, lectures, performances, and educational projects. The centre awards three to six month residencies open to artists of different media.

Jun Kaneko working inside the beehive kilns at The Bemis Centre for the Arts.
Photograph courtesy of The Bemis Centre for the Arts.

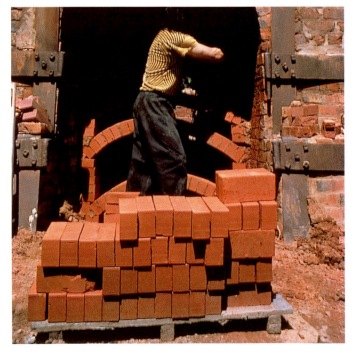

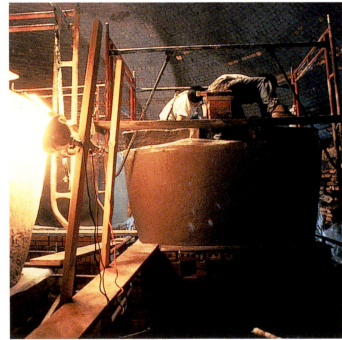

Kohler Arts Centre, Wisconsin, USA

The centre is a major innovator and exploratory laboratory for artist-in-industry collaborative programmes. It is now set up to run architectural projects. Caroline Court, an artist from Detroit, Michigan has participated in many of the artist-in-industry programmes. From the artist's point of view, this residency offers artists industrial materials and technologies that they otherwise would not have in their studios.

Specialised workshops

There are now a number of specialised workshops that will produce large-scale, monumental, site-specific sculpture. Large-scale is taken here to mean works that have a human dimension to works in excess of 10 m (33 ft) high, produced in a variety of architectural clays and brick. Usually a team of experts carries out the work for the artist. Artists wishing to develop large-scale public art works in brick or ceramics can now take advantage of these facilities without any prior knowledge of ceramics.

In Denmark Ebsen Madsen has set up the Tommerup Centre within a working brick factory and in Holland Henke Trumpie has developed the specialist workshop facility and group 'Struktuur 68'.

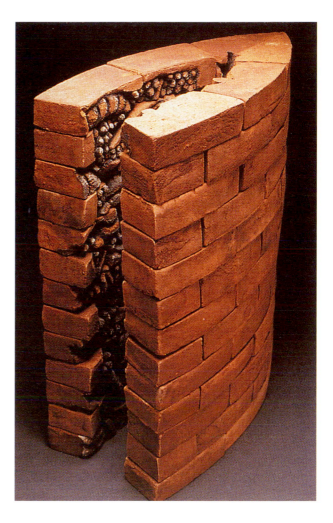

Persephone by *Caroline Court, 1992.*
Photograph courtesy of the Kohler Arts Centre.

Tommerup Centre, Denmark

In 1987, Ebsen Madsen and Gunhild Rudjord set up the artist workshop Keramisk Vaerksted at Tommerup in the clay-rich area of Funen in Denmark. The setting up of these facilities has been a catalyst for a number of major international large-scale ceramics projects using both the traditional factory-glazed brick production and the more experimental new facilities set up by Madsen. As Madsen explains:

We often have to invent things, because besides making plaster moulds, we also make our tools and machines. The ability to think untraditionally, to have the necessary qualifications, to make quick decisions, and have the courage to carry through impossible ideas… that means we can decide what is important and stretch the limits of what clay can do. The workshop has also been an incubator for some of the most exciting things that have happened in our field.

Many artists have worked with architects to produce decorative glazed brickwork and architects developing individual designs have sought help

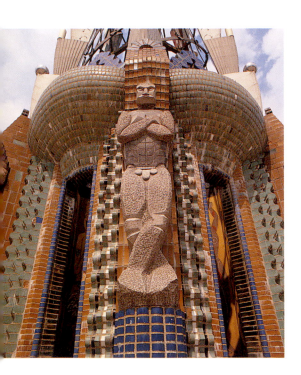

Above: Bjorn Norgaard, detail of Thor's Tarn (Thor's Tower)*. Photograph by Larsn Kaskov.*

Right: Bjorn Norgaard, Thor's Tarn (Thor's Tower)*, 1986. Height: 26.5 m (87 ft).* *Photograph by Larsn Kaskov.*

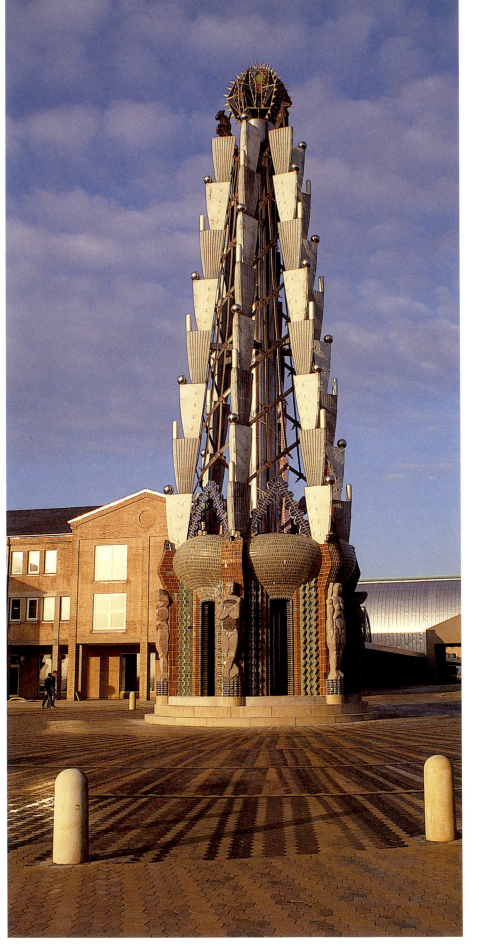

and collaboration in finding glazed bricks for building decoration. In Denmark there has been a revival in the use of such decoration in the post-modern era. *Thor's Tarn* was created in 1986 by artist Bjorn Norgaard in Copenhagen Denmark. Measuring 26.5 m (88.3 ft) high, and 8 m (26.2 ft) in diameter. The tower is constructed from 26,000 glazed bricks, steel, glass and concrete. Another artist, Emil Gregersen, has worked with the architects Friis & Moltke to create the distinctive tower structure at the JTAS telephone headquarters at Slet Athus. A third artist, Merete Baker, designed the patterned brickwork at the Sandbakken housing development in Skade near Arthus, in collaboration with C.F. Moler, Architects.

Struktuur 68, The Hague, Netherlands

Henk Trumpie founded Struktuur 68 in 1968. The studio has applied itself to the manufacturing of large-scale ceramic sculpture in collaboration with many international artists (many of whom have been unfamiliar with ceramics). In 1968 while working with CoBrA, a post war group of artists from Copenhagen, Brussels and Amsterdam, the studio developed a palette of brightly coloured glazes that have become the hallmark of Struktuur 68.

An important part of a professional meeting between art and craft can produce innovative and experimental ideas and push the boundaries of a material and a philosophy.

In close co-operation with the different artists the team work out the models or drawings, and together they invent solutions and techniques sometimes leading to a new architectural approach. Work is usually built and modelled solid and then cut into sections and hollowed out so eventually the work is fired in large architectural blocks as in the brick factory. Trumpie states that:

Anybody confronting the enormous Gate of Ishtar [see picture on p.8], erected about 2500 years ago in Babylon, will experience the elements on which the activities of our studio are based: ceramics, architecture/art, relief and colour. Artists working together with specialist studios can be traced back to 15th century Florence where the Della Robbia family established a workshop in 1464 based on their realisation of ceramics. Designers and artists involved with ceramics within architecture are often not ceramicists or craftsmen familiar with this specific field. It is therefore vital that they work in collaboration with specialised factories or studios offering the relevant facilities and expertise.

These factories, centres and foundations have proved to be an important vehicle for enabling brick artists to expand their knowledge and realise

creative and ambitious projects which otherwise would not have been possible for artists working in isolation from small unequipped studios. These collaborations have also served to strengthen and develop positive links with art and industry.

Symposia

Symposia allows for a radical development in international exchange between artists, whereby brick has become a cross-cultural material, commenting on a number of social, cultural and historical issues. It has become an essential arena for international artists to work together for intensive periods creating collaborative, experimental and innovative works of art. The symposium is also an important catalyst for increasing debate on a number of issues relating to the creative, social, cultural, industrial and historical implications of working with a traditional material such as brick. One of the first brick factory symposiums was held in Poland, on the Russian border, in 1960. The symposiums were very useful to artists from iron-curtain countries, as they provided one of the few opportunities to communicate with the outside world. Other examples include a symposia in Germany, put together by the organisation Keramische Gestaling, in 1997, to highlight the absence of brick within the city of Dresden since the war, and one held in Beer-Sheva, Israel, in 1997, to create a series of permanent site-specific sculptures.

The revival in the use of brick has encouraged the brick industry to become major sponsors and participants of the brick symposium. In July 1999 the University of Wolverhampton organised the symposium Creating The Yellow Brick Road as part of the Ceramics Millennium Arts Festival celebrations in an attempt to explore and strengthen the links between art, architecture, architectural ceramics and industry. It debated experimental and ground breaking ways in which industry, artists, architects and landscape architects could work together, benefiting from a mutual understanding of what each could offer the other and pushing the boundaries of what is possible in the creation of a new vision for the future. Over 70 tons (70 tonnes) of fired and unfired brick was donated by the brick industries who also provided workspace, kilns and labour.

Important issues were discussed at the conference and symposium, such as the effect of Modernism on architecture, the loss of decoration and adornment, the loss of specialist craftspeople within the brick industry, and the role of the brick industry today. Issues such as how to re-equip manufacturers with such specialist skills, and how to encourage architects and commissioning bodies such as local authorities to incorporate creative ceramic work into the design of buildings were two major concerns.

One major problem discussed with reference to the industry in the UK, is the tendency for urban buildings to remain rooted in Neo-classicism,

whilst architects and designers have moved on. Brick companies (mainly for financial reasons), have been unable to keep pace, and architects are looking to Germany and Japan for superior products. It was hoped that the debate would encourage new links between ceramics and industrial applications that have become very separated over the previous decades. This may have an effect on the way the brick industry operates in the future not purely manufacturing a necessary product and servicing artists and architects but being totally involved in the artistic and creative forces which drive such artistic expression. It was hoped that a new way forward might be stimulated through such discussion.

Artists development through symposia

For many artists the chance to work in a new material at a symposium can bring about exciting results. At the Creating the Yellow Brick Road symposium, for example, Peter Randall-Page, well known for his stone-

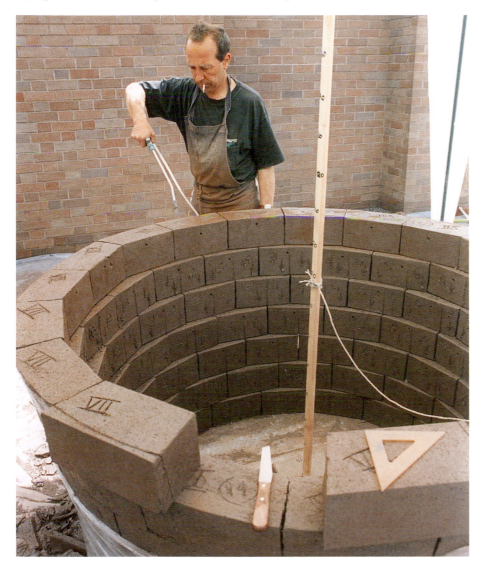

Left: Peter Randall-Page, working on his egg form, using pole and string to determine the circumference. Photographs by Nick Hedges.

Above: Bricks cut and shaped with wire-cutter.

Above: Bricks cut and shaped with knife.

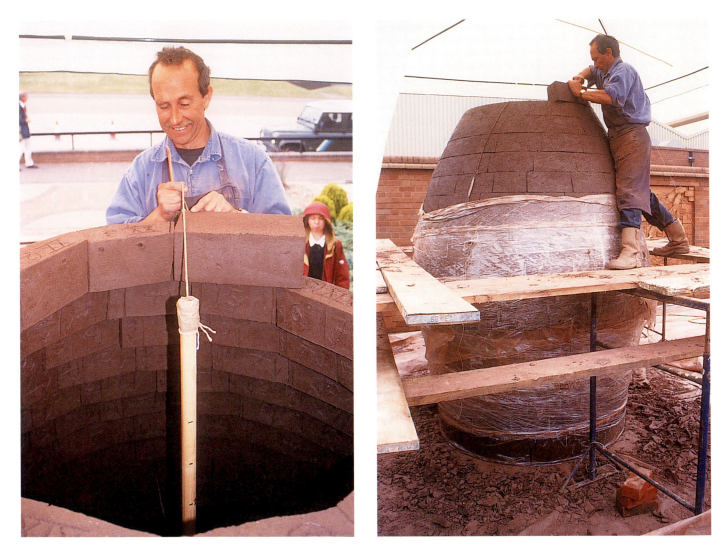

Above, left: Cantilevered bricks cut and built up, then carved on the outside. Photograph by Nick Hedges.

Above, right: Egg shape emerging. Photograph by Nick Hedges.

carving, worked at the Blockleys Brick factory to create a hollow egg-shaped form, 5 m (16.7 ft) high, constructed from a series of cantilevered, wedge or arch-shaped bricks. Using a pole and string to determine the circumference of the circle, a precise methodology was applied to the making process akin to that applied in his stone carving. The bricks were cut as arch bricks to a prescribed angle. The construction evolved by cantilevering each layer of brick to maintain stability and carving the surface as the shape emerged. The strength of a cantilevered structure was very apparent in the presentation of Tim Ronalds the architect who had orchestrated The Landmark entertainment centre in Ilfracombe, Devon (see p.151), Randall-Page decorated the egg-like structure with a black manganese slip.

For me, work created at symposia provides the opportunity to explore a personal language free of the inevitable restrictions of public commissions. The intense creative atmosphere working with artists from different cultures and traditions brings about wholly unexpected conclusions enabling work to develop using familiar methodologies and extending

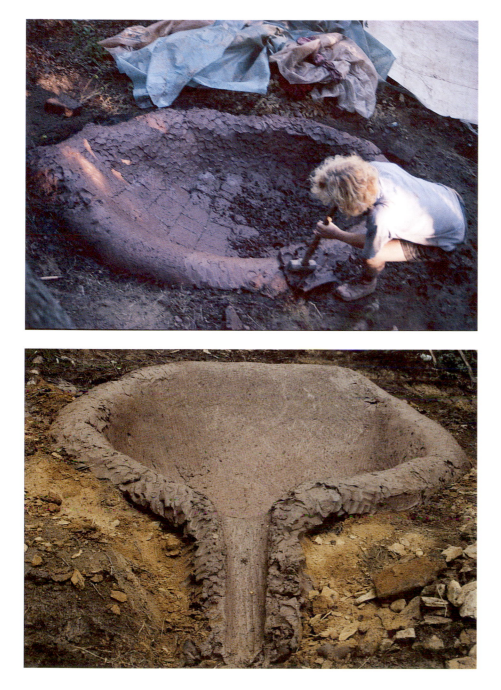

Left and below: Gwen Heeney, Forced, *bricks were hammered into a shaped hole and then sawdust fired in situ.*

their possibilities. For example *Forced*, developed at the Resources Wales symposium in 1996 was created from brick forced into the ground and sawdust fired in situ. Time spent at the Yellow Brick Road symposium enabled me to develop the specialist skills I had learnt at the brick factories developing the creative potential of complicated wooden formers to produce *Insight*. This certainly has implications for the development of my site-specific public commissioned work.

Commissions, artist residencies, sponsorship and costing

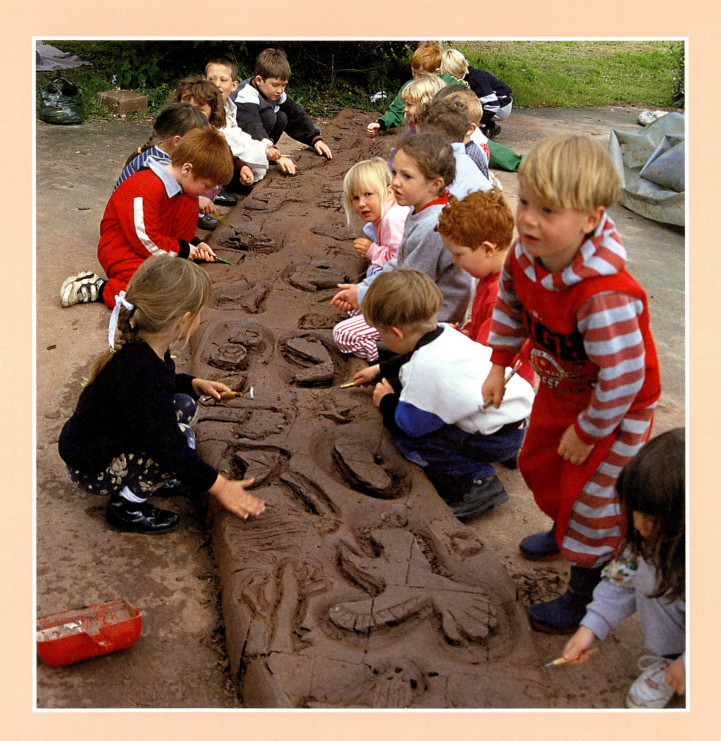

Leighton Pathway, project by Gwen Heeney, Leighton Junior School, Powys, Wales, 1977. Carved brick.

This chapter explores the various ways that artists can procure commissions for site-specific artworks in the public domain. Artists may initiate a public commission themselves, they may apply for a commission or artist residency through a public competition, or they may be invited by the client or artists' agency to put forward a proposal for a commission. I will also discuss sponsorship and costing of public commissions and residencies.

Public commissions

When applying for a commission initially the most important thing to do is to visit the site to get a sense of the environment and the inhabitants. Inspiration for the artwork needs a great deal of research, which will involve looking at local history and geography, appropriate myths and legends and contemporary local events. The functional, decorative, narrative or conceptual aspect of the work needs to be explored. Artworks may need to be integral to, or enhance a specific space or existing building. Their purpose may be to bring about change within a particular environment. Community involvement may need to be an essential ingredient. All these relative facts need to be explored.

It is also important to acquire a sense of the scale of work required along with the appropriate use of materials and colour and form for that site. When a decision is made to use brick you will need a sound rationale behind its use for that particular commission. In the case of many of my own commissions the use of brick will often tie in with an historical use of the material or complement materials, or the brick already used on

Presentation board for Nine Benches, *Britannia Park, Cardiff Bay. This piece was inspired by the façade of the Pier Head building in Cardiff Bay.*

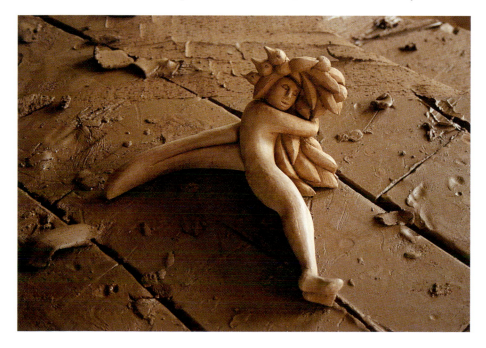

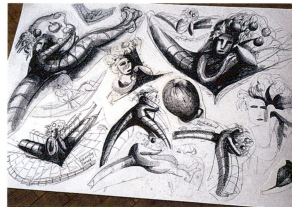

Above: Initial sketches for maquette of Rhiannon.

Left: Maquette for Rhiannon, *Atlantic Wharf, Cardiff.*

Left: Site for Rhiannon *before construction, Atlantic Wharf, Cardiff.*

Below: Gwen Heeney, Rhiannon, *Atlantic Wharf, Cardiff.*

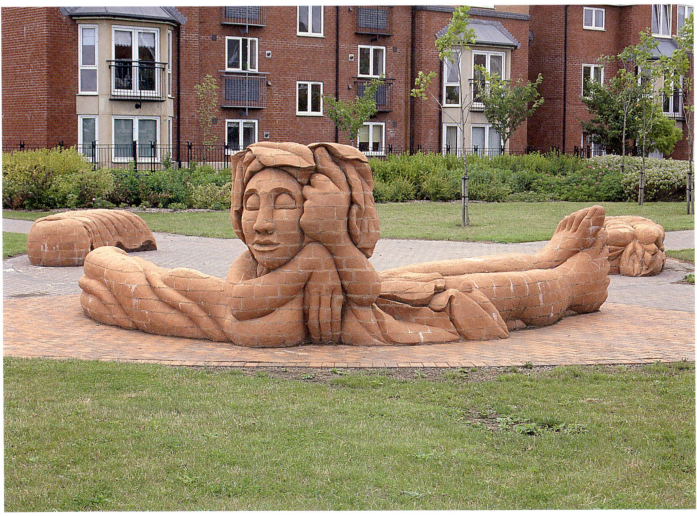

site. In the *Nine Benches* for Cardiff Bay I used Dennis Ruabon Red. This had also been used by Ruabon to produce the terracotta façade of the Pier Head building, in the Victorian era, which overlooked the site. The brick of *Rhiannon* at Atlantic Wharf complemented the new housing already built on the estate.

When I give a presentation for a commission I usually take a maquette (scale of 1:20), with presentation boards showing the site and artwork superimposed through photomontage or PhotoShop, or 3D animation. A1 boards can be seen by all the clients at once and give the artist cues from which to conduct the interview. (For the Glan Clwyd Hospital commission I was interviewed by 20 people, including the hospital trustees, and the visual arts team.) A presentation projected from a laptop computer can be really impressive, but I find not everybody has the essential technology for the projection, and so to be on the safe side you have to take everything (including projector) to the interview. At this stage it is always useful to have a brick factory committed to the proposal. (See also the *Mythical Beast* project in Chapter Four.)

Self-initiated commissions

A number of artists see the potential within a certain environment, building or landscape for the realisation of an idea. The idea will then become the force behind a series of moves towards realising the project. This does result, however, in an enormous amount of work on the artist's part to gain sponsorship and to liaise with industry on the production process. For students, initiating an idea needs a great deal of confidence, but this may be the first step in a career in public art.

Public Competitions and commissions

In the UK, a number of artists use the commission's pages of the *AN* (Artist Newsletter) and the Creative Media pages of *The Guardian* newspaper to apply for relevant commissions, often advertised as collaborative projects with the local community, or with local industry.

When an artist is well known for a certain type of work they, along with a number of selected artists, may be invited by the clients, architects and/or artist agencies to put forward a proposal for a commission. These would then be considered, with a final proposal chosen for the project.

Artist residencies and community projects

Artist in residence programmes are usually organised by the Regional Arts Councils or by artists' agencies and are advertised in magazines such as the *AN*. Residencies are very competitive and artists who are able to raise sponsorship before the interview may have an advantage. A number of brick factories sponsor school and community projects, supplying

green bricks for carving on site then transporting them back to the factory for firing. The factories usually need to be approached by the organisation employing the artist – usually the school or artists' agency. The artist is paid either a flat fee or a daily rate. Other expenses such as foundations, builders, transport to site and scaffolding should be met by the school or commissioning body.

Artist in Residence programmes usually fall into a number of categories:

1. The artist is commissioned to create a piece of their own work with community and school workshops running alongside.
2. The artist is commissioned to orchestrate and produce a work which is to be made and designed by the community/children.
3. The work is designed by the artist and carried out by the community/children.
4. The work is designed by the community/children and made by the artist.

David Mackie, who works on a number of community projects involving urban regeneration, believes that:

Accessible artworks can contribute a sense of identity and character to a specific environment and can facilitate a sense of ownership. Artwork can reflect and reinforce quality and innovation in urban development and

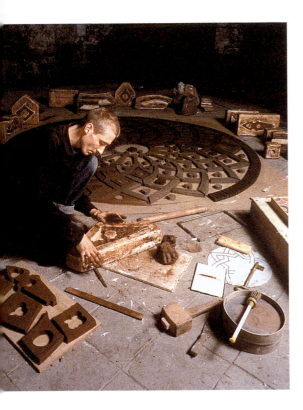

Above: David Mackie working in his studio.

Below: David Mackie, project at West Lea Infants School, Buckley, 1995.

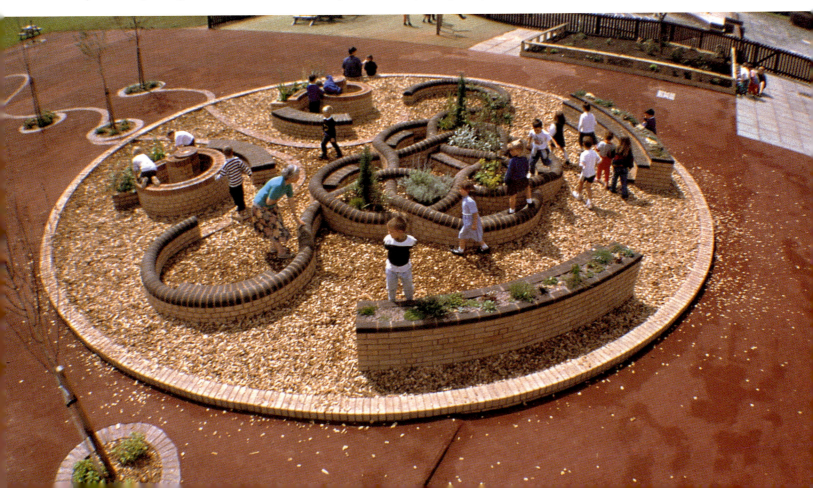

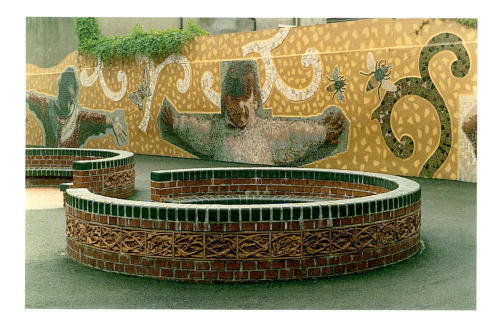

Left: David Mackie, Nests, *Grangetown Infants School, Cardiff, 1996.*

alternative perspectives, such as those of residents, can inform the design process as a whole.

Dilys Jackson, like Mackie, is based in Wales and also works on community projects. She has created a series of benches with schools and local communities to be sited along the Ogmore Valley cyclepath in South Wales. The benches were built and installed with the support of Environment Wales and Sustrans, developers of the National Cycle Network. Ibstock Brick donated bricks.

People are fascinated by the idea of being able to make their 'mark', to become part of a durable public work. They have some notion of the great

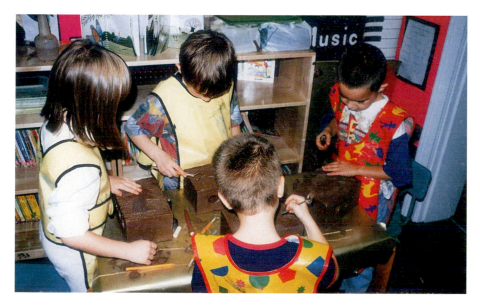

Above: A brick sculpted by one of the children.

Left: Detail of children working on bricks.

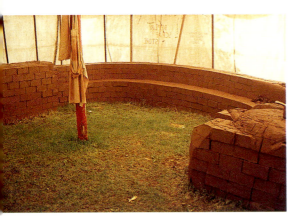

Above: Marquee erected to work in, on Branwen Arena project, Oldford Junior School, Powys.

brick and the tile works of ancient civilisations that may still be seen today and they can imagine a simple act of carving as similarly giving them a place in history. It is a safe and economical process, which can involve large groups working together. It is an ideal way to involve the community in producing works for their environment.

(Dilys Jackson)

Artist residencies often require working on site in the environment or in a temporary studio. During the making of the Branwen Arena I worked in a 10 m (39 ft) long marquee in the school grounds, sometimes in sub-zero temperatures and had to cover the work with blankets during the night. *Taliesin Sculptured Bench* (a 10-tonne/9.8 ton sculpture) was made on a sprung wooden floor of the railway café whilst it was closed for the winter. Working on site can present a number of problems related to the transporting of large amounts of green brick so that they arrive at the site intact and are returned to the factory for firing intact after carving and dismantling. This can render them very fragile. Large-scale projects often require the hire of forklifts and experienced transport companies. This could have serious repercussions on the project budget, as transport companies work independently of the factory.

I always choose a residency which requires me to create my own work with related workshops running alongside. The site-specific functional nature of my own work in carved brick presents a number of opportunities for people to be engaged with and participate in a creative process.

Below: Branwen Arena, 1997. Based on the story of Branwen from The Mabinogion.

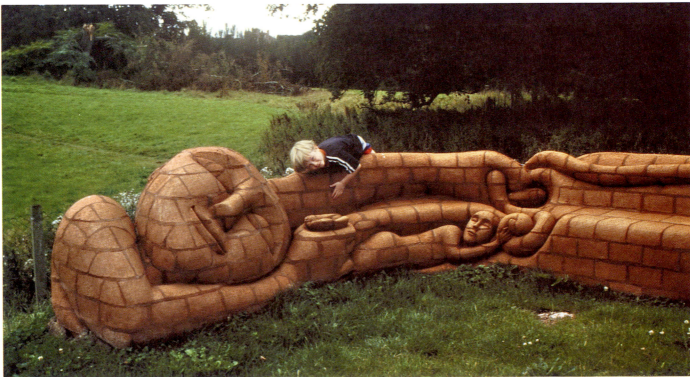

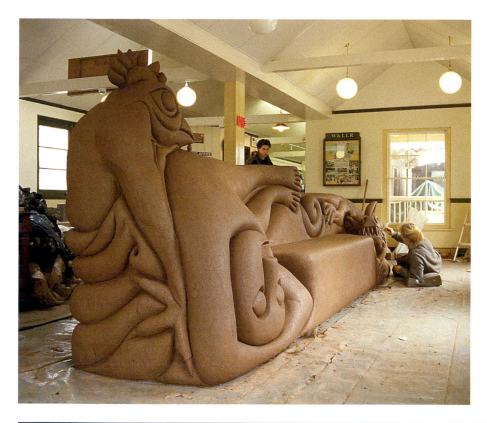

Left: Sculpted bench Taliesin *of carved brick, Llanfair, Caereinion, Powys, made in the café of the Light Railway whilst closed during winter.*

Below: Finished bench Taliesin *in position outside the leisure centre, Llanfair Caereinion, Powys. This bench was unfortunately sited (unbeknown to me) on a favourite spot for children to play ball. They were not very pleased with the arrival of the sculpture – a lesson for all; do thorough research before agreeing to projects and check out the site.*

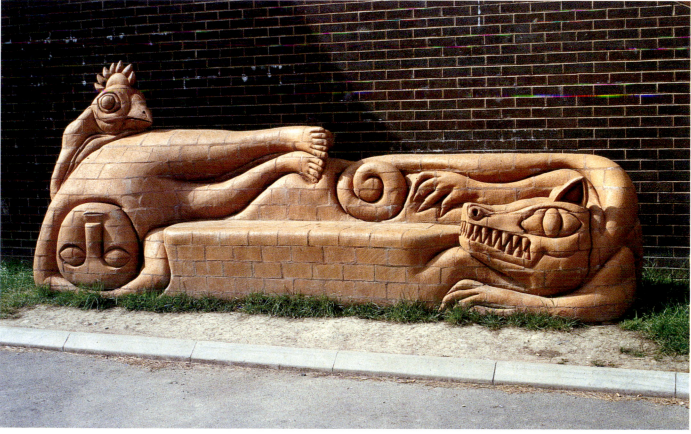

Right: Drawing in the school grounds. One pupil brought her horse, which the whole school took turns to draw.

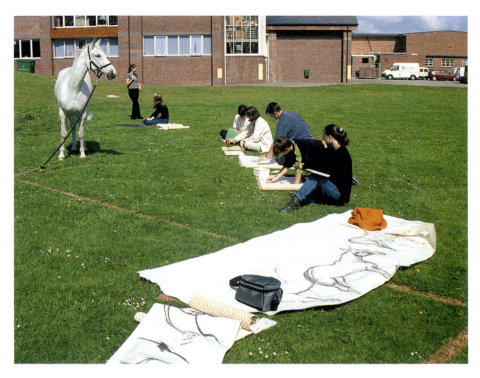

Below: Bid Ben Bid Bont, *showing the horse section and hand of Bran, inspired by the story in* The Mabinogion *of the God Bran stretching across the waters to allow his men to cross the sea.*

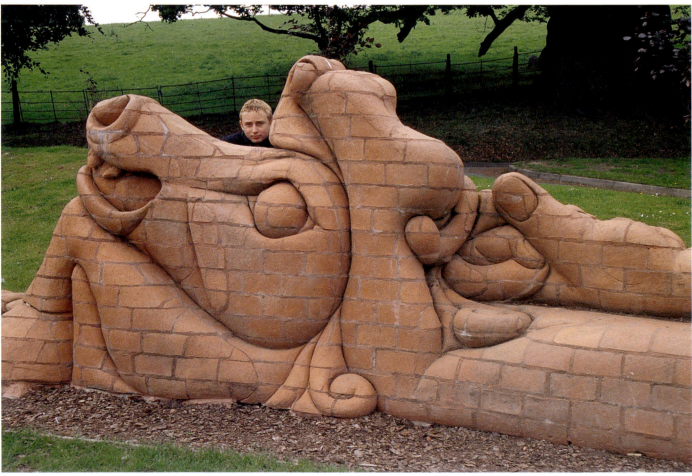

The residency programme gives me the chance to communicate directly with an audience, and the interaction of the public with the work and with certain aspects of the making process fosters a sense of ownership and helps to develop respect for and understanding of the work.

For example, *Bid Ben Bid Bont,* based on the school motto and tales from the Welsh myths was commissioned by Llanfyllin High School and the Arts Council of Wales, the brief being to create a sculptured bench in the grounds of the school and initiate a series of related workshops with the school and community. Dennis Ruabon sponsored the project providing 17 tons (17 tonnes) of unfired brick/architectural block which were delivered to site, constructed and carved in the studio, then dismantled and returned to Ruabon for firing. During the 12-month part-time residency an excellent studio was provided in the old stable block in the grounds of the school.

Pupils were involved at all stages of the project. Ideas were developed through drawing, storytelling, and research into historical and contemporary art. Maquettes were constructed with sixth form pupils who also helped with the initial construction of the work. Carving workshops were organised with younger children, each carving their own brick. It was important that all of the pupils were able to access the artist at all times in order to view the entire process. When the carving was complete and the work dismantled, the whole school assisted over a period of two weeks in the hollowing of each of the 3000 blocks/bricks (necessary for an even firing). As part of the project children from the school visited the factory to see the firing. Evening workshops with other members of the local community were also organised.

For a number of my commissions, a way of ensuring community involvement is through the creation of a pathway carved by the school

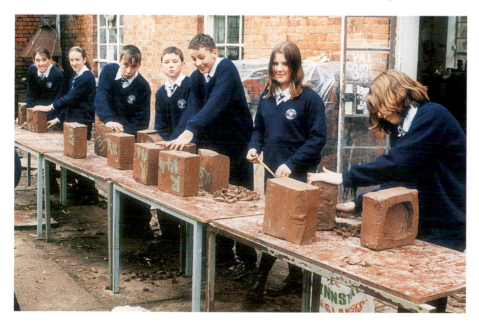

Pupils from the school hollow out the carved bricks, which make up the sculpture.

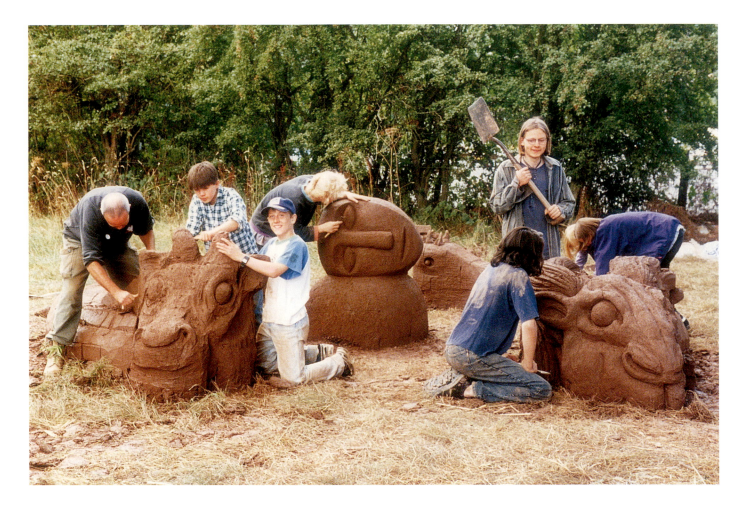

Artist in residence at Powis Castle, 1996. Work carried out with community groups and children. Temporary artwork carved from Ibstock Brick, green bricks delivered to site.

or community, which relates to my commissioned piece. I have also worked with communities on one-day and three-day outdoor workshops where temporary non-fired structures were built, with wet brick delivered to site.

The American artist Caroline Court sees community involvement in certain aspects of her work as an essential part of her creative process. *Penelopeia,* a 4 m (13.3 ft) -tall brick arch inspired by Homers epic tale *The Odyssey*, stands on the front plaza of the US Customs Inspection Facility at the Ambassadors Bridge in Detroit. It is constructed from approximately 2,100 hand-cut wedge-shaped and standard bricks. The form is pierced by an opening that reveals over 340 carved and glazed bricks made by the many people who participated in the project. These included US Customs inspectors, commercial truck drivers, neighbourhood children, students and the various tradesmen who worked on the installation. In carving sessions at her studio and at other locations in the neighborhood participants were invited to carve their name and sentiments onto a soft unfired brick. This community project was initiated as part of the Art in Architecture Program which gives 0.5% of the estimated cost of a Federal building or courthouse for commissioning works of art.

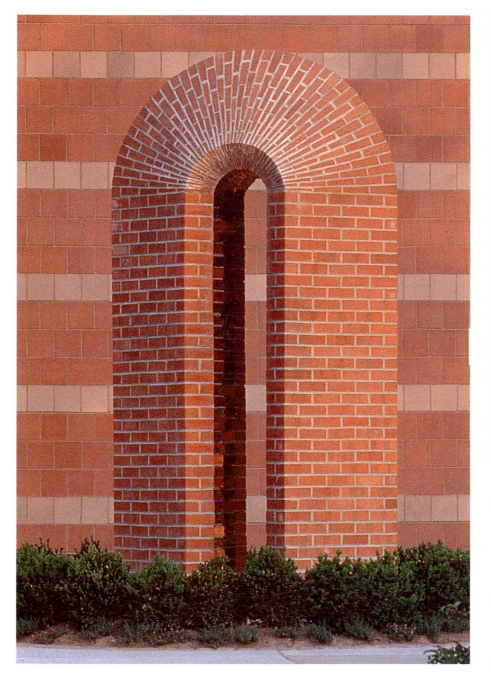

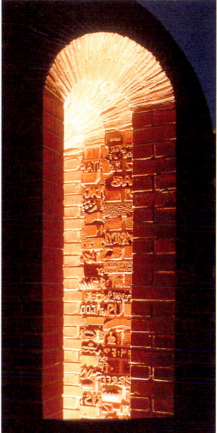

Above: Caroline Court, Penelopeia, *lit at night. Showing bricks which have been carved individually by community groups.* Photograph by Tim Thayer.

Left: Caroline Court, Penelopeia, *dimensions: 3.7 x 4.6 m (12.5 x 15 ft). Made from shale bricks and located in the plaza of the US Customs Inspection Facility, Ambassadors Bridge, Detroit.* Photograph by Tim Thayer.

Sponsorship & Costings

Commissioning fees

In the UK, *AN* publishes fact sheets and has a help line which may deal with many issues relating to costing projects. Public commissions are carried out under so many different circumstances that a general rule on costing cannot always apply. The standing of the artist, complexity of commission, time scale of commission and installation all need to be assessed. In some circumstances it may be necessary to employ an

estimator or quantity surveyor. Each commission is unique and may present unforseen problems, so allow for this in the project budget and timetable.

Design Fees

The fees for initial concept designs can range from £250 to £1500. Ideas can represent months of work and years of experience and education.

Terms of Contract

You must always draw up a contract for public art commissions. If you are not working with an artists' agency you can obtain a ready published 'Visual Arts Contract' from *AN*, these can be downloaded from their website. Always state your terms clearly. Presentation of invoices at various stages of the contract is important – very few artists can afford large overdrafts. Sometimes commissioners tend to treat artists as contractors, not taking into account that they work on small budgets and do not have facilities for large-scale loans. Always have your payments made in stages. Artists' agencies can act as intermediaries between the artist and client, and can help to organise payment in stages. It may also be important to have your work signed off at various stages along the way so that there is no request to repay monies already paid if the client decides not to go ahead with the commission at any stage. An example could be as follows:

- First payment 25% upon completion of Stage 1.
 Detailed design stage, including costing, material and method specification. This stage completed by a given date when the design will be presented to the client and agent, and upon acceptance the contract signed.
- Second payment 25% upon commencement of Stage 2.
 Preparation of work in a brick factory.
- Third payment 25% upon commencement of Stage 3.
 Site preparation and installation of work on site. Making good of the site. Clearing away debris after construction – may need to hire firm for this.
- Fourth payment 25% upon formal acceptance of the work.

Installation costs for brick sculpture

- Insurance (artists indemnity)/public liability.
 Usually the artist is responsible for all insurance before the work arrives on site and also for all public liability insurance covering their activities both on and off the site in respect of creation, delivery and installation of the work. Public liability insurance to a minimum of £5 million is necessary at the time of going to press. It is important

to note that public artists need public liability for their lifetime because any fault with your work will be liable to you at any time. This means that if the work is faulty and falls on somebody 20 years after it has been installed you (or your bricklayer) could be liable. Otherwise you would need to keep up your insurance until you die! Artists may also require an indemnity insurance to cover any design faults.

- Engineers' consultation fees
- Transport/Carriage
- Hire of equipment (excavators, concrete mixers etc.)
- Extra labour costs (craftsmen)
- Landscape clearance fees
- Landscape artist's fees
- Site restoration after installation
- Rental of accommodation close to the installation site
- Hire of fencing to enclose site

Use of artist's work for advertising purposes

High profile projects provide the opportunity for the sponsor to promote their goods or services. In the case of the *Mythical Beast,* Ibstock Brick have used the image in their catalogue for the past ten years.

Gaining sponsorship through the media

Using the press as a means of publicising a project, and requesting funding, can be a very effective way of finding sponsorship. For example, in my own Ebbw Vale commission, extra finance was urgently needed to continue the planting for *Mythical Beast* and I turned to the press for help.

I had an article published about the commission in the local newspaper asking for sponsors. A list of relevant local industries and businesses was sought and an invitation was sent to each, inviting them to a presentation. A slide presentation was given with information and drawings. There was a positive response and sponsorship was gained. All media coverage must name the sponsors.

Sponsorship agreements

It is important to be clear about what you can offer the sponsor. Do not commit yourself to anything which may be binding and you could find difficult to fulfil, simply in order to get the sponsorship. It could be advisable to make, with the sponsor, a written sponsorship agreement. Normally the sponsor will want the company logo prominently displayed in the vicinity of the piece, and may also want the right to use the piece within their own promotional materials. Ibstock Brick, for instance, display their logo in close proximity to the piece, and also had the right to use the Garden Festival logo on their own publicity material with the wording 'Official Sponsor of Garden Festival, Wales'. Ibstock were given advertising space in the Garden Festival programme at special

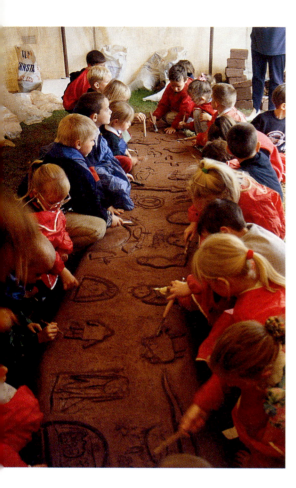

Children carving bricks for Oldford Pathway, *Oldford Junior school, Powys.*

rates, and had their logo included on Garden Festival literature. Ibstock were also provided with complimentary passes and use of hospitality facilities at the Festival.

In return, Ibstock supplied materials, use of factory facilities to create the piece, transport to the site for the completed piece, and pavers on which the sculpture was placed. The agreement between the artist and Ibstock covered such issues as insurance (Ibstock provided public liability insurance for work in the factory), workspace, drying and firing facilities. It was agreed that dimensions and clay weight, type of clay and firing temperatures should all fall within the normal production range of the factory. The cost of providing clay, workspace, drying and firing were all covered by Ibstock.

Public funding

Funding opportunities from sources such as in the UK, the British National Lottery, should also be investigated. New initiatives for artists and industrial collaboration exist. Grantmaking trusts can also be approached for project funding. It is important to remember that applying for public funding can be a very lengthy process, perhaps taking up to a year for large projects. Many local authorities have officers who can give advice on applying for public funding for arts projects.

Conclusion

With its historical, social and contextual possibilities there is enormous potential for further exploration of the creative use of brick. The potential for industrial collaboration and artistic, architectural and technological intervention are dramatic, affecting the way we perceive a material which for 10,000 years has never failed to adapt itself to a rapidly changing world.

Current movements such as symposia are a lively field for collaboration between artists, industry and architects and a meeting ground for experimentation and innovation. Industrial collaborations with high profile international artists have created opportunities for the realisation of large-scale site-specific public artworks. This has had repercussions for ceramic practitioners giving new insights into a familiar material. The educational implications are exciting and I feel it is important that we encourage our students to see the broader picture and enable them to become involved in professional projects.

There is enormous potential for collaboration between industry and education. Industrial experience challenges the contemporary, conventional and somewhat restricted view of studio based ceramic practice. Through the exploration of industrial techniques and methodology students can play a crucial role in reinventing both traditional materials and

attitudes to architectural ceramics in the 21st century. By welcoming students onto the shop floor, and supporting and sponsoring local community and school projects, industry can play an exciting role in creating opportunities for artists to work in a public context.

In the 21st century it would be excellent practice for the brick companies to improve the aesthetic qualities of their products by employing up-and-coming artists fresh from university and training them up as designers for industry, thereby giving the brick industry the creative input it needs.

Within the UK, NESTA (the National Endowment for Science Technology and the Arts) is the new funding body formed to encourage individual artists to work on designated projects. It provides opportunities for individuals who wish, for example, to spend a period of time experimenting in a brick factory, to receive funding. This is one step further in the development of a collaborative working situation to promote the creation of large-scale ceramic works for public sites. The creation of a forum would provide an arena for further discussion and open up more opportunities for industry, architects and artists to meet and discuss current issues.

Suppliers and Services

Brick suppliers

UK

Baggeridge Brick Plc
Fir Street, Sedgley, Dudley,
Midlands DY3 4AA
Tel: 01902 880555 Fax: 01902 880432
Managing director: Alan Baxter

Blockley's Brick Ltd.
Trench Lock Industrial Estate,
Telford, Shropshire, Tf1 5RY
Tel: 01952 251933
Managing director: David Roberts
Sales director: Ian Cook

Brick Development Association
Woodside House, Winkfield,
Windsor, Berks SL42DX
Tel: 01344 885651 Fax: 01344 890129
E-mail brick @brick.org.uk
Senior Architect: Michael Hammett

Dennis Ruabon
Hafod Tileries, Ruabon, Wrexham,
North Wales, LL14 6ET
Tel: 01978 842283 Fax: 01978 843 276
Managing Director: Clive Gibb

Hanson Brick Plc (HQ)
1 Grosvenor Place, London SW1X 7JH
Tel: 0207 245 1245 Fax: 0207 235 3455

Ibstock Brick (HQ)
Over Lane, Cattybrook, Almondsbury,
Bristol, BS32 4BX
Tel: 01454 614573 Fax: 01454 617031

Ibstock Brick
Lodge Lane, Cannock,
Staffordshire, WS11 3LT
Tel: 01922 701077 Fax: 01922 417808
Factory manager: Brian Stead

Ibstock Hathernware Ltd
Station Works, Rempstone Road,
Normanton on Soar, Loughborough,
LE12 5EW
Tel: 01509 842273
Managing director: Geoff Hollis

Shaws of Darwen
(Architectural ceramics)
Waterside, Darwen,
Lancashire BB3 3NX
Tel: 01254 775111 Fax: 01254 873462

USA

Endicott Clay Products Co.
P.O. Box 17, Fairbury, NE, USA 68352
endicott@endicott.com

International Brick Collectors Association
Managing editor: Peggy French
Tel: (513) 683-4792
Frenchie@I. net

The Logan Clay Products Company
201 South Walnut Street, Logan,
OH 43138
Tel: 800 848 2141 Fax: 740 385 9336

Scandinavia

Hans A. Petersens
Nybolnor, Teglvaerk, Sonderjylland,
Denmark

Europe

Belgian Brick Federation/ Belgische Bakisteenfed Eratie
Bloemenerf 4, 1652 Alsemberg,
Belgium
Tel: (02) 511 2581 Fax: (02) 513 2640

SUPPLIERS OF MORTARS AND EPOXY RESINS

Mortar

Tilcon produce an extensive range of
coloured sand. Samples of brick can
be matched for colour.

Tilcon Scotland Ltd
250 Alexandra Parade,
Glasgow, G31 3AX
Tel: 0141 554 1818 Fax: 0141 554 6377

Tilcon North Ltd
Lingerfield Scotton, Knaresborough,
North Yorkshire HGS 9JN
Tel: 01423 864041 Fax: 01423 864049

Tilcon South Ltd
Mortar Division, Cadeby Quarries
Cadeby, Nuneaton, Warwickshire
Cv13 0BB
Tel: 01793 698600

Epoxy resins

Structural Adhesives are the main
suppliers of epoxy resin to the brick
companies. They also supply epoxy
paint for brick and brick pavements.

Structural Adhesives Ltd
Bushby Brook Works, 16 Spenser St,
Leicester, LE5 3NW
Tel: +44 (0) 116 246 0766. Fax: +44
(0) 116 276 5753

SUPPLIERS OF SPECIALIST TOOLS AND EQUIPMENT

UK

Alec Tiranti Ltd
70 High Street, Theale, Reading,
Berkshire RG7 5AR
Tel: 0118 930 2775 Fax: 0118 932 3487

Blockleys Brick Ltd, Telford
Supply specialist cutting wires/bows
for use with brick. These can be
ordered from the factory for £46.50
(at time of print). *See brick suppliers*.

Craftline
Cairneycroft, 133 Draycott Old Road,
Forsbrook, Stoke-on-Trent ST11 9AJ
Tel: 01782 393222

Potclays Ltd
Brick Kiln Lane, Etruria, Stoke-on-
Trent, Staffs. ST4 7BP
Tel: 01782 219816

Potterycrafts Ltd
Campbell Road, Stoke-on-Trent,
Staffs. ST4 4ET
Tel: 01782 745000
www.potterycrafts.co.uk

USA

Axner Pottery Supply
P.O. Box 621484, Oviedo, Florida
32762.
Tel: 800 843 7057

Mile Hi Ceramics, Inc.
77 Lipan Street, Denver, Colorado
80223.
Tel: 303 825 4570

Transport

There are many brick haulage specialists throughout the country. It is important to work out beforehand if a forklift is needed because of difficult access, or a lorry with a crane is required. The brick company you are dealing with can advise on a haulier.

Centres of excellence for the production of large-scale artworks

USA

Archie Bray Foundation for the Ceramic Arts,
2915 Country Club Avenue, Helena, MT59602, USA
Tel: 406/443-3502 Fax: 406/443-0934

Web site: www.archiebray.org

Bemis Centre for the Arts
724 South 12th Street, Omaha, NE 68102-3202
Tel: 402 341 7130
International Programs/Media Coordinator: Susan Schonlau

John Michael Kohler Arts Centre
608 New York Avenue, P.O. box 489, Sheboyan, Wisconsin, 53082-0489
Tel: (414) 458-6144

Scandinavia

Tommerup Bygningskeramik
Skovstrupvej 57, DK 5690 Tommerup, Denmark
Tel: +45 6476 1404. Fax: +45 6476 3701
Director: Esben Madsen

Europe

Struktuur 68
2512 BH, Den Haag, Nieuwe Molstraat 27–31, Netherlands
Director: Henk Trumpie

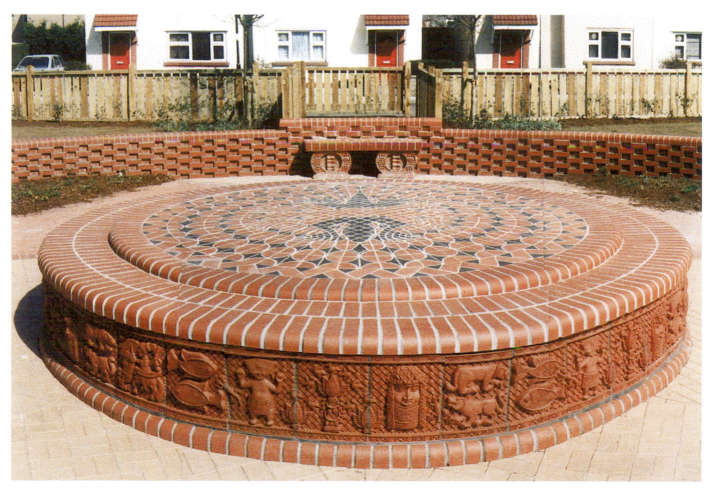

West Close Square commission by David Mackie, Cardiff, 1994.

Bibliography

Books

Adams, Arthur Frederick, *Terracotta of the Italian Renaissance*, Terracotta Association, Derby, 1928.

Becker, Howard S., *Art Worlds*, University of California Press (Berkerly/Los Angeles/London), 1984.

Bond, James, Gosling, Sarah & Rhodes, John, *Oxfordshire Brickmakers*, Oxfordshire County Council, Dept. of Museum Services, 1980.

Cassell, Michael, *Dig It Burn It Sell It*, Pencorp Books, 1990

Cunningham, Colin, *The Terracotta Designs of Alfred Waterhouse*, Wiley-Academy, 2000.

Davis, Douglas, *The Museum Transformed, Alberville Press, 1993.*

Dumbleton, Michael, *Brickmaking: A Local Industry, Ascot/ Bracknell/Workingham*, 1993.

Hammond, Martin, *Bricks and Brickmaking*, Shire Album Publishers Ltd, 1998.

Jodidio, Philip, *Contemporary European Architecture Vol. 3*, Taschen, 1995.

Kirkeby, Per, *Brick Sculpture and Architecture Catalogue Raisonné*, Kunsthaus Bregenz, 1997.

Moorey, P.R.S., *Ancient Mesopotamian Materials and Industries; The Archeological Evidence*, Clarendon Press (Oxford), 1994.

Peirs, Giovanni, *Construire en Brique en Europe*, Iannoo, 1994.

Porter, Venetia, *Islamic Tiles*, British Museum Press, 1995.

Stratton, Michael *The Terracotta Revival*, Weidenfeld & Nicholson, 1993.

Lynch, Gerard, *Brickwork, History, Technology and Practice*, Volumes 1&2, Donhead Publishers Ltd, 1994.

Wigzell, Elaine, *The BDA Guide to Successful Brickwork*, 2nd edition, The Brick Development Association.

Magazines, Journals and Catalogues

The Architects Journal, 'Per Kirkeby's Brick Enigmas' Mead, Andrew, October 29, 1998.

The Architects Journal, 'The Healing Arts', Tessa Jaray, 1999.

American Ceramics, on Charles Simonds and John Beardsley, Vol 11, No.3, 1994.

American Ceramics, 'Shrines for Potters', Rick Newby, Vol. 9, No.3, 1991.

Brick, its History and How it is Made, General Shale Products Corporation, Tennessee, USA, 1986.

Bricks, Tiles and Terracotta (catalogue), Chester City Council, 1985.

Ceramics Art and Perception, 'Architecture Without Walls' (article on Robert Harrison), Rick Newby, No.10, 1992.

Ceramics Monthly, 'From Intuition to Form' (interview with Jacques Kaufmann),February 1999.

Ceramic Review, 'Houses on Fire', Jane Perryman, No 162, 1996.

Creating the Yellow Brick Road (symposium papers), University of Wolverhampton, 1999.

Industrial Archaeology Review, 'Brick Kilns: An Illustrated Survey' Hammond, M.D.P., Vol. 1, No 2 – Oxford University Press, Spring 1977.

Kerameiki Techni, 'Franz Stahler' Enzo Biffi Gentili, issue 27, December 1997.

Keramikos, 'Franz Stahler' Marissa Vescovo, No. 19, April 1991.

Picasso, Painter and Sculptor in Clay (catalogue), Royal Academy, London, 1998.

Per Kirkeby (catalogue), Jill Lloyd, Tate Gallery Publishing, 1998.

Shaping Earth (catalogue), Wolverhampton University, 2000.

Glossary

Blocks Architectural bricks often three times the size of normal bricks, and solid rather than hollow.

Brick bond The pattern in which bricks are laid on top of and adjacent to each other, enabling them to tie in, forming a stable unit.

Continuous kiln A type of kiln in the shape of a tunnel, which is at full temperature in the centre. Bricks enter the kiln cold stacked on a trolley which moves through the centre of the kiln, firing the bricks, and comes out again cool.

Crocodile kiln A type of intermittent kiln which opens like the mouth of a crocodile.

Clamp kiln A very basic kiln, the bricks to be fired actually construct the kiln themselves.

Cutting box Special wooden or metal formers in which extruded bricks can be re-cut into a new shape with a metal wire. If the clay is very soft it can be thrown into the cutting box to shape it.

Intermittent kiln A kiln which is packed cold, fired up to temperature and unpacked when cooled.

Kibbler A machine used to grind the clay into small particles.

Nova rota A machine used to further reduce the clay particles and force them through perforations in a wet pan.

Oxidation A neutral atmosphere in the kiln, where there is adequate oxygen for the firing.

Reduction An atmosphere in the kiln, whereby the oxygen intake has been reduced and the flame is forced to extract it from the bricks, causing a change in chemical structure and colour.

Routing machine A machine which is run from a computer programme in order to cut out a 3D model or design.

Setting Placing or packing bricks into the kiln.

Specials Handmade 'special' bricks, not made on the production line of factory, often complicated shapes thrown into wooden formers or recut from extruded bricks in wooden formers.

Stillage Metal drying racks on which bricks (specials) are air-dried before being wheeled into mechanical dryers.

Index